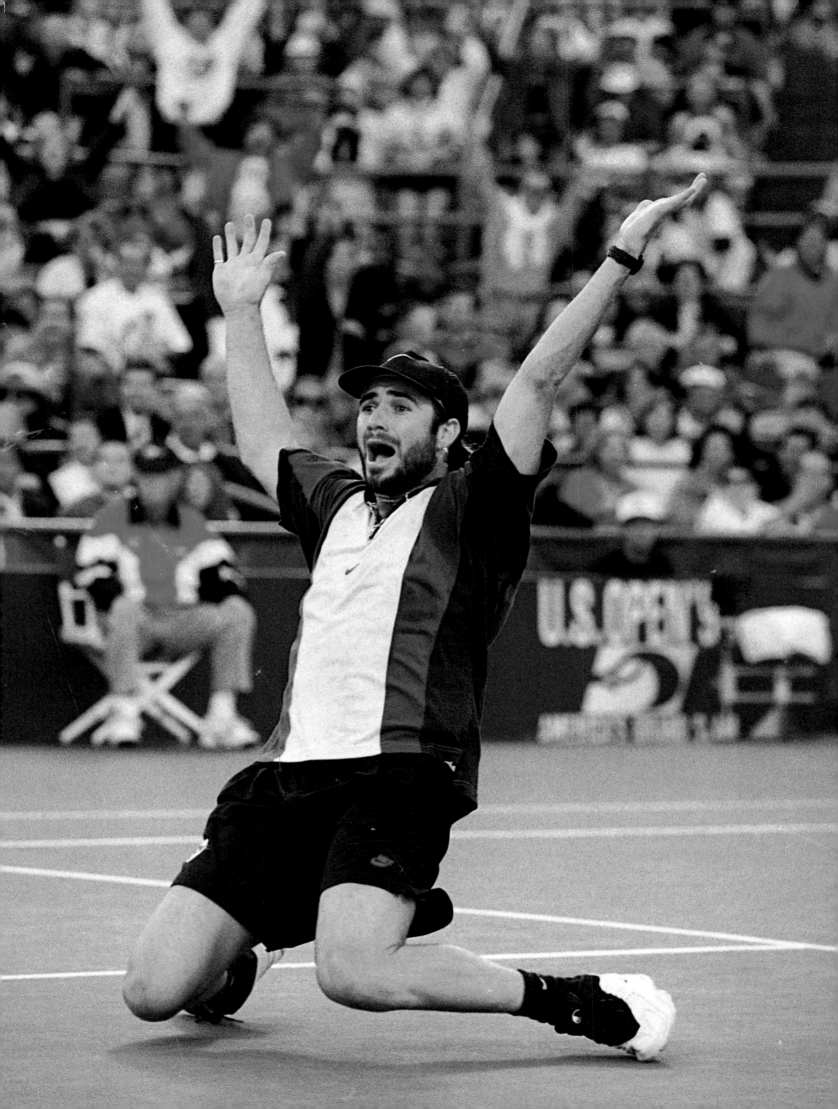

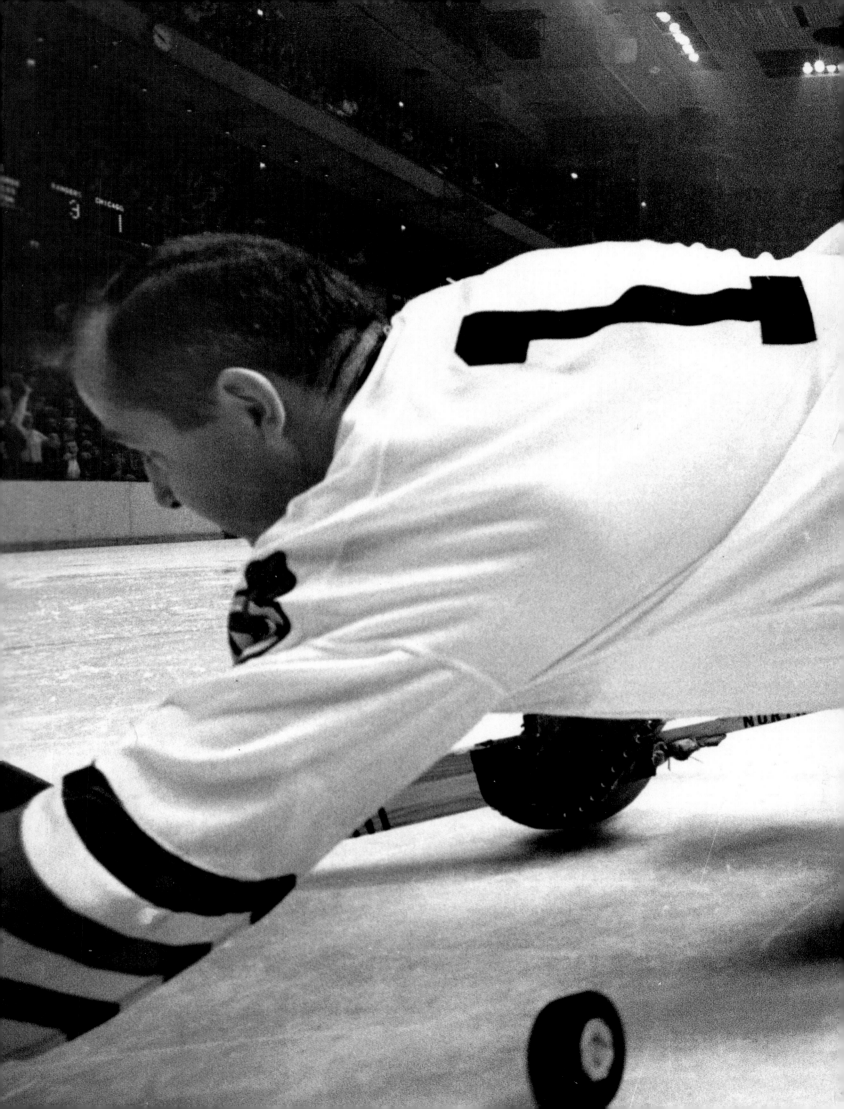

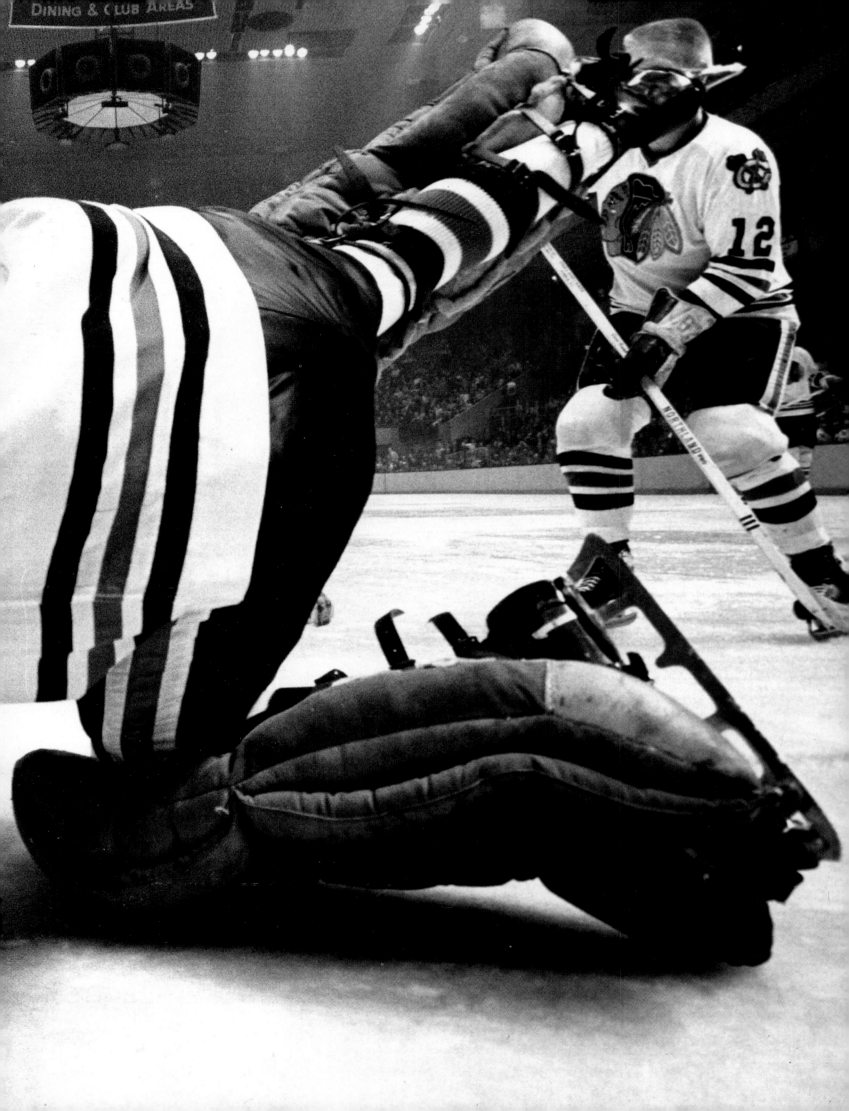

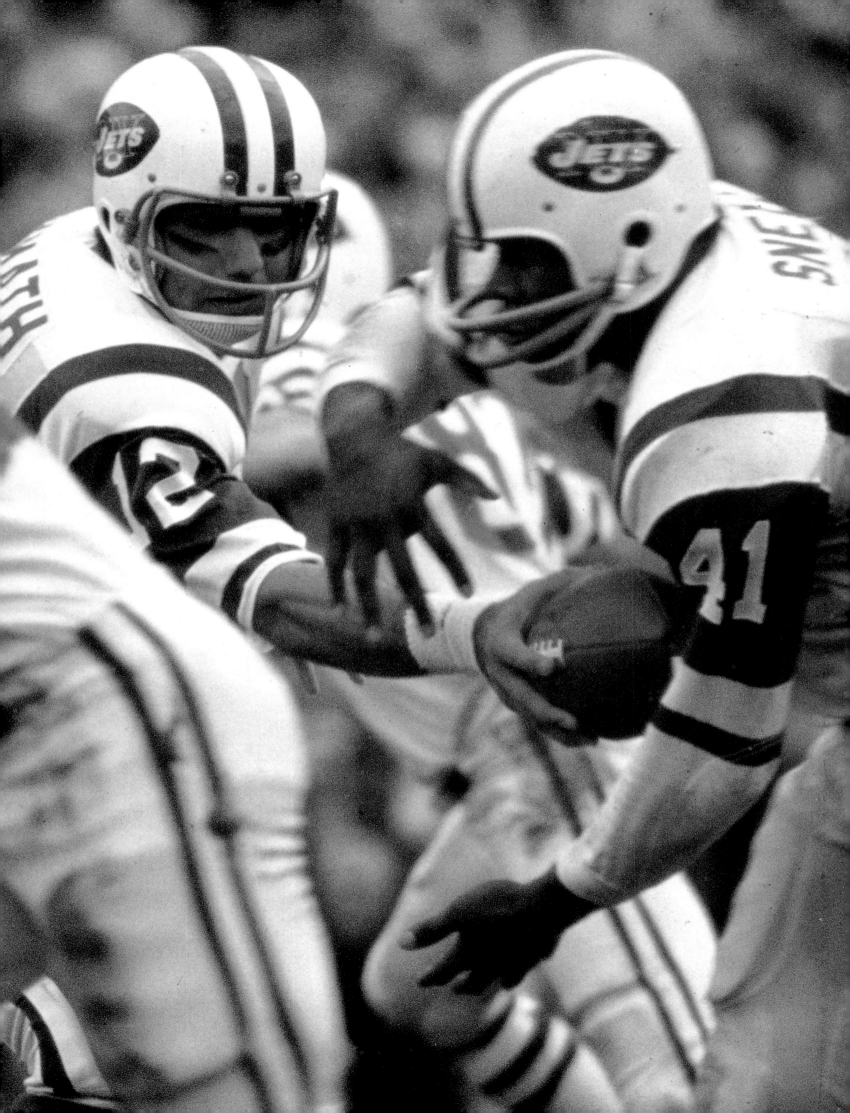

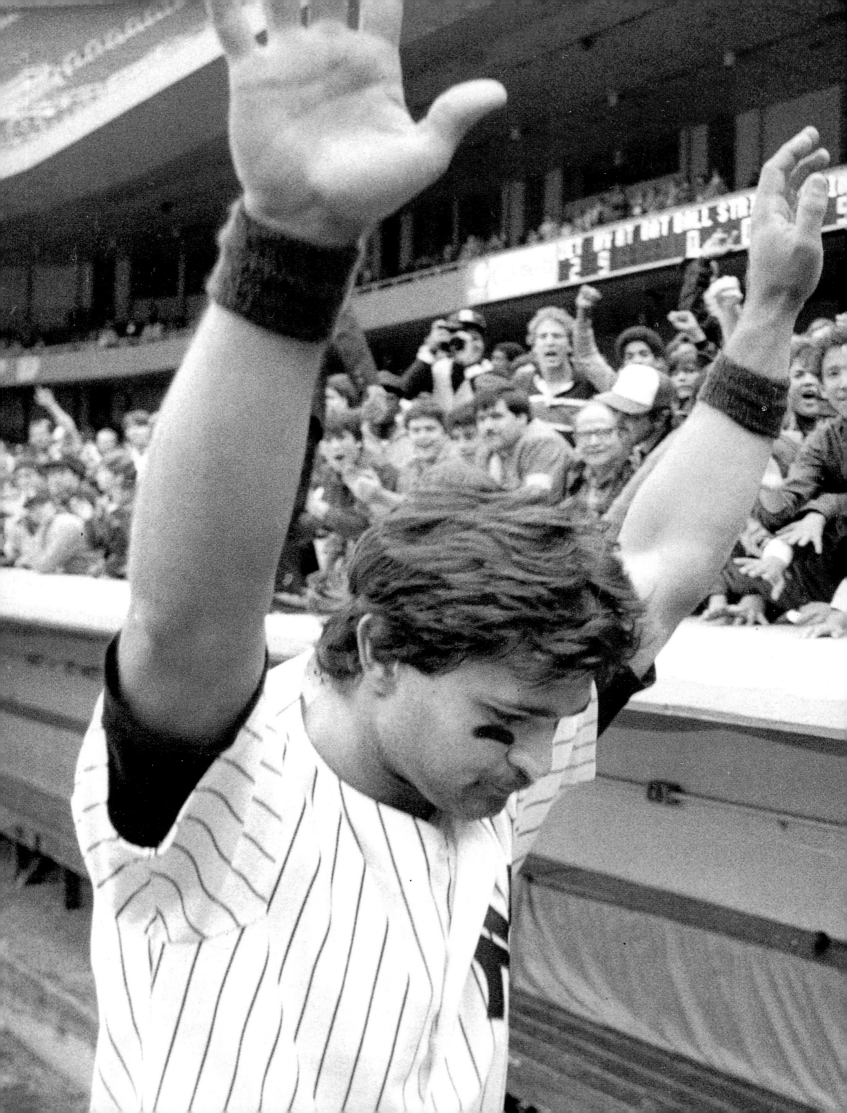

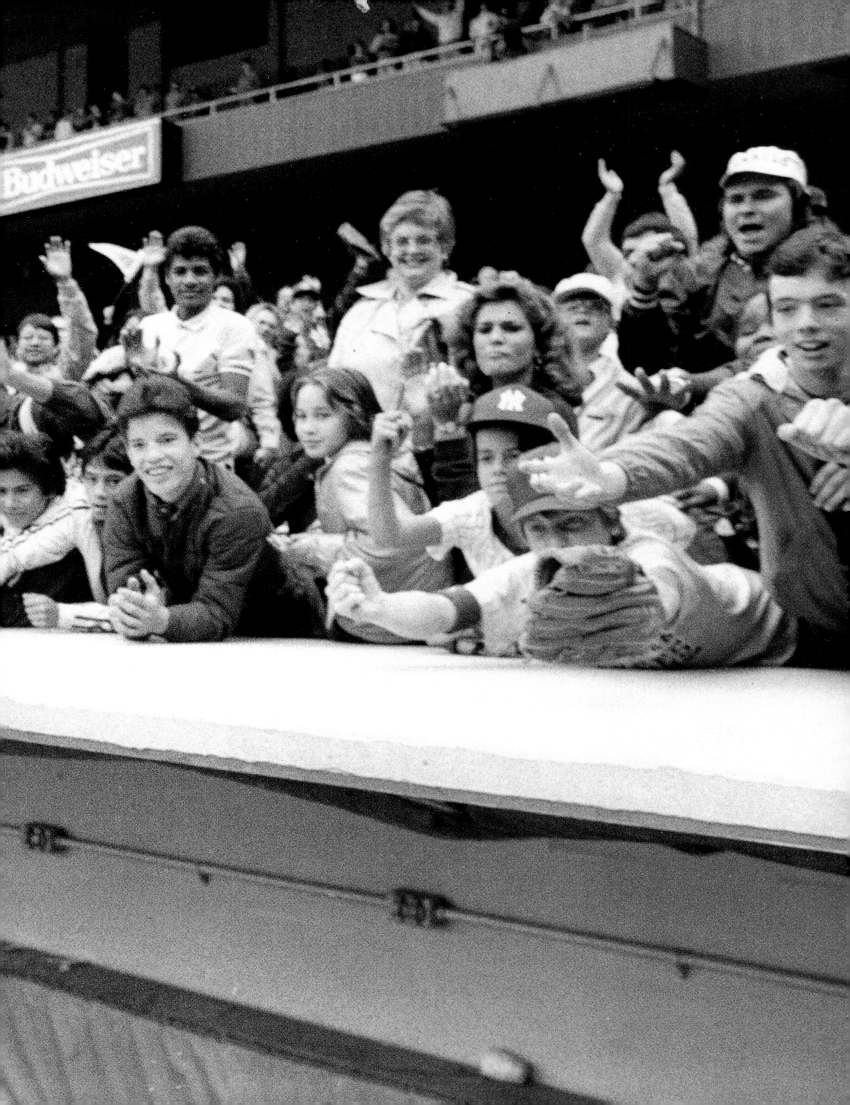

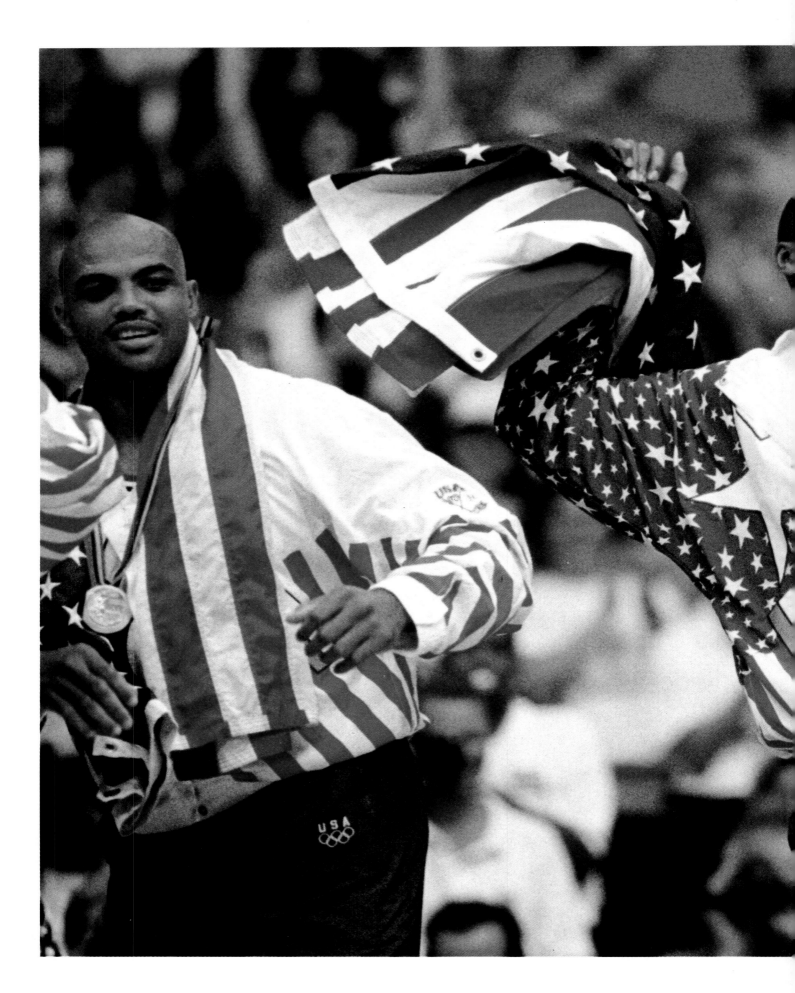

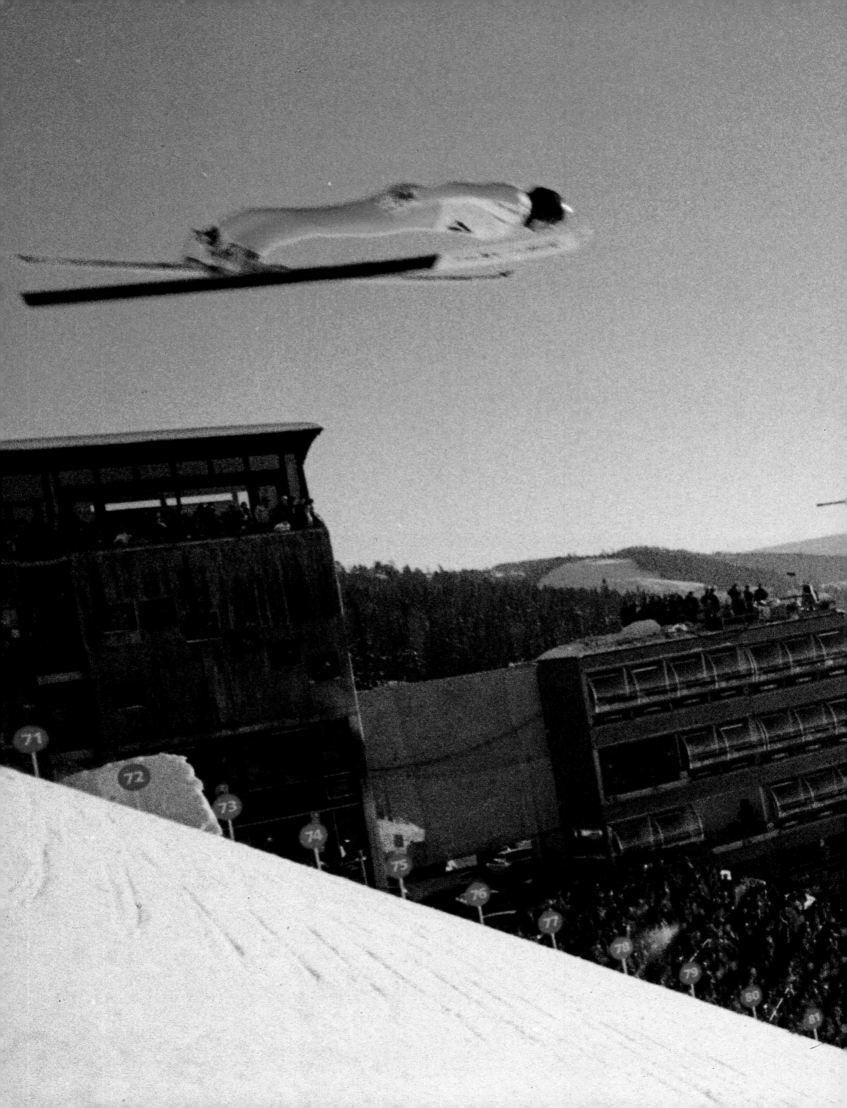

Capturing *the* Moment
The Sports Photography of Barton Silverman
Introduction by Dave Anderson
With contributions by Ira Berkow, Neil Amdur, and Mark Bussell

PENGUIN
STUDIO

Opening sequence:

Andre Agassi exulting after winning the U.S. Open in 1994.

Blackhawk goalie Glenn Hall goes sprawling in vain as the puck rolls under him during a game against the Rangers in 1966.

Jets quarterback Joe Namath hands off to Matt Snell for the only touchdown in New York's 16–7 victory over Baltimore in Super Bowl III.

Don Mattingly responds to the roar of the Yankee Stadium crowd after winning the batting title on the last day of the season in 1984.

Magic Johnson waves the American flag after the United States Dream Team clinches the gold medal in basketball at the 1992 Olympics in Barcelona. Charles Barkley is at left.

Jens Weissflog of Germany on his gold-medal jump in the 120-kilometer ski jump in Lillehammer, 1994.

PENGUIN STUDIO
Published by the Penguin Group
Penguin Books USA Inc., 375 Hudson Street,
New York, New York 10014, U.S.A.
Penguin Books Ltd
27 Wrights Lane, London W8 5TZ, England
Penguin Books Australia Ltd, Ringwood, Victoria, Australia
Penguin Books Canada Ltd
10 Alcorn Avenue, Toronto, Ontario, Canada M4V 3B2
Penguin Books (N.Z.) Ltd, 182–190 Wairau Road, Auckland 10, New Zealand

Penguin Books Ltd, Registered Offices: Harmondsworth, Middlesex, England

First published in 1996 by Viking Penguin, a division of Penguin Books USA Inc.

1 3 5 7 9 10 8 6 4 2

LIBRARY OF CONGRESS CATALOGING IN PUBLICATION DATA
Silverman, Barton. Capturing the moment : the sports photography of Barton
Silverman / by Barton Silverman; introduction by Dave Anderson;
additional texts by Ira Berkow, Neil Amdur, and Mark Bussell.
p. cm.
ISBN 0-670-86881-7
1. Photography of sports. I. Title.
TR821.S56 1996
778.9′9796—dc20 96-14676

Printed in the Singapore

ART DIRECTION AND DESIGN BY JAYE ZIMET

This book is dedicated to my loving wife, Marlene, my

dearest friend and confidante, whose love and support

have enabled me to pursue and accomplish my dreams,

and to my wonderful triplets, Chad, Heather, and

Samara, who have brought immeasurable joy into my

life and who are a continuing source of inspiration.

—Barton Silverman

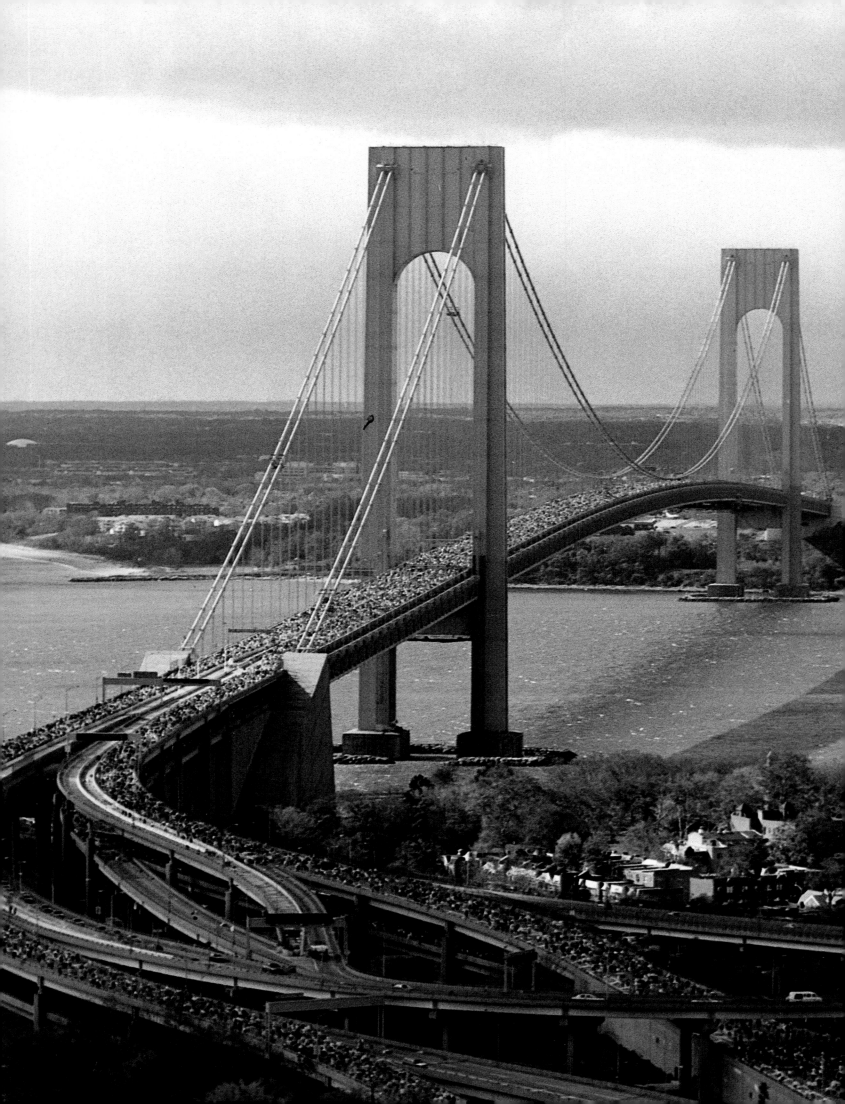

Contents

New York City Marathon, 1995.

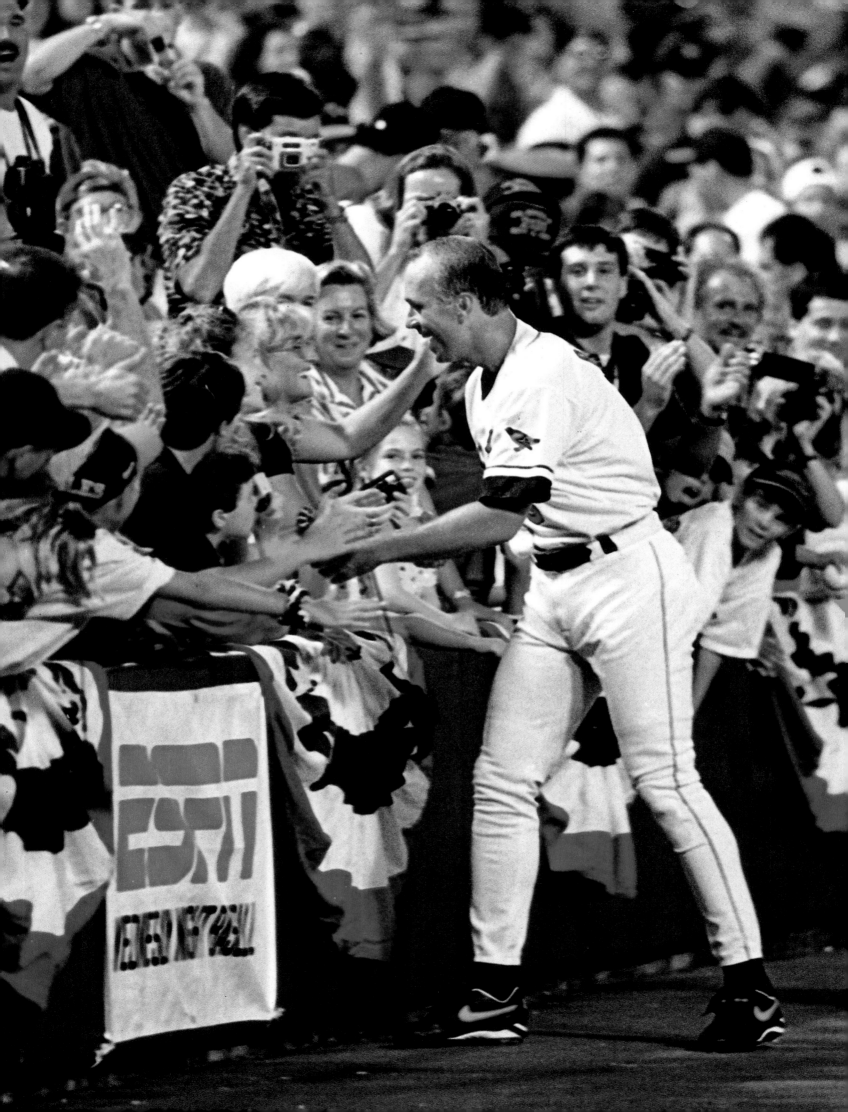

Introduction

D A V E A N D E R S O N

He had settled into his assignment that Wednesday, taking pictures for *The New York Times* of Monica Seles in her quarterfinal match at the 1995 U.S. Open Tennis Championships, but suddenly Barton Silverman's beeper sounded: Call the office immediately.

"What's up?" he asked.

"We finally got you a credential for Cal Ripken's game in Baltimore tonight. Can you get there?"

"What about this tennis match?"

"Ripken is a bigger story," he was told, meaning the Oriole shortstop's record-breaking 2,131st consecutive game. "They want to take it on page one."

"Can't somebody in Washington drive up?"

"They're too busy with the President."

"I don't have anything with me except my cameras. I don't even have a toothbrush."

"We'll get you a car and a hotel."

"Do I have a position?" he asked, meaning a specific space among the photographers.

"No, but you can do it."

He sighed and thought, *It's always "Depend on Silverman to do it."* But invariably Silverman does it.

As he did that day and night.

Tossing his Seles film into a locker (where it would be picked up and brought to the *Times* photo lab), he drove to nearby La Guardia Airport and

Cal Ripken, Jr., after breaking Lou Gehrig's consecutive-game streak, September 6, 1995.

Before and after Ripken's record-breaking game became official.

hurried to the gate just as the door was about to close for a two o'clock shuttle. Sweating in his white shirt and white slacks and carrying a big lens, with three cameras and a film bag dangling from his shoulders, he plopped into a seat for the flight to Washington's National Airport.

His adventure had only begun.

After parking his rental car outside Oriole Park at Camden Yards, he still was not sure how his film would be transmitted. The wire services, which usually do that as a courtesy, were too busy. But he noticed an empty photo room. Allsport, another photo service, would edit and transmit his images. Minutes later he squeezed into the photographers' pit behind home plate.

He had a position and transmission, but with batting practice about to begin, he needed photos.

As he walked onto the field, so did Cal Ripken. About an hour later, in the *Times* office on West Forty-third Street in Manhattan, sports editor Neil Amdur was wondering what wire-service photos had arrived for the first edition.

"We don't need the wires; we've got Silverman," sports photo editor Steve Jesselli said. "He's already transmitted seven or eight photos."

As the game progressed, his photos kept coming. When the television screen in the *Times* office showed Ripken trotting around the ballpark and slapping hands with the fans in the fifth inning after officially breaking Gehrig's record, somebody shouted, "Look, Barton's on the field, right behind him."

When the *Times* chose a page-one photo for its final edition, it was Barton Silverman's shot of Cal Ripken with the fans.

Earlier that night, an editor was writing credit lines for the sports photos. "If Barton's in Baltimore," he said, "the credit on this Monica Seles photo must be wrong."

"No," he was told. "Barton shot Seles early, then he went to Baltimore to shoot Ripken."

Whatever the problems, *The New York Times* had depended on Barton Silverman to do it. And he had done it. He always does. He's the world's best newspaper sports photographer. The defining word there is "newspaper." As good as magazine sports photographers are, they work week to week, some-

times month to month. He works hour to hour, sometimes minute to minute.

"In all the years I worked with Barton," says Steve Fine, a *Times* photo editor from 1983 to 1992, "he never went to an event without coming back with a dress page picture."

In addition to the dress, or first, page of the sports section, his thousands of *Times* pictures have also appeared on other *Times* pages. And wherever they appear, his admirers seem to know they are his without even checking the credit line. He talks about wanting to get the "peak of action," and invariably he gets it. The basketball player's hand above the basket. The figure skater at the top of a leap. The home run hitter's expression as he watches the ball soar toward the stands. The night Reggie Jackson hit three homers in the 1977 World Series finale at Yankee Stadium, not every photographer had all three swings. Barton did.

Monica Seles, U. S. Open, 1995.

And when his wife, Marlene, gave birth to their triplets (Samara, Heather, and Chad, in that order) on June 18, 1980, he hoped to photograph all three arrivals.

"But they wouldn't let me in the delivery room with my camera," he says. "I got the pictures anyway. I gave the camera to one of the doctors and he took them."

To his sense of capturing the moment, he tries to add a sense of art. At the 1995 U.S. Open at Shinnecock Hills, he noticed the soft glow of the late-afternoon light. Late the next afternoon he peered through the zoom lens of his Canon EOS-1 at the shadows streaking Greg Norman's face.

"My portraits are more the Rembrandt style, with shadows, as opposed to the flat light," he would explain later, staring at his photo of the Australian golfer. "Rembrandt had a technique of highlighting one side of the face, with the other side in shadows. I studied art, you know."

Now people study Barton Silverman's art.

Photography has various art forms: commercial, illustration, studio, news. But perhaps the most difficult is capturing consistently for a newspaper the most meaningful moment of a sports event or a sports personality. Nobody does it better than this sometimes blustery Brooklyn-born photographer as he surveys his subjects, anticipating the image that tells the story.

"If you're not in the right position," he says, "you can't get the picture."

To get that position, he's been known to put on a "game

Reggie Jackson hitting one of his three home runs in game six of the 1977 World Series.

Above: Greg Norman, 1995.
Below: Reggie Miller, 1996.

face" as aggressive and as competitive as that of any athlete he shoots.

"In this business," he says, "you can't always be the nice person you want to be."

While shooting an event, he's more bulldog than toy poodle. And quicker than a cobra.

"You got to be quick or you're dead," he says. "You can't ask 'em to do it again. You can't tell basketball players to take the three-point shot again. You can't tell horses to run the race again. You either get it or you don't."

Invariably, he gets it. Not only more often and more artistically than most sports photographers, but against newspaper deadlines that dwindle edition by edition.

At an afternoon game his deadline might be four or five hours away, but in the evening it might be only minutes away. And he's not working in the comfort of a studio.

At the Olympics, he's jostling with other photographers to focus on the finish of the 100-meter dash or trudging through snowdrifts for a better angle at the ski jump. At the New York City Marathon, he's leaning out of a helicopter while strapped to his seat, pleading with the pilot to fly "lower, lower." At a football game, he's bundled in a storm coat against subfreezing weather, but he's not wearing gloves, the better to snap the shutter. At a baseball game or a tennis match, he's sweltering in 95-degree heat. At a golf tournament, he's hiking up hills and across meadows. At a basketball game, he's squatting only a few feet beyond the baseline, bracing himself against a seven-footer crashing into him.

"Some basketball players don't even try to avoid us when they come flying," he says. "Some use us as a cushion."

But he gets the best photos because he knows as much about the sports he covers as he does about lenses and lighting.

"You've got to know the sport," he says. "In football, you study the quarterback and his receivers. If you cover a team game after game, you get to know a quarterback has certain favorite receivers he will go to in certain situations. In baseball, when Reggie Jackson was up, you knew he was going to try to hit a home run, so you didn't waste your time thinking he might hit a grounder to the shortstop. You've got to discipline yourself to anticipate the action."

His anticipation is almost mystical. Once, while I was in a Super Bowl

press box, I noticed Barton hurrying along the sideline to a new position at the other end of the field from where the ball was.

"Nothing's going to happen on this play," I said to a colleague. "If Barton is going down to the other end of the field, nothing will happen until he gets there and gets everything in focus."

And until Barton set up his cameras in a new position, nothing important did happen. It's almost as if the big play of the game wouldn't dare occur until he was in position to photograph it.

"The reason I cover sports, it's like a game I play," he says. "It's not like covering a politician's press conference where the mayor is going to flick his eyes or show a piece of paper. If I miss it, he's going to do it again. With sports, you have to be on top of the game. You set up a couple of cameras. You play the angles, you play the percentages. And you're in competition. Let's face it, the *Times* editors are going to use the best picture. If the Associated Press or Reuters provides a better picture of the winning touchdown, the *Times* is going to use it. You're at the mercy of their thinking."

Not only does Barton get the image more often than most sports photographers get it, he has gotten it when others didn't get it at all.

At the 1992 Winter Olympics, he plodded through thick snowdrifts up the men's downhill course in the French Alps to an icy bump where the skiers momentarily soared in midair. Before the competitors skidded down the mountain, forerunners tested the course. But as dozens of photographers were setting up and checking their equipment, they suddenly wondered, How many forerunners had gone by? Five? Six? Like the others, Barton wasn't sure.

"I didn't know if the next guy was the last guy," he recalls, referring to the forerunners. "Or if the next guy was the first real guy. I just thought I'd get a shot of him anyway to make sure my film was advancing."

While other newspaper and news-service photographers were asking each other, "Who was that?" Barton had the only photo of Patrick Ortlieb of Austria, whose time as the first skier in the men's downhill would turn out to be the best one.

Patrick Ortlieb, Albertville, 1992.

"At the Olympics," he says, "the wire services, the big magazines, they have a whole battery of photographers. They can afford to experiment. I'm usually there by myself. At the Olympics I always feel like I'm up against the world."

At the Summer Olympics, he has covered as many as six dif-

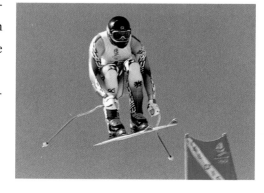

ferent events in one day, sometimes in steaming heat. At the Winter Olympics, he has worked three or four different events in a day, sometimes outdoors in bone-chilling weather.

"The skiing is over, so now I'd like to relax and have a bowl of soup to warm up, but it's not like that," he says. "They want me to go to a hockey game that's already started. If I'm lucky, I make the last twenty minutes of it, then I'm on the way to figure skating. And they want the picture of the moment. If you get to figure skating after putting in fourteen hours up and down the mountains and somebody slips in front of you and you don't get the picture, you're a bum. If they see that picture in another newspaper the next day, they'll say, 'Silverman was there. He should've had that picture.' "

His editors seldom say that, because Barton Silverman is as much reporter as photographer.

"Working for a newspaper, I'm a photo-reporter," he says. "I'm recording the event as it happens. The next day that event, that moment, has to be in the newspaper. So basically you're looking for the big play of the game. That's what the readers want. I'm there to record history, and the readers want to see it the next day in the paper."

More than anybody else, he wants to see it too.

"On an out-of-town assignment," he says, "the greatest satisfaction I have is going to the airport the next morning, buying the *Times*, and seeing somebody else on the plane looking at my pictures and saying to myself, 'That picture really goes with the story.' It's not that I want bragging rights. It's just for my own satisfaction."

And for his own legend.

He doesn't pretend to be subtle or sophisticated. In the photographers' pit next to the Yankee dugout at Yankee Stadium, he suddenly will shout, "Did you get that one? That was terrific. That was marvelous."

In a restaurant in the French Alps during the 1992 Winter Olympics, he turned toward a waitress and said, "Señor." Wrong language, wrong country, wrong gender.

At the 1995 United States Open golf championship, he was joined by another *Times* photographer testing a new high-tech Japanese digital camera, one of only two dozen in the world at the time. The first day of the tournament, the digital camera worked perfectly. The second day, problems developed. Barton was informed that the digital camera wasn't functioning properly,

that he was now the only *Times* photographer with a working camera.

"That's why I'm here; I've got everything they need," he said. "That's why I didn't want to use that new camera. When they asked me to try it, I told 'em, 'I'm recording history. I can't take any chances.' But if you come up with good images, you've got to be a little lucky."

Luck, of course, is the residue of design, as baseball sage Branch Rickey once said. During a cycling race in the Catskill Mountains, Barton was perched in the back of a small truck that stayed ahead of the leaders. He couldn't see what was ahead of him on the road, only what was behind the truck. Suddenly he saw a shadowy figure next to the cyclists. He snapped the shutter.

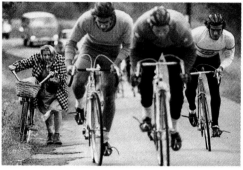

Columbus Day, 1975.

"That's the picture of this old woman plodding up a hill with her bike next to the racers," he says. "I didn't even know I had it."

New color presses in a new printing plant will enable *The New York Times* to use color photos on its news pages for the first time. But except for photos that have appeared in color in the *Times'* Sunday magazine and in other Sunday feature sections, photos in the *Times* have been in black and white. He doesn't complain.

"It's my newspaper blood," he says. "When I take my film back to the office around eleven o'clock after a baseball or basketball game and I'm walking out of the building half an hour later and there's my picture in the paper, that's a tremendous feeling. Other people don't understand that. They don't have newspaper blood."

To him, six elements contribute to creating a good sports photo.

"One, the subject matter: the athlete, the personality," he says. "Two, the action. Three, the facial expression. Four, the lighting. Five, the composition and the color. Six, technique: a different camera or a different lens. Any of those elements make one photograph more exciting than the next. And the more elements you can include in one photograph, the better it is."

He can't remember having all six of those elements in any one photograph.

"The closest one," he says, "was when I put the camera in the hockey net."

As a young *Times* staff photographer, he suggested a Sunday layout of photos from a camera attached to the rear of a goaltender's net during a Saturday afternoon game between the New York Rangers and the Chicago Blackhawks at the old Madison Square Garden. But his photo editors were skeptical.

"How do we know we'll get anything?" one said.

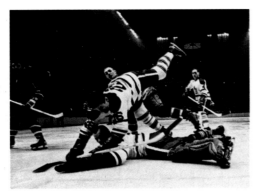

In the old Madison Square Garden, 1966.

"I'll test it in Wednesday's game," Barton said. "Then we can shoot the Saturday afternoon game for the Sunday paper."

"But only if the test works," the editor said.

While the Garden crew was changing to the hockey configuration after a Tuesday night basketball game, Barton supervised the stringing of a wire under the ice to the camera in the net from a first-row seat behind the boards, where he would snap a remote-control shutter. But on learning that the ice was only five-eighths of an inch thick, he worried.

"I thought, *What if a skate cuts the wire?*" he recalls. "What if a player trips on the wire and breaks his leg?"

Wednesday night's test convinced his editors that the camera, hidden in a white box to blend with the white ice, would produce unusual photos. But before the Saturday game, Blackhawk goaltender Glenn Hall protested to the referee about the strange little box in the back of his net.

"It was there Wednesday night," one of the Rangers told him. "It's not in your way."

Hall finally agreed. Barton Silverman had his Sunday layout from an angle that a newspaper had never before provided its readers. As the youngest staff photographer in *Times* history, he had another feather in his cap. Born on September 8, 1942, he grew up in the Bensonhurst section of Brooklyn, the son of a Fulton Fish Market merchant. He was six when his father, Harry, died of a heart attack. He was raised by his mother, Stella, and two older sisters, Anne and Evelyn. One day he was cleaning a closet when he discovered cameras and lights that his father had used.

"I'm twelve years old, in the seventh grade," he recalls. "To me, it was like finding jewels."

Not long after that, while walking to Seth Low Junior High School one morning, his friends Shelly Reinish and Joel Vidders mentioned that they wouldn't be walking home with him that afternoon. They were staying after school to join the camera club.

"I thought, *I've got all this camera equipment at home, I'll join too,*" he remembers. "That opened my door to paradise."

At Lafayette High School, he emerged as the president of the camera club and the school photographer (with permission from the principal to be excused from any class if a photo had to be taken). At Brooklyn College, he was the

photo editor of the student newspaper and yearbook. He also worked in a neighborhood photo studio.

"I shot weddings, two a weekend, thirty dollars a wedding. That was big money for a kid then," he says. "My mother needed the money. We were a lower-middle-class family. I think that's where I got my competitive drive."

Having taken business courses at Brooklyn College, he was hired as a photographer for an advertising agency. But he found it too boring, too structured. He watched fashion photographers spend hours staging the model and the lighting. If the photos didn't come out just right, they would stage it again, sometimes again and again. He didn't have the patience. He answered the *Times'* classified ad for a photo lab technician in 1962 and got the job.

"When I didn't have to be in the lab, they let me do weddings; the staff guys wouldn't stoop to that," he says with a laugh. "You got the bride and groom coming down the steps. I got forty dollars for one shot. Pretty good after getting thirty dollars to shoot a whole wedding."

But he wanted to shoot sports. One afternoon he bought a ticket to a Mets game at the Polo Grounds, sat in the stands with his secondhand Rolleiflex, and searched for a subject. One of the *Times* staff photographers was shooting the game, so he needed something different. He noticed a boisterous fan jumping and yelling. He shot two rolls of film. That night he showed his pictures to the lab supervisor.

"What's the chance," he asked, "of these showing up in the sports section as a feature?"

Coincidentally, the *Times* assistant sports editor, Jim Tuite, had requested photos of Mets fans. When the photos were shown to Tuite, he splashed five of them across the sports page.

"They paid me fifteen dollars a picture, seventy-five dollars," Barton recalls. "That was better than going to weddings."

After that, whenever photos had to be delivered to the sports department from the lab, Barton took them himself. One day he mentioned to Jim Roach, the sports editor, "If there's anything going on that the staff guys don't want to cover, I'll do it." He shot surfers. He shot an overnight sailing race.

"I climbed up on the mast and shot down," he says. "My first monthly *Times* publisher's award. I wasn't even on staff."

In 1964 he earned a worldwide Hague Award, the first of his numerous honors, for photos of the construction of the Verrazano Bridge, some from a

shaky catwalk high above the dark water of the Narrows where New York Bay widens into the Atlantic. In 1965 he was promoted to the *Times* staff, but since his replacement in the lab had not yet been hired, he was developing other photographers' film on the November night the lights went out all over New York City.

"Get your camera," he was told. "See what you can get."

Outside the *Times* offices, he peered toward Times Square, where the buildings and billboards known as the Great White Way were in darkness except for the eerie beams of automobile headlights.

"We had photographers running all over the city," he remembers, "and I'm thinking, *Here's the picture, half a block away.*"

To get that picture, he needed to shoot down at the Times Square traffic from a perch high in the office building that was then being renovated into the Allied Chemical Tower. But during the renovation the building was closed. Inside the entrance, a security guard glared at the twenty-three-year-old man approaching with a camera.

"Nobody's allowed in here," the guard barked.

"I'm with *The New York Times*, I've got to make a picture."

"Nobody's allowed in here."

"I've got to get upstairs to make this picture for *The New York Times*."

"Well," the guard said, "I've got to call Allied Chemical."

"I'll pay for the call," Barton said, handing the guard a $20 bill. "Keep the change."

"I guess it's all right," the guard said. "Just be careful."

Barton walked up the stairs and between the scaffolding until he was looking down on Times Square illuminated only by the streaks of car headlights. He shot a roll of film and hurried downstairs and across Seventh Avenue to the *Times* office, where he resumed developing other photographers' film as well as his own.

"My initiative made my reputation," he says. "I had a career night."

His career had only begun. Through the years he has covered all sorts of news assignments for the *Times,* but sports would reflect his best moments as well as many of sports' best moments.

"That's the feel for the game," he explains. "And we shoot a lot more film now than we used to. We used to shoot two or three rolls at a baseball game. Now we shoot fifteen to twenty."

At a baseball game he usually shoots from the photographers' pit near the first base dugout.

"I'm focusing on every swing I think will break the game open," he says, "but it's so difficult now to get a good picture in baseball. Maybe the ballplayers don't want to get hurt. They don't dive for balls as much as they used to. They hold the runner at third more instead of sending him in. There aren't as many collisions at home plate."

Collisions occur much more often in football and hockey, but basketball has provided Barton's favorite subject.

"Michael Jordan has been the best," he says. "He's got those acrobatic moves and his tongue is usually hanging out. In almost any NBA game, I get half a dozen good pictures in the first quarter. Basketball is great for photographers, but the hardest sport is boxing. Everybody is looking for the knockout punch. But if the fighter's back is right in front of you, you can't get it. In boxing you got to be lucky. And there are only so many ringside positions at a fight. You don't always get one."

At the Muhammad Ali–Larry Holmes fight in Las Vegas in 1980, he was shooting from a platform far from the ring, but twice he hurried to ringside between rounds.

"Just to see what I could get," he recalls. "After the tenth round, I ran down there next to a photographer who let me squeeze in. Ali was on his stool and I had room to shoot because the other photographer was changing film or had the wrong lens on. The next thing you know, they called off the fight. I had Ali sitting there, battered and beaten, and the other guy didn't. He looked at me and said, 'Why did I do you a favor? You're my competitor.' "

Of all the sports, horse racing provides the one moment a photographer can't miss: the finish.

Ali vs. Holmes, Las Vegas, 1980.

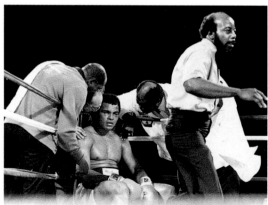

"If you do," he says, "you might as well go home and not even process your film. You play the percentages. The more cameras you have going for you, the better chance you have. Most of the remotes are down on the rail, but the jockey doesn't raise his whip at the finish. He does it a split second after. To get the jockey's reaction, I put a remote with a shorter lens farther down the rail from the finish line. Most photographers use a longer lens thinking they'll get a tighter image, but they're sacrificing the jockey raising his whip."

Like any competitor, Barton is always looking for an edge. During the Jets' training camp in 1980, he crouched close to where rookie wide receiver Johnny "Lam" Jones lined up and asked a new assistant coach to signal him what the next pass pattern would be: to the sideline, over the middle, deep toward the goalposts. When he knew it would be a deep pass, he had time to hurry down field to get into position. The next day, after the new assistant coach had inquired if the Jets permitted photographers to ask about the next play during practice, Barton was told not to do it again.

"Didn't you see that great picture of this rookie in the paper today?" he replied. "That's what you get when I know where the pass receiver is going to go."

But the Jets provided one of Barton's few regrets. When the Jets stunned the Baltimore Colts 16–7 in Super Bowl III, one of pro football's historic upsets, quarterback Joe Namath trotted off the Orange Bowl field holding up his right forefinger, signaling his team's number one stature. But Barton wasn't in position to shoot Namath's face with his finger in the air.

"I wasn't thinking," he recalls. "When Namath ran off, I should've been in front of him. I stayed with Coach Weeb Ewbank instead. I blew one. That was my first Super Bowl game. I didn't have the foresight. That's a moment I'd like to do over again."

Nobody else got that picture of Joe Namath, at least not from the front, but that doesn't soothe his regret. He always wants the most meaningful moment, no matter what any other photographer gets or doesn't get. One day at the U.S. Open tennis championships, all the photographers were aiming their cameras at the server. All but one. Barton Silverman was squinting through his lens at the player at the other end of the court.

The different angle. Barton Silverman always wants the different angle, the different photo. Invariably, he gets it.

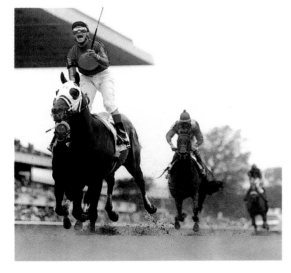

Thunder Gulch winning the Belmont Stakes, 1995.

Bart Silverman's Adventures in Winter Wonderland

IRA BERKOW

My enduring image of Bart Silverman—the sports photographer as artist, the sports photographer as genius, the sports photographer virtually without peer—is seeing him dressed and equipped and ready to embark on an assignment looking like Admiral Peary, Mathew Brady, Jesse James, and an Arabian pack camel rolled into one.

I see him about to venture forth from our small wooden complex in the Media Village at the Lillehammer Winter Olympics in February 1994. Well, not just February and not just Norway, but in the dead of winter and only about 350 miles south of the North Pole.

On this day he will trudge to the top of a mountain in order to capture for the pleasure of posterity the men's downhill ski race. But at this moment in my mind's eye, he is at the front door of our place, having clomped there from his room in his thick ski boots. It is early morning, before the sun—that measly thing in this part of the world at this time of year—is about to make its craven appearance. The intrepid Silverman is putting on the finishing touches to his remarkable sartorial assemblage.

But we are getting ahead of the story. Our hero had awakened in the bed that is nearly hidden in his small room by an array of cameras and lenses on the chairs and dresser, two black trunks of photographic equipment in the middle of

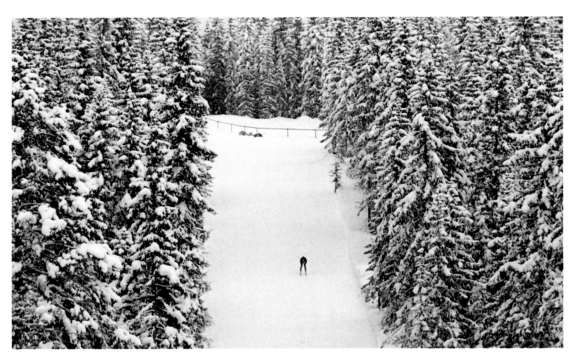

the floor, and two duffel bags full of clothing. He has learned from hard experience that in such mean circumstances the pro needs at least two of everything, from cameras and batteries to, well—"You always need a backup, especially of underwear," he says. "You never know when your laundry won't be returned."

He had awakened at about 5:00 A.M. because the first bus to the venue leaves at 6:00, and he wants to be on the mountain and in the best place possible to shoot his shots, and the place is competitive—first come, first situated. He is usually among the first on the scene, and will stand in the brutal cold for about four hours, from around 7:00 to the start of the competition, at 11:00, and stay until the affair is over, at about 2:00.

In his room, he somehow located and donned the following: two pairs of long johns, a turtleneck shirt, and a woolen ski sweater; a pair of chino pants and a pair of padded, insulated ski pants; for the feet, two silk liners, two pairs of heavy woolen socks and toe warmers in the ski boots, and steel clamps, or mountain cleats, for the ski boots to keep him from falling off a mountain. The clamps are only sometimes successful, however, and he has on occasion found himself descending the mountain in a most unexpected fashion, head over heels.

Next in apparel come the down parka, the ski cap, the parka hood over the cap, the scarf, and, on his back, a knapsack loaded with forty rolls of film, three packs of batteries, and three cameras. He won't use all the rolls, but in the bitter cold rolls often freeze up and crack, so he needs extras to feel secure. At length, he would pull on two pairs of liner gloves and the padded mittens.

On his shoulder he adjusts the straps of his 400-millimeter-lens camera, his

300-millimeter-lens camera, a 200-millimeter zoom camera, and a couple of short lenses. It appears that with the equipment and clothes, he's put on some 60 pounds. How he can walk, let alone take his routinely glorious pictures, is a stupendous achievement. A lesser man would have collapsed from the burden and lain at the doorstep, refusing to move unless lifted by a crane.

Now the unswerving Silverman—though, it must be conceded, a sometimes swaying Silverman because of the load—fastens the mouth and nose covering of the hood of his survival parka, which is reminiscent of what Peary wore in his exploration of the Arctic. At long last, only Silverman's eyes are exposed, and shifting like Jesse James checking out the Northfield bank.

And Brady, the great Civil War photographer, would have been proud of our Silverman, because he is ready for anything, including, and especially, his daily combat with the elements.

Few ever consider, when they pick up the newspaper—or this book, as it were—all that goes into the physicality and planning of the picture that they are enjoying. And it is understandable. I didn't know, nor appreciate fully, until I lived in the room down the hall from Bart for three weeks in Lillehammer.

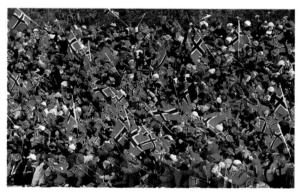

The sportswriter, too, has difficulties, but rarely do people want to hear about them. I learned long ago that people are not terribly interested in how tough a reporter—or, I guess, a photographer—had it. They just want the story of the event, in words or pictures. The foxhole tales of a sportswriter bring little sympathy anyway, because many believe that a sportswriter is to work what a bagel is to a truck—no relationship whatsoever.

Spectators at the men's 50-kilometer cross-country ski race, Lillehammer.

The same probably holds true for sports photographers. After all, you're at courtside, or behind the dugout, or, for that matter, on a mountaintop. What a seat! You should be thrilled!

About Lillehammer, for example, I don't say anything about how Hal Bock of the Associated Press, after a week there, slipped on ice while in the line of duty and broke a bone in his wrist and had to be shipped back to New York. I don't say how other writers, upon hearing this, began throwing themselves on the ice in hopes of being sent home too.

But not Bart. Oh, he might complain when he learns that the typically ace shot he shot has been relegated to a back sports page. He would be less than

human if he did not despair of the sometimes purblind decision of a lamentably addled editor. No matter. He was on the mountain the next day, checking the lighting and the shadows and anticipating the moments—the split seconds—that only a superb, experienced sports photographer can expect, and one of the significant attributes that separate, in the end, the great from the good.

Bart told me of the moment at the awards ceremony for the American skier Tommy Moe—who had won a gold medal at Lillehammer—when his hand had got so cold that he could not press the button on his camera! Shortly, with blowing and flexing, Bart got his fingers to work. And while he did not get the shot he yearned for, he snapped an excellent one.

I empathize. I had an exclusive interview with the Crown Prince of Monaco, Albert Grimaldi, a member of his country's bobsled team. As I took notes on the freezing mountaintop I discovered a strange thing happening to the index finger of my now-gloveless right hand. It was growing stiff, and it hurt. I was getting frostbitten! But of course I couldn't stop writing—this was an exclusive interview! I switched the pen in my hand from the normal way to holding it like a dagger.

Prince Albert paused for a moment to watch me stabbing my notebook. I think he was too kind to comment. After a short while he said, "Got to get back to my sled." Which, I feel, he knew to be music to my ears.

Similarly, it is a kind of music to the eyes with which Bart Silverman's sports photographs enchant us. As we delight in them, who really cares about the trouble and the effort they took to get? Perhaps only one who has been a soldier with Bart in the pursuit of the story.

And as I sit by a crackling fireplace, looking over the photos for this book, I marvel at one and then another, and turn to a third, with an index finger that still has not quite thawed out.

Always in Focus

NEIL AMDUR

Sports photography has always been one of the most glamorous and challenging aspects of journalism. Capturing that special moment of a game or match, often under less than perfect conditions, requires the same feel, spontaneity, and instinct that championship athletes bring to their pursuit of excellence. A last-second shot, a winning putt, the ninth-inning home run, and the so-called "thrill of victory and the agony of defeat" are the ingredients that feed the photographer's lens and psyche.

Posing a particular athlete, coach, or commissioner in a studio for a magazine cover story or newspaper feature is clearly an art form. But so too is working the sidelines of a pro football game in twenty-degree weather, or standing on the slopes of an Olympic downhill ski run, waiting—and looking—for that special moment that can define the event. Both approaches bring messages to readers/viewers in dramatic fashion.

For over thirty years, Barton Silverman has been more than a sports photographer who has been in the right spot at the right time. He has brought a luminous originality that sets his work apart from that of other sports photographers—whether searching for a freshly creative photo from a helicopter during the New York City Marathon or zeroing in on a goalie making the crucial save in a New York Rangers hockey game.

Silverman's ability to corral that special moment com-

New York City Marathon, 1994.

bines an aggressive determination, sports sensitivity, a keen eye for detail, and a seemingly tireless energy level. All of these qualities go into creating the winning picture.

Being aggressive is more than simply staking out a favorable position in a stadium or arena. Yes, it helps. But with Silverman, it is the bold willingness to take a chance on a stretch-run photo with a remote camera at the Belmont or the under-the-basket battle for a rebound at a Knicks game. It is also a state of mind: Silverman attacks an assignment with the ferocity of Jimmy Connors slashing a two-handed backhand winner and then savoring the moment.

No shot is too distant or daunting for Silverman. One reason is because he understands sports. But it is not simply knowing the rules of the game or having been an athlete, neither of which defines greatness in a photographer. Rather, Silverman has that special feel for what goes into a great picture.

The depth and dimension of his photos are complemented by a sense of timing and urgency. It is no small feat to combine players, clock, and situation into one exposure. But Silverman's keen eye takes you there and fills the frame with precision, poignancy, and sometimes provocation.

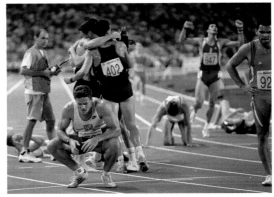

A classic example was the emotionally moving picture he took after the 1,500-meter run in the decathlon at the 1992 Barcelona Olympics. The contrast among the athletes at the finish—from exultation to exhaustion—caught the competi-

Above: Jimmy Connors, U.S. Open, 1980s. Below: Decathlon, Barcelona, 1992.

tive experience. It did not matter who had won or lost; you were simply drawn to the outburst of emotion that these world-class competitors were now releasing after a two-day, ten-event ordeal that had stripped them to the core. Silverman nailed that imagery—dead, solid perfect.

Silverman's event energy is legendary. I have seen it at Super Bowls, Olympic venues, and U.S. Open tennis tournaments, but the most astonishing Silverman saga that I witnessed was at the 1979 Pan American Games in San Juan, Puerto Rico. I was covering the event as the lone reporter for *The New York Times.* Silverman was sent as the photographer. It was the middle of the summer, in the Caribbean heat and humidity—a four-shower-a-day assignment. Yet, somehow, Barton managed four-venue-a-day shoots, from early-morning

swim heats to late-night boxing matches in a sweltering hall. And, of course, he had to fret over transmitting photos.

The quantity of his work was astounding. But it was the quality of the work that bowled me over.

"I don't know how you did it," I said after we had returned to New York.

"C'mon, it wasn't that hard," he said. "I just followed you around and kept shooting."

"But you never get tired," I persisted.

"Hey, the camera never sleeps."

Amen. There is no closed book on Barton Silverman, because his shutter is always at the ready.

The shot put, Pan Am Games, Puerto Rico, 1979.

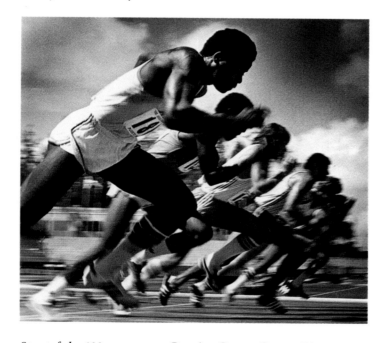

Start of the 100-meter race, Pan Am Games, Puerto Rico, 1979.

The Art of Barton Silverman

MARK BUSSELL

This book, *Capturing the Moment*, is a testament to the art Barton Silverman created from photographing sports. But his sensibilities and professional obligations have reached beyond racetracks, gridirons, and boxing rings. For many years, Barton was on general assignment for *The New York Times*. A photographer on general assignment must be able to shoot everything from still lifes to war, and so Barton's assignments ranged from French chefs to presidential campaigns to famous blizzards. In this role, Barton was consistently able to take a complex, or difficult, or even bland situation and turn it into photographs that would engage people and make them understand the event as he did—almost always under deadline pressure. Barton's presence upgraded the entire *Times* photographic report, both by the visual beauty of his pictures and by his competitive spirit.

John Morris, picture editor of the *Times* from 1967 to 1973, said that he had been impressed from the start by Barton's drive to be the best. Morris said, "Out of that determination came a discipline which gave him a remarkable ability to size up a situation and bring back that one picture that told it—or the key pictures if it was a feature story."

"He felt pictures, as well as seeing them," Morris said. "He did whatever necessary to place himself so that the reader would share his feelings upon seeing his images. I was richly rewarded to have him as the spark plug of a talented staff. He was and is a credit to the *Times*—an enormous asset."

While on general assignment, Barton was also creating many of the wonderful sports images collected here. When looked at chronologically, they mark

Skaters in Central Park, New York, 1979.

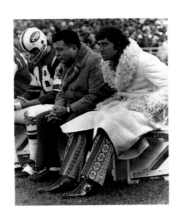

An injured Joe Namath on the sidelines, 1971.

some of the high points in the memories of the baby boomer generation, but they also note the social changes in the stands and arenas that echoed the evolution of American life.

Barton's richly atmospheric pictures are imbued with soundtracks and smells. In his earlier photographs, arenas are filled with white men and their sons, and the rising vapors of Vitalis and White Owl cigars. Later, as more black players took the field, more black fans sat in the seats. Then women appear in the stands, and Joe Namath's feats make it okay for men to sport sideburns and wear bell-bottoms. Hairspray is smelled in the locker room for the first time. Marching bands give way to blaring, prerecorded rock-and-roll anthems. Early on these photographs are mostly in black-and-white. Then comes the age of cool color and digital imagery, capturing millionaire second stringers, super-agents, and sound bites against the hyperproduced backdrop of luxury stadium entertainment.

The thirty years that Barton has been at the *Times* have given him a front-row seat to important events in the American saga. He feels the weight of the responsibility as the eyes of the *Times'* readers. "I'm recording history," he said. "The reader of my paper has already seen the image on TV. They have already heard about it on the radio. Now they want to remember it. Are they going to remember it by my photograph?"

In 1968, Barton was sent to Chicago to cover the Democratic convention. Other *Times* photographers were shooting the political scenes inside the convention hall, so Barton drew the task of covering the tension in the streets. He took some of the most telling pictures of the confrontations, moving from the safety of the press area to place himself between the police and the students. He ended up being arrested for his efforts. One of the final frames that Barton took—of a big officer swinging a club right at him—appeared in *Life* magazine, as well as in *The New York Times.*

In 1971, Barton was sent to the Magdalen Islands, Canada, to document the hunting of baby seals. Early reports of the methods of fur "harvesting"—crushing the skulls of the seals to avoid damage to the valuable body fur—had been causing the first waves of public revulsion. After being "socked in" by three days of rain and fog, Barton and a reporter were finally allowed out to where the seals were being killed. Confronted by bad weather and hostile hunters, Barton needed to find an image that embodied the horror and cruelty of the situation without its being too gory for his editors or readers. Since he was

not able to show a clubbing, he imagined a scene in his head that spoke of the brutality to come. So Barton framed a live seal in the foreground, and waited for an armed hunter to move to the right spot in the background. The picture is of innocent life oblivious to approaching death.

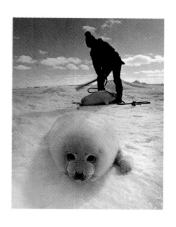

The clubbing of a baby harp seal, Magdalen Islands, Canada, 1971.

Whatever he photographs, Barton tells you more than the "peak of action." LeRoy Neiman, the painter, who has known Barton for almost thirty years, said, "Barton is a sociologist. He's not just snapping pictures."

The environments in Barton's pictures are so dense that they can create multiple commentaries on the subject. For example, Barton shot an assignment for *The New York Times* magazine in 1983, for a cover story on Tommy John called "The Never-Ending Boyhood of an American Hero." But the cover image was clearly of a ballplayer who was far from being a boy. You were physically close to him, but his face was doused with shadow. You could not see John's eyes—as with a movie cowboy whose name you never learn, this was the hero you never know.

For the inside of the magazine, Barton photographed John's backyard—the perfect lawn, the perfect wife (whose hair was cut as neatly as the grass), the towheaded children, and the happy dog jumping in front of a fake waterfall. Barton showed the ballplayer in iconographic settings, and the images were embracing and cynical at the same time.

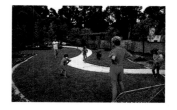

Tommy John and family, 1983.

The surprises in Barton's pictures come from the perpetually shifting references in his mind, a card deck constantly shuffling. When asked how he thought to put the camera down low on the dirt to shoot racehorses pounding toward the finish, he says that he was thinking of the opening scene in the film *The Wild Ones*, where you hear the thunder of the motorcycles on an empty road before you see them roar up over the horizon.

The unexpected pairings in his images also speak volumes—the old woman pushing her bike as cyclists race past. Or, in his New York City Marathon photographs, when individual runners look tiny against the bridges and the skyline or, in other photographs, where thousands of marathoners—as a group—dwarf the city. It is a double pun, playing man off his creations.

Narrative ability, the embrace of atmosphere, and unusual juxtapositions are all essential elements in Barton's work, but the use of light is the distinguishing characteristic. He says that "lighting is number one. A picture can be exciting just to have a lighting vision."

Many of Barton's photographs are backlit. "In the early stages of my career

when I was shooting weddings for extra money, I used backlight," he recalls. "You know, the bride, the groom, kissing. That style stays with me . . . the image with a shadow goes back a long way."

Barton's photo of Jens Weissflog after winning the ski jump competition in the 1994 Olympics was given its meaning by the shadow of the crossed skis and the shadows of the crowd you never see. The light and the race were both behind the runners on the track in Los Angeles in 1984, and both suffering and solace are edged with the fading sun.

Barton credits certain photographers for their early influence on him. "*Life* magazine was my Bible," he said. "Every Thursday or Wednesday, when *Life* magazine came out, I would be first in line at the newsstand."

"I didn't have idols like baseball, Mickey Mantle," Barton said. "I had my own heroes—George Silk, John Dominis, Mark Kaufman, John Zimmerman, Irving Penn, Bert Stern, Avedon." He reviewed the pictures in his mind's eye. "John Dominis. Essay on Africa. Late-afternoon lighting. Highlights on subject matter. Irving Penn. Used high-key, washed-out blacks and whites." His eyes lit up at the memories. "High contrasts. Instead of flesh tones. Lots of blacks and whites."

But now fellow artists recognize Barton's work. Neil Leifer, another master sports photographer, said of Barton, "He has a gift. He is immensely talented. You can't say it's luck over twenty-five or thirty years. He just doesn't miss. And he gets better. He's a genius at what he does. It's as simple as that."

Fred McDarrah, the influential editor and photographer, said, "Barton certainly has an unbelievable eye. You can't teach that. He can see things that other people can't."

Barton Silverman could be the model for a dictionary's definition of art: A human effort to imitate, supplement, alter, or counteract the work of nature by a conscious arrangement of elements using intuitive faculties and learned techniques in a way that affects the aesthetic sensibility. Barton can apply this learned technique and intuition while lugging loads of long lenses around the crowded, subzero sidelines of a football game and still manage to create a sublime image from the split-second collision of 300-pound gladiators. If you admire the beauty of the end result and imagine the cold, or the heat, or the noise, or the shoving and the chaos, you can begin to understand the rarity of Barton's gift.

Capturing *the* Moment

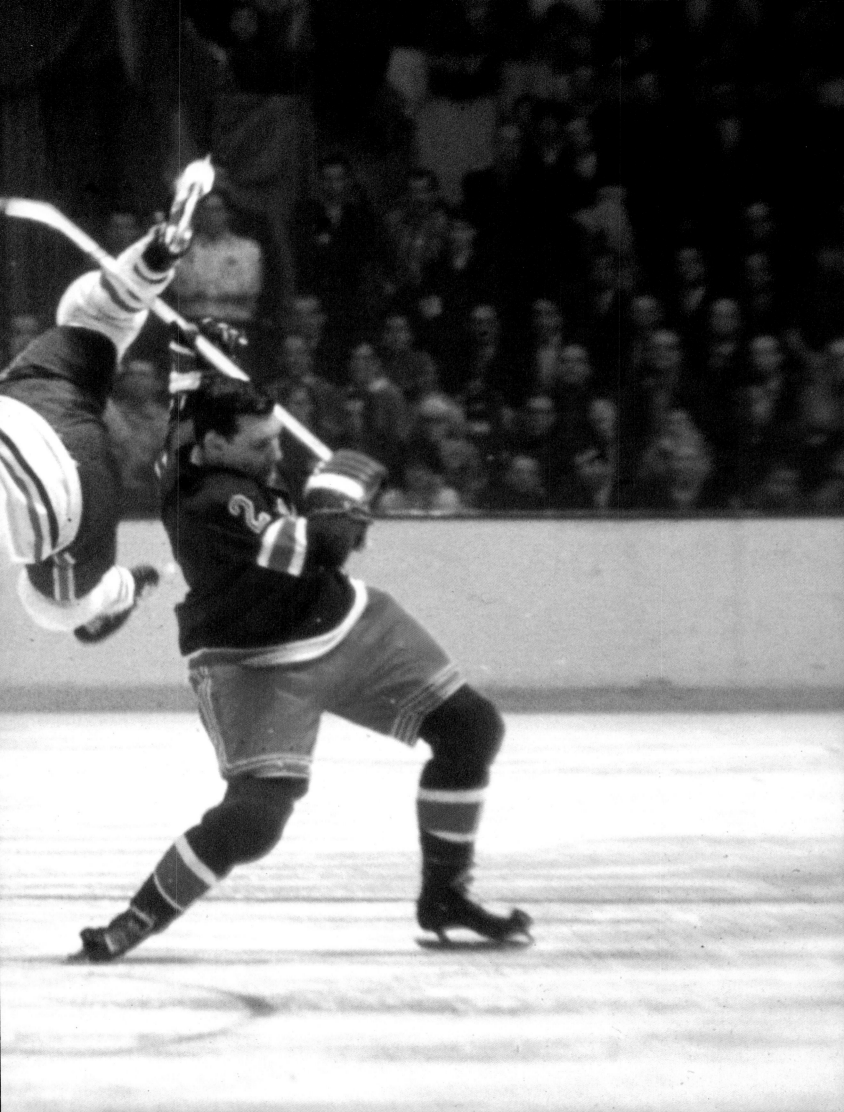

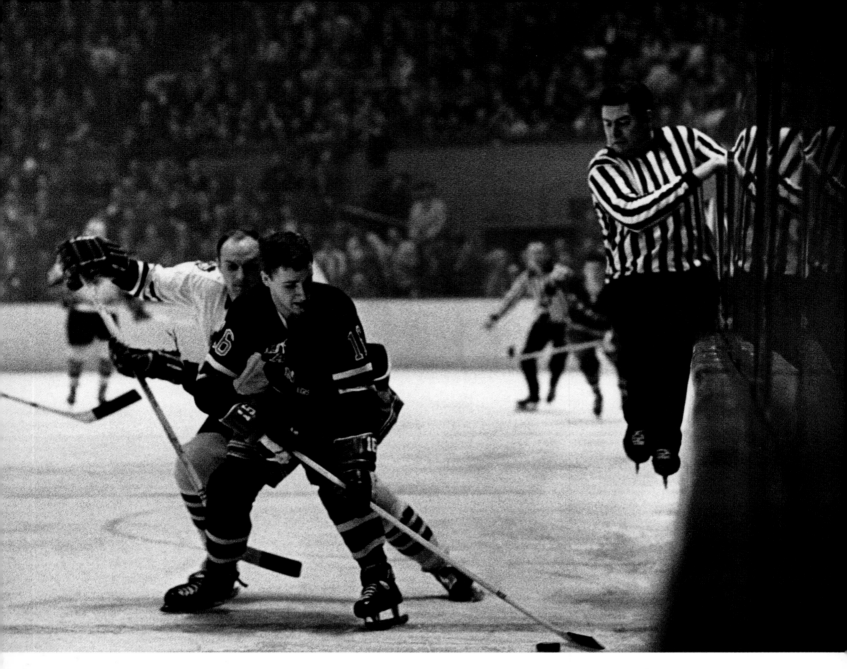

Linesman George Hayes elevates himself along the boards as he tries to get out of the way of the puck during a 1967 Rangers-Blackhawks game at the Garden. Rod Seiling (16) of the Rangers and Doug Molins of Chicago scramble for the puck.

Previous pages: Up and over goes Bobby Rousseau of the Montreal Canadiens as he is flipped by Wayne Hillman of the New York Rangers during a game at the old Madison Square Garden in 1965.

A fight between the Rangers and the Canadiens at the Garden.

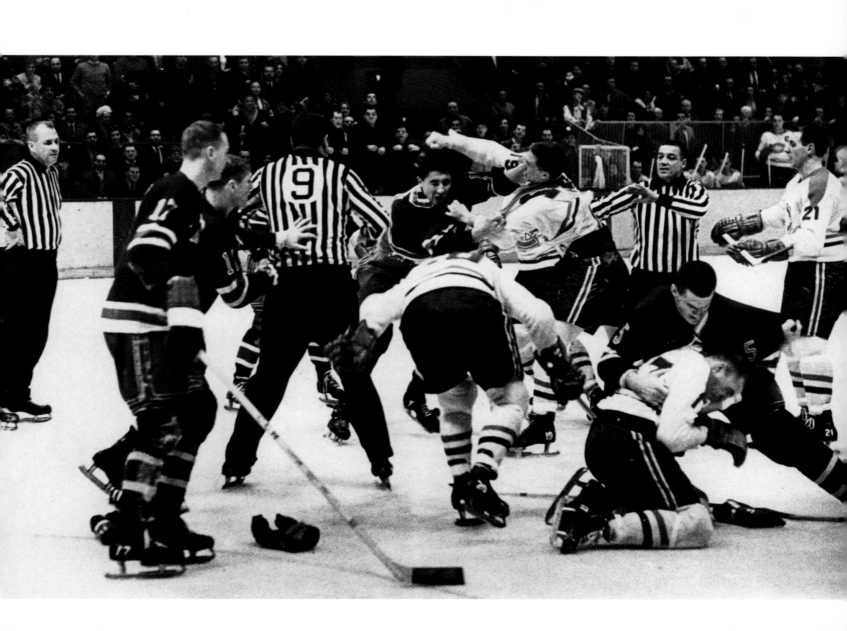

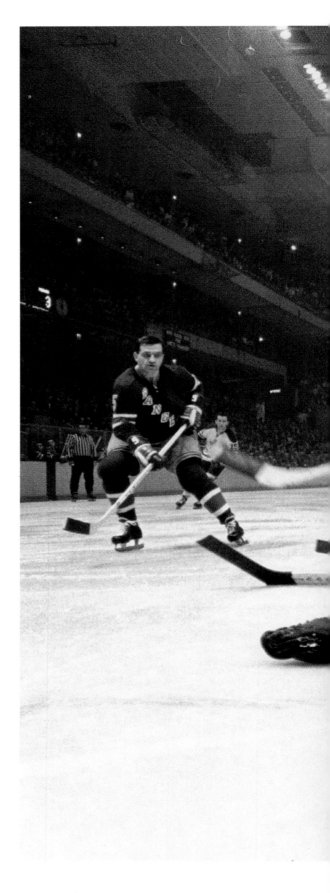

Toronto goalie Johnny Bower sprawls to the ice trying to stop a shot by Bernie Geoffrion of the Rangers (5) as the other players look on during a game at the old Garden. For this game, I mounted a small camera low on the back of the cage, trying to get a different angle and perspective. I had to build a box about ten inches square, to protect the camera, and paint it white to hide it. I tested it in one game, then used it for real the next two times. The Rangers won all three games. A month later they went on a losing streak, and the coach then, Emile Francis, was a superstitious type who remembered their success with my mounted camera. So John Halligan of the Rangers asked if the team could borrow my box, "to change our luck," but after a couple of games it was destroyed.

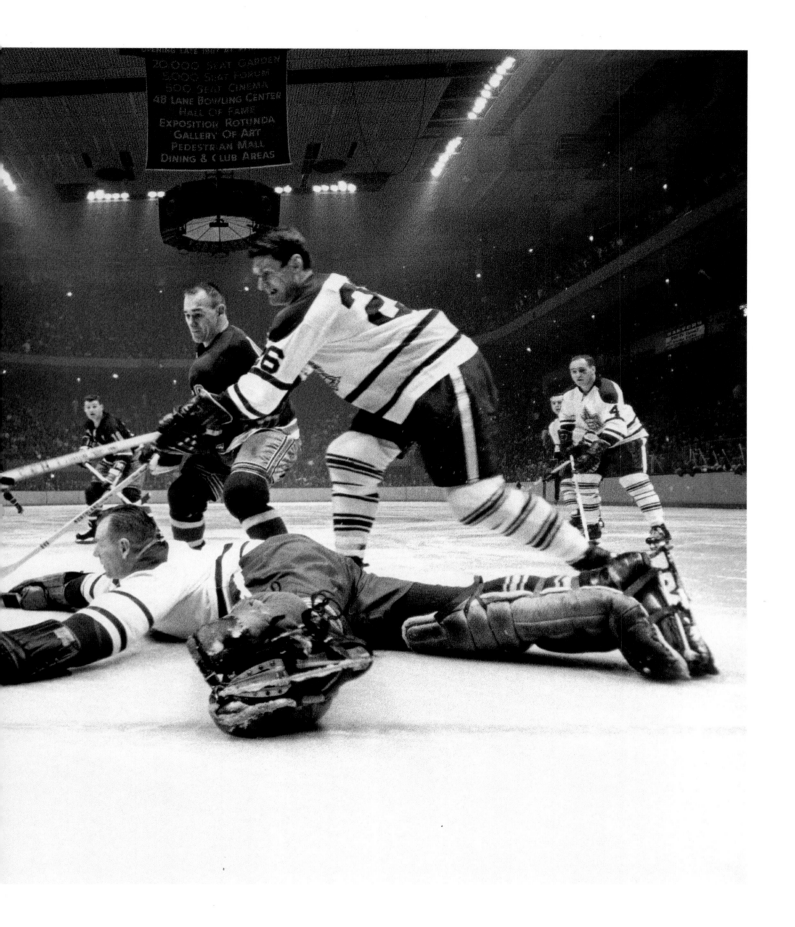

Overleaf: Gordie Howe, the legendary Detroit Red Wings star, trails his hand along the boards during a 1965 game against the Rangers at the old Garden.

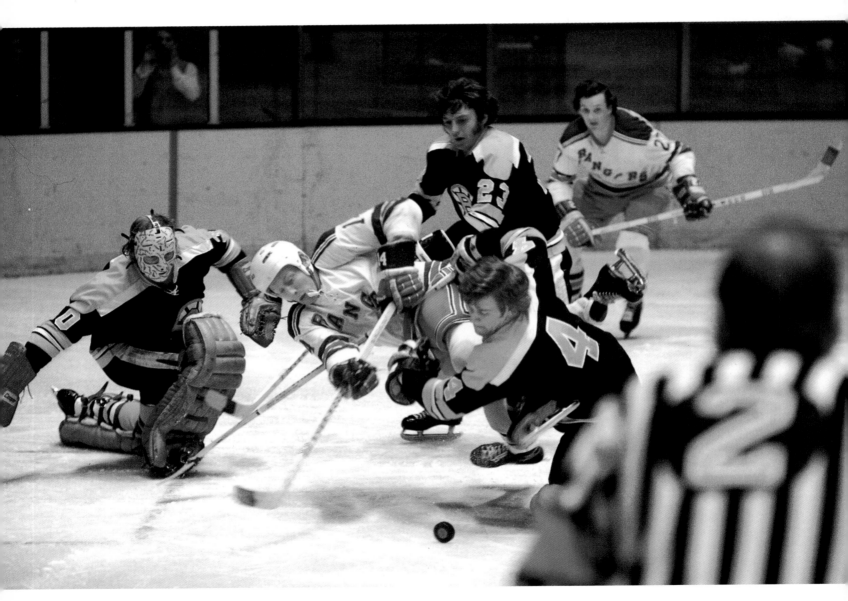

Goalie Gerry Cheevers of the Boston Bruins (30) stopping a shot by Bruce MacGregor of the Rangers (14), as Bobby Orr (4) and Matt Ravelich join on the defense. Seen in the background is Ted Irvine of the Rangers.

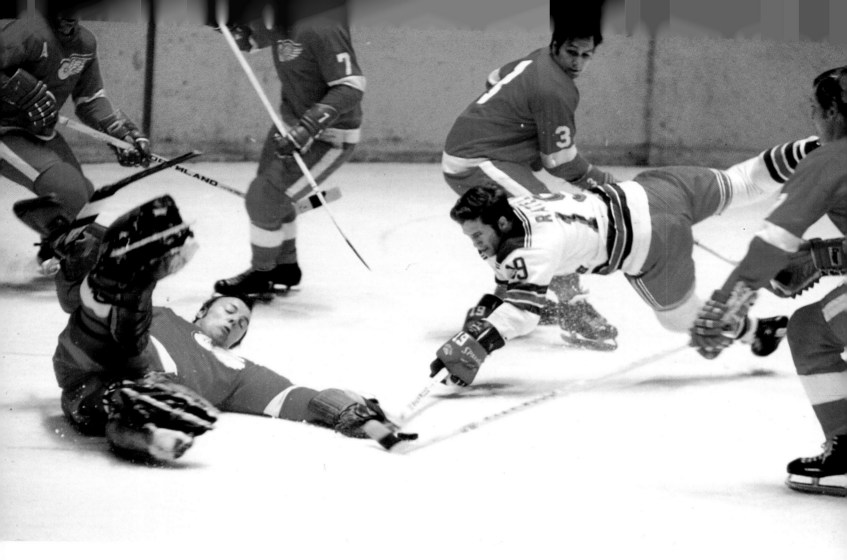

Jean Ratelle of the Rangers (19) about to collide with the Detroit goalie during a 1972 game at the Garden.

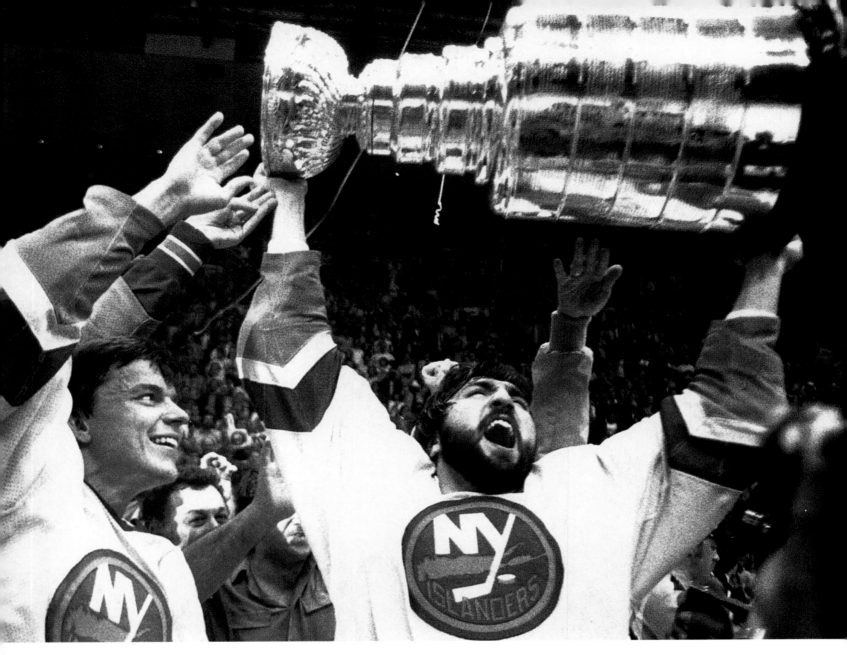

Clark Gillies of the Islanders holds the Stanley Cup aloft
after the team won one of its four N.H.L. championships (1980–83).

Mark Messier of the Rangers reacts after scoring the 500th goal of his career during
a game with Calgary on November 6, 1995.

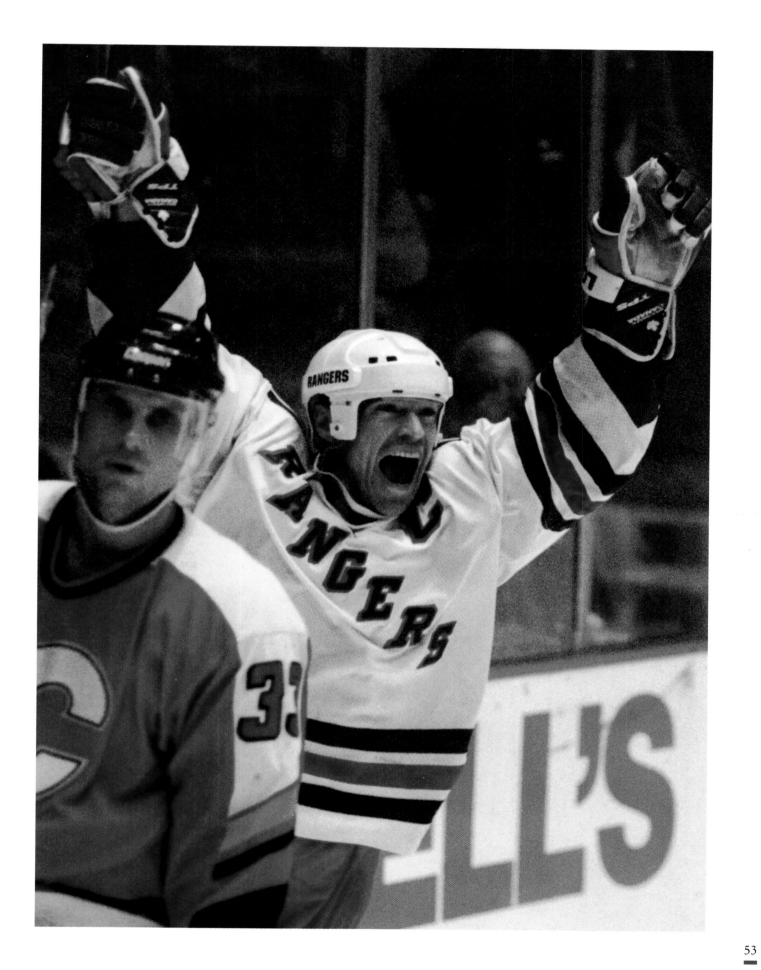

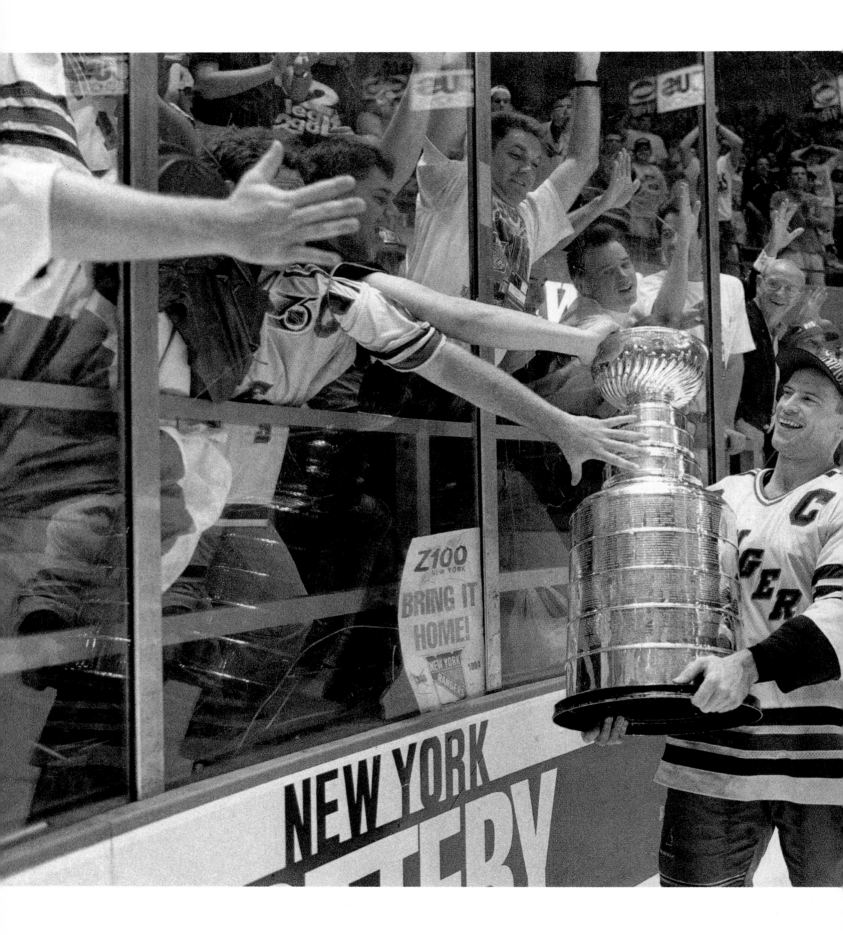

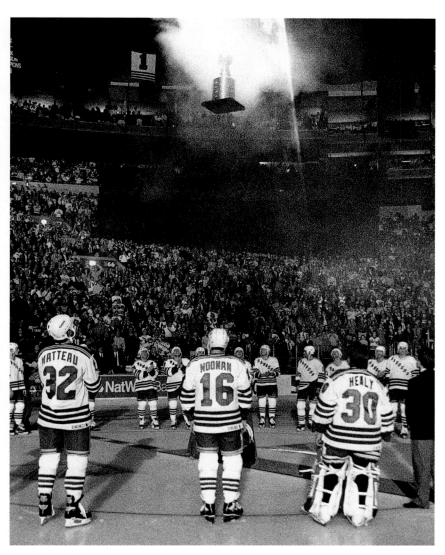

On January 20, 1995, at the first game of a season delayed by a labor dispute,
the Stanley Cup gets center stage at Madison Square Garden
after being absent for fifty-four years.

*Mark Messier shares the joy of a newly won Stanley Cup with fans at the
Garden after the Rangers defeated Vancouver in the final game in 1994.
It was the Rangers' first N.H.L. title since 1940.*

*Overleaf: Claude Lemieux of the New Jersey Devils holds the Stanley Cup aloft
with his teammates after they defeated the Detroit Red Wings at the Meadowlands in 1995.*

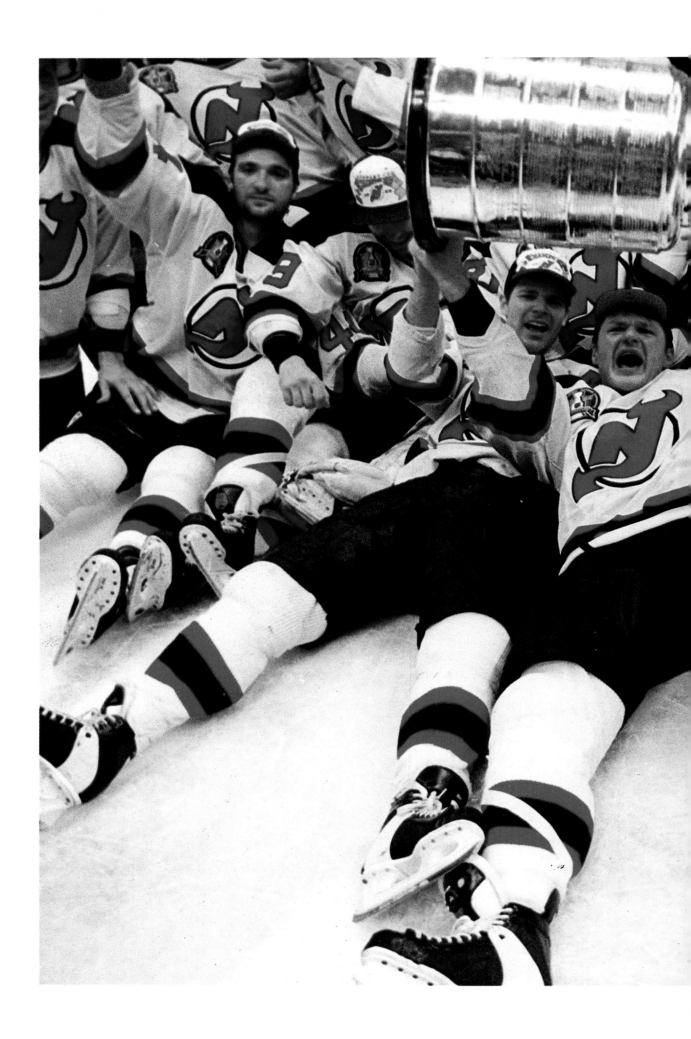

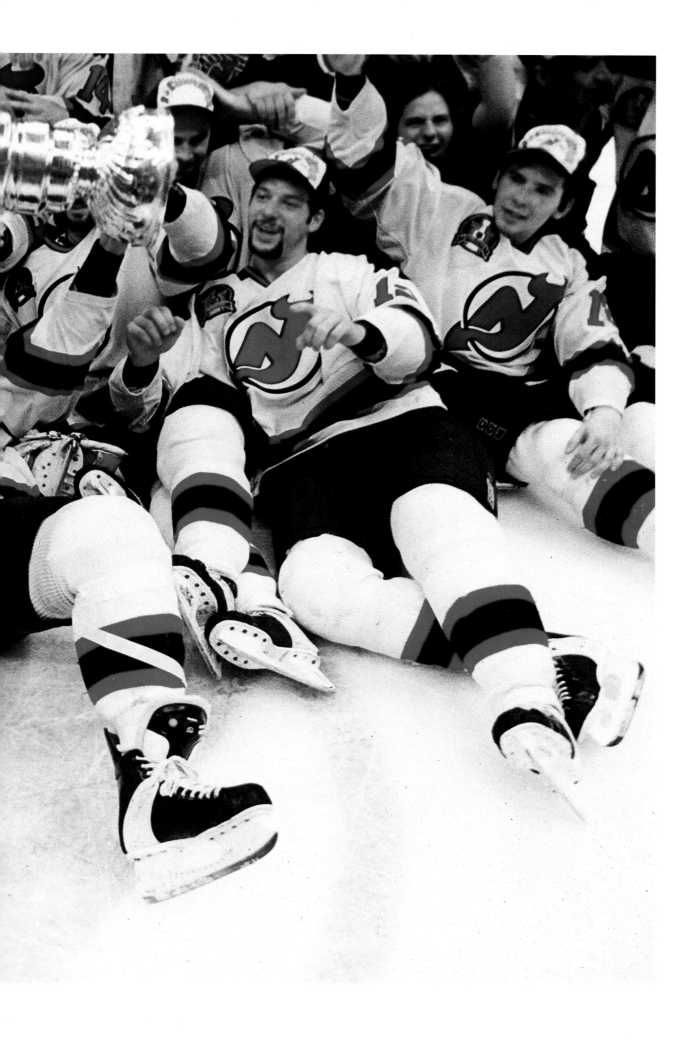

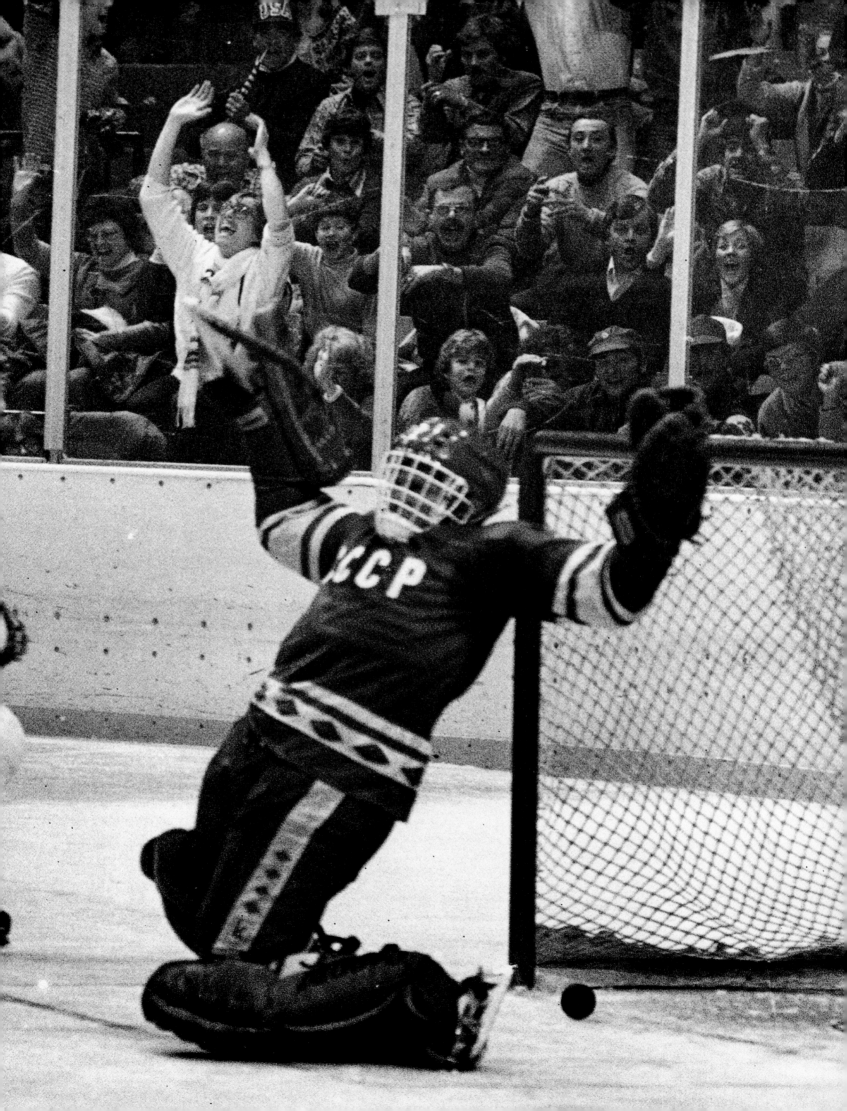

Previous pages: The United States hockey team scoring the winning goal against the Russians at the 1980 Winter Olympics at Lake Placid, New York. Known as the "Miracle on Ice," this victory was one of the most stunning upsets in Olympics history, and set up the Americans to win the gold medal in their next game.

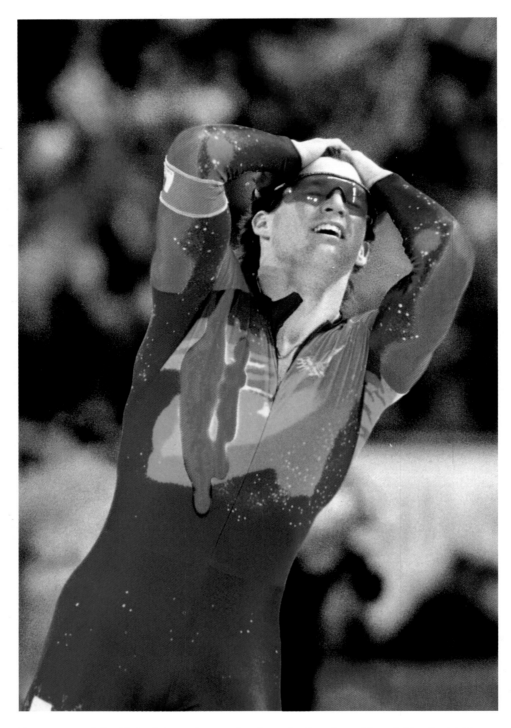

Dan Jansen of the United States is ecstatic after winning the gold medal in the 1,000-meter speed-skating competition in Lillehammer, 1994. Jansen had been trying for more than ten years to win an Olympic gold medal.

Tonya Harding of the United States showing the judges her broken laces during the finals of the women's figure-skating competition in Lillehammer. She was allowed to reskate, but went home without a medal.

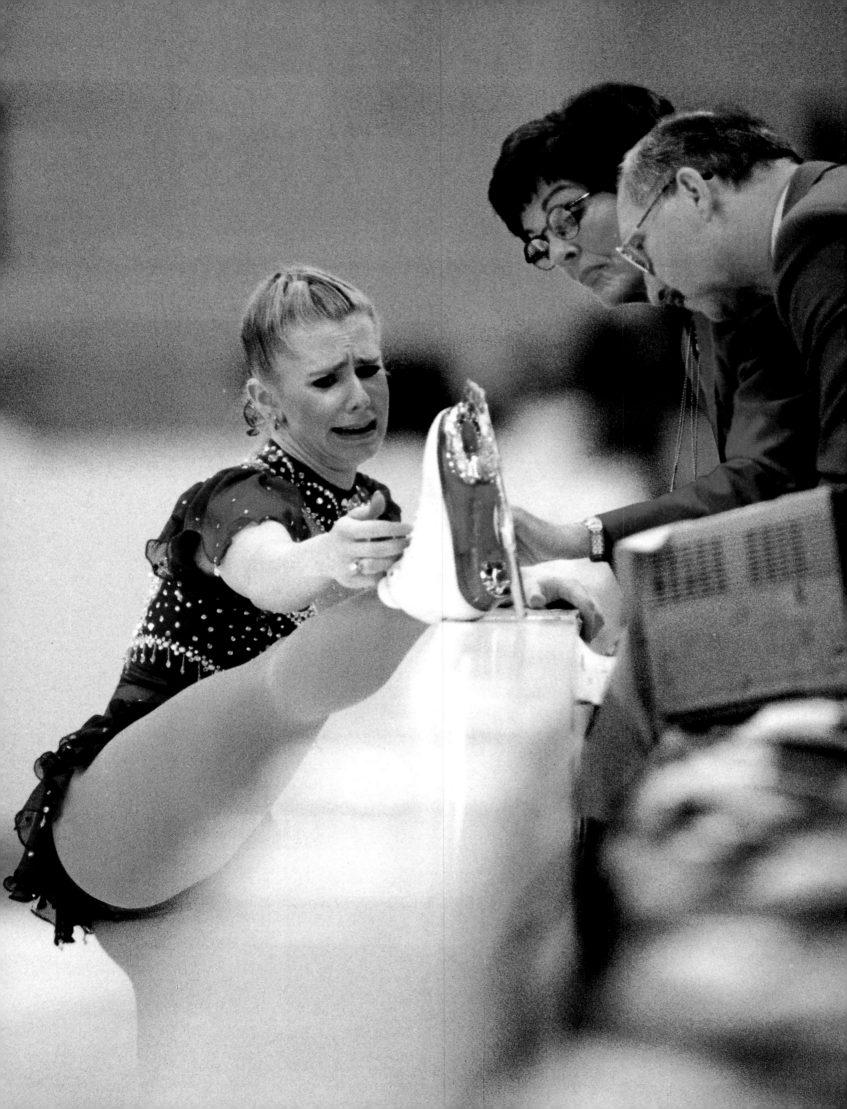

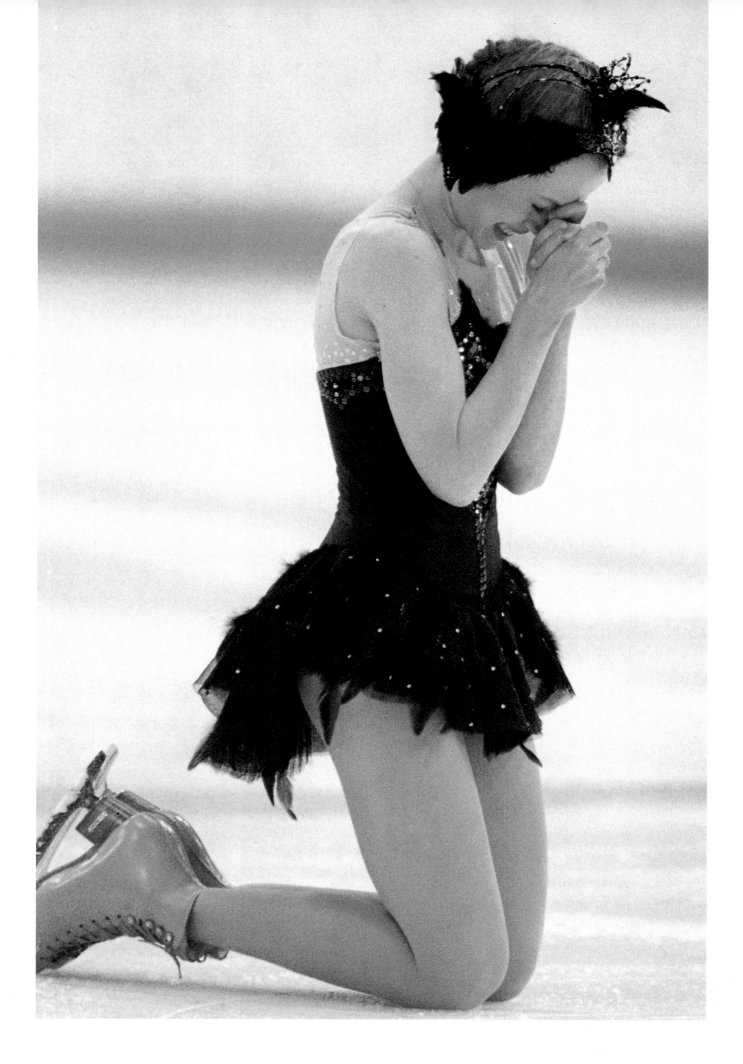

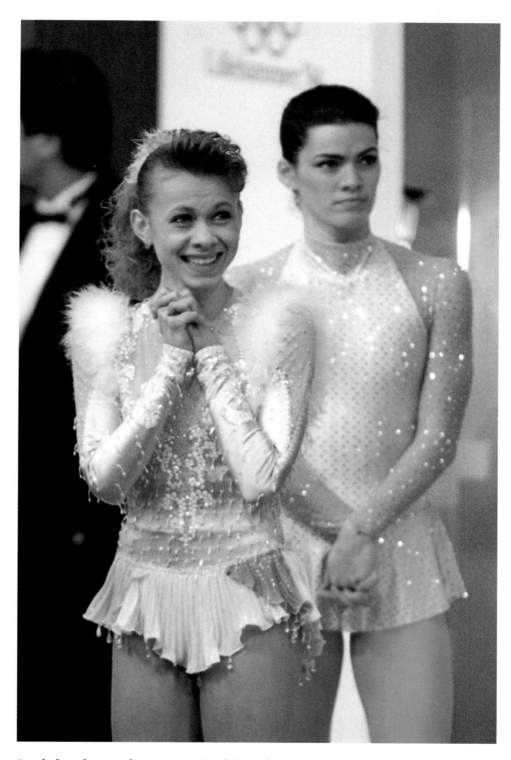

Just before the awards ceremony, Baiul shows her excitement over her gold-medal performance while Nancy Kerrigan of the United States looks on with disappointment, waiting for the ceremony. It turned out that officials couldn't find the music for the Ukrainian national anthem, but Kerrigan didn't know that and was irked by what she perceived as Baiul's delay.

Oksana Baiul of Ukraine reacts after her short-program performance in the women's figure-skating competition, Lillehammer.

Vladimir Smirnov of Kazakhstan overtaking Silvio Fauner of Italy en route to the gold medal in the men's 50-kilometer cross-country race in Lillehammer.

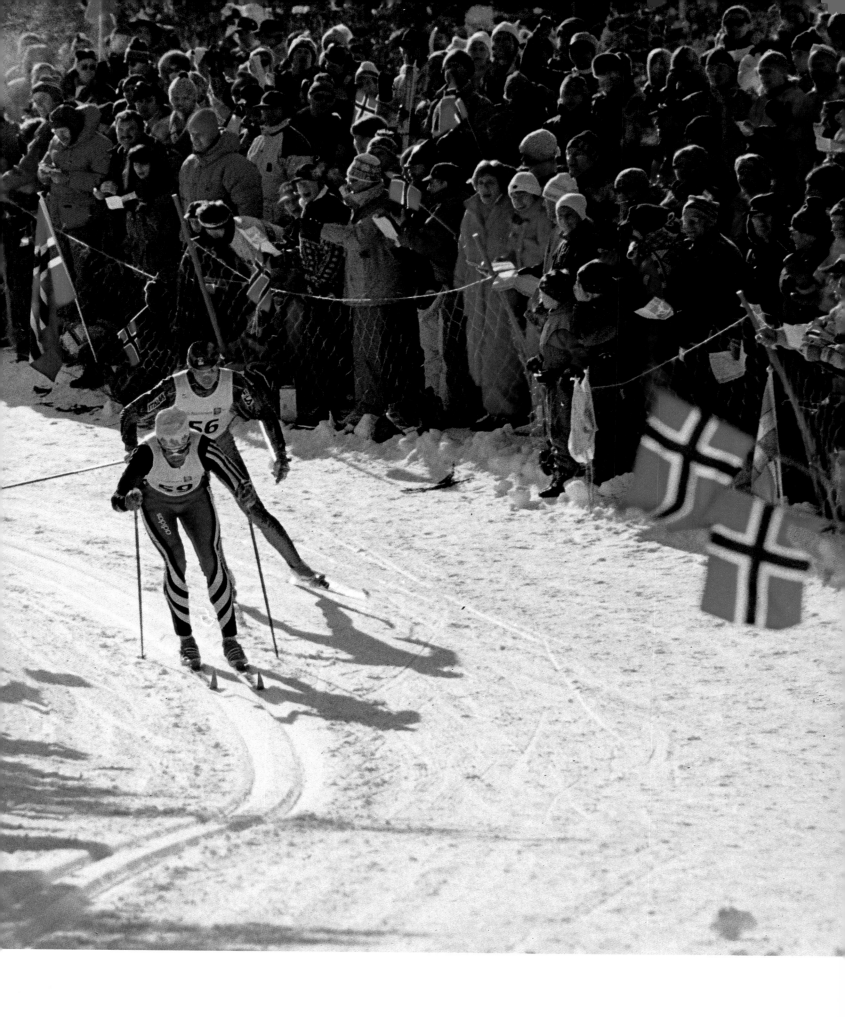

Overleaf: In the late afternoon sunlight, Jens Weissflog raised his skis in a victory salute after realizing he had won the gold medal.

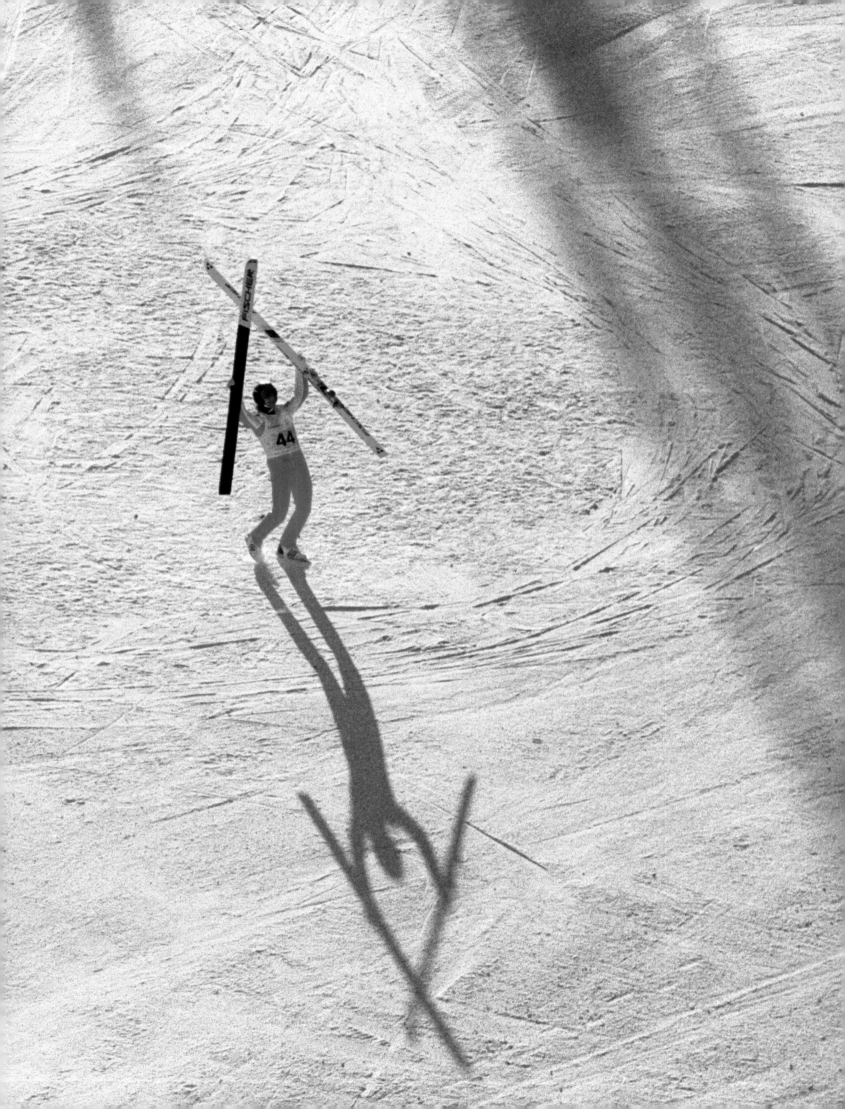

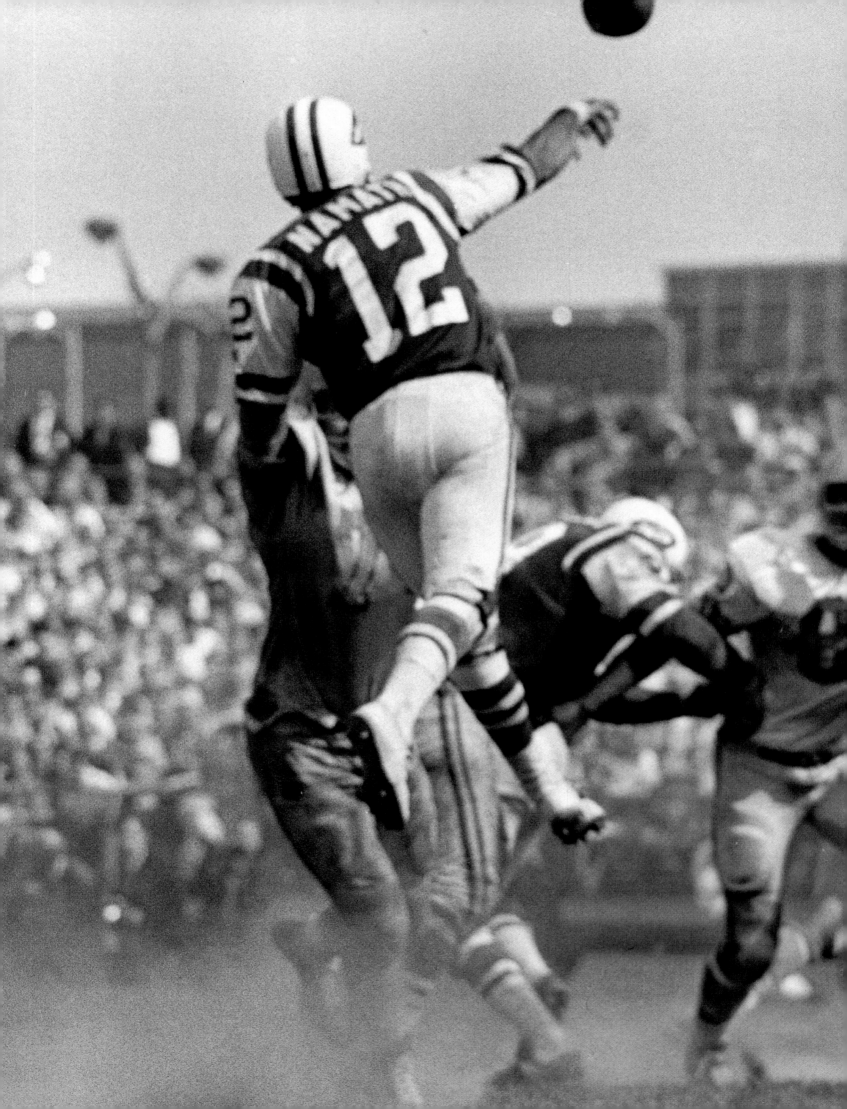

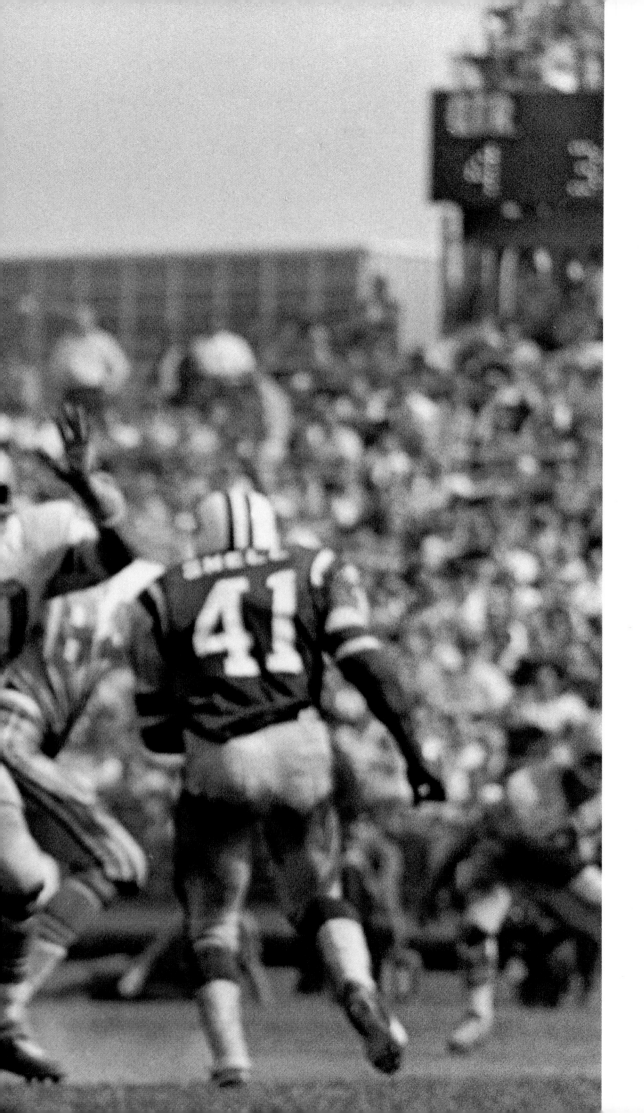

Terry Bradshaw, the Pittsburgh quarterback, during a play-off game in 1979. Bradshaw led the Steelers to four Super Bowl victories.

Namath warming up before a game with the Houston Oilers in November 1969 at Shea Stadium.

Previous pages: Joe Namath of the Jets leaping and completing a pass during a game against Houston in 1966 at Shea Stadium.

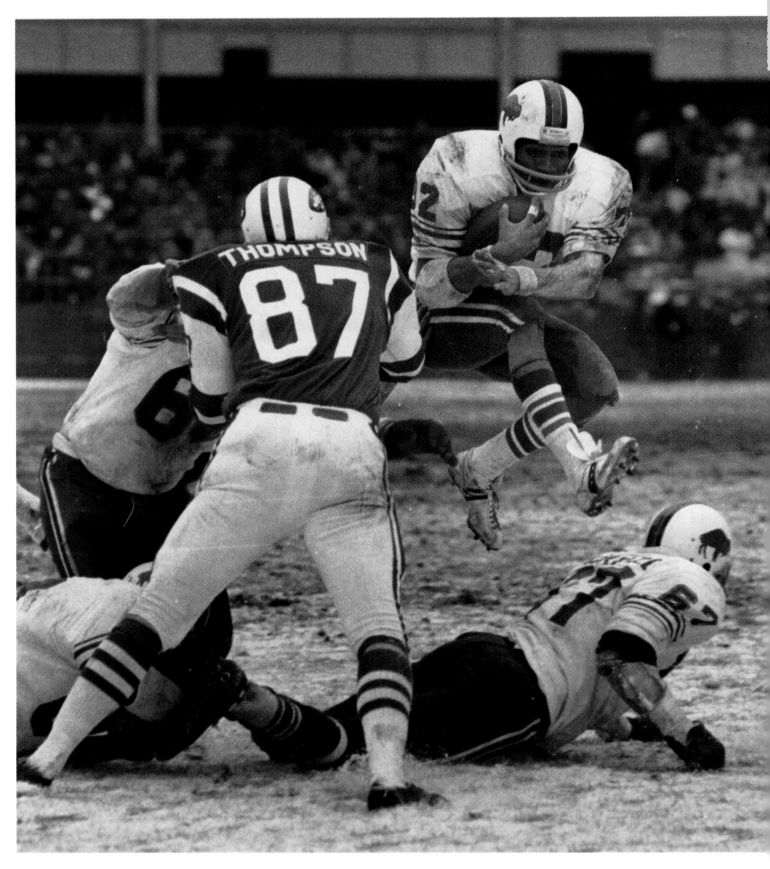

O. J. Simpson of the Buffalo Bills rushing during his record-breaking day against the Jets on December 16, 1973. As snow covered the Shea Stadium field, Simpson surpassed Jim Brown's single-season rushing mark of 1,863 yards; he would eventually become the first runner to surpass the 2,000-yard mark.

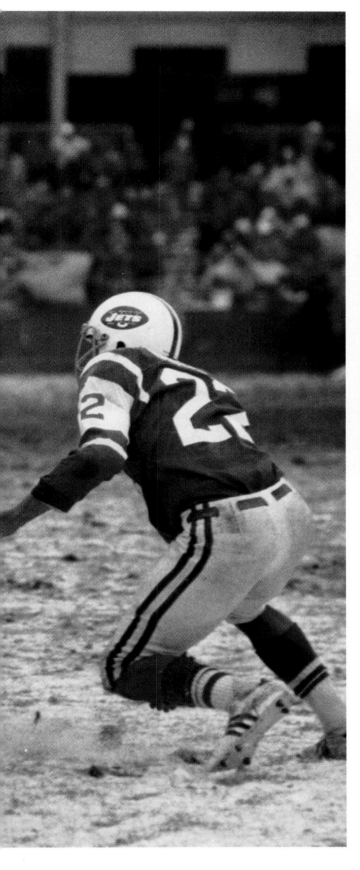

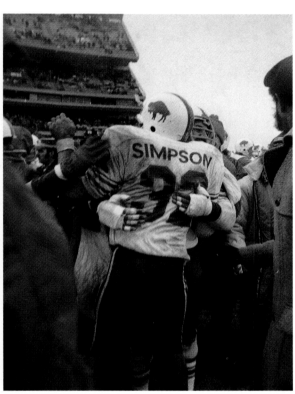

*Kevin Long of the Jets breaks
away during a game in 1981.*

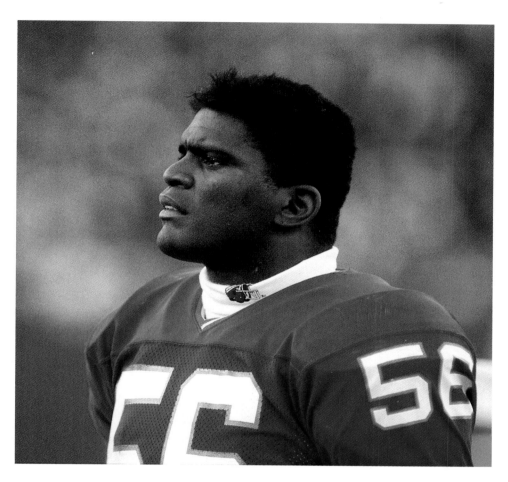

Lawrence Taylor of the Giants on the sideline during a 1991 game against Philadelphia. Taylor was the defense's leader for more than a decade, during which time he established himself as one of the greatest linebackers ever.

Scott Brunner of the Giants walking off the field during a snowfall in Washington during a game against the Redskins in 1982.

Joe Montana scoring a touchdown against the Cincinnati Bengals in Super Bowl XVI in 1982.

Woody Bennett of the Dolphins scoring against the Jets in the American Conference championship game of the 1982 season. The game, played in a downpour that provided the name "Mud Bowl," was won by Miami.

Overleaf: Chris Burkett of the Jets lunging into the end zone in a game against Baltimore in 1993 at Giants Stadium. The Colts' Alan Grant tried to stop him.

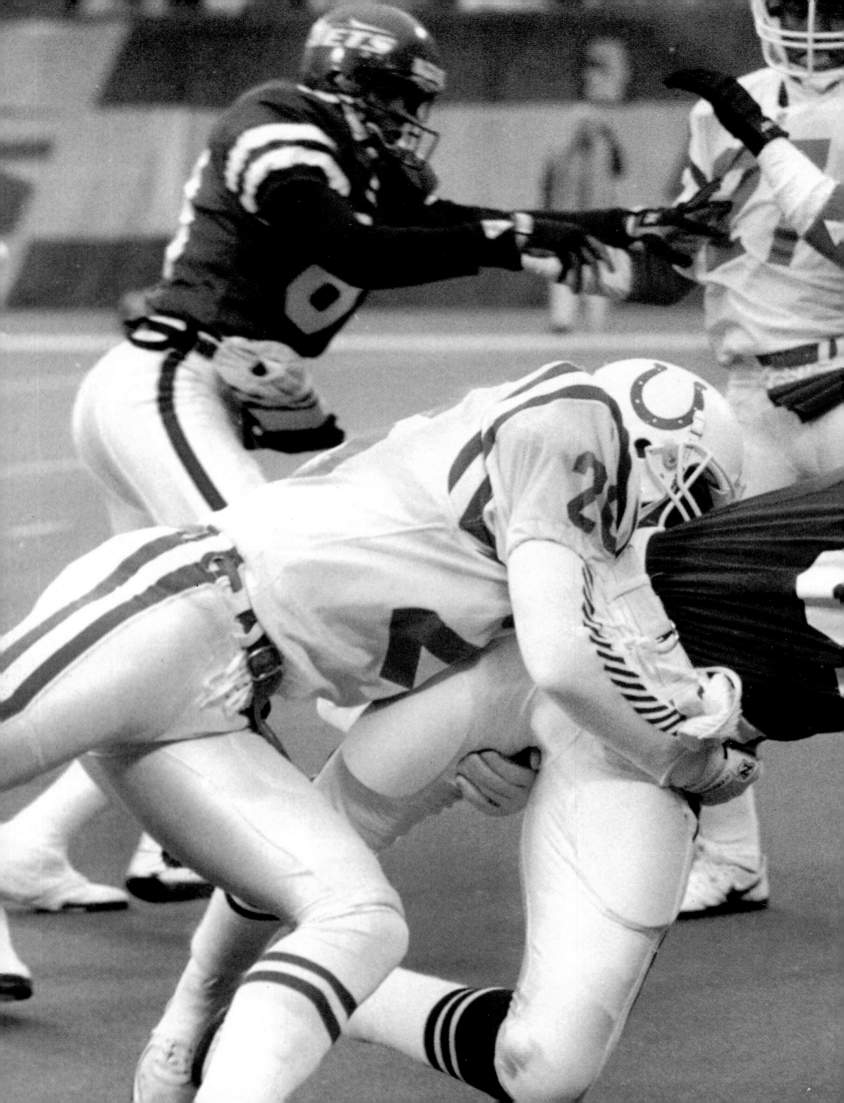

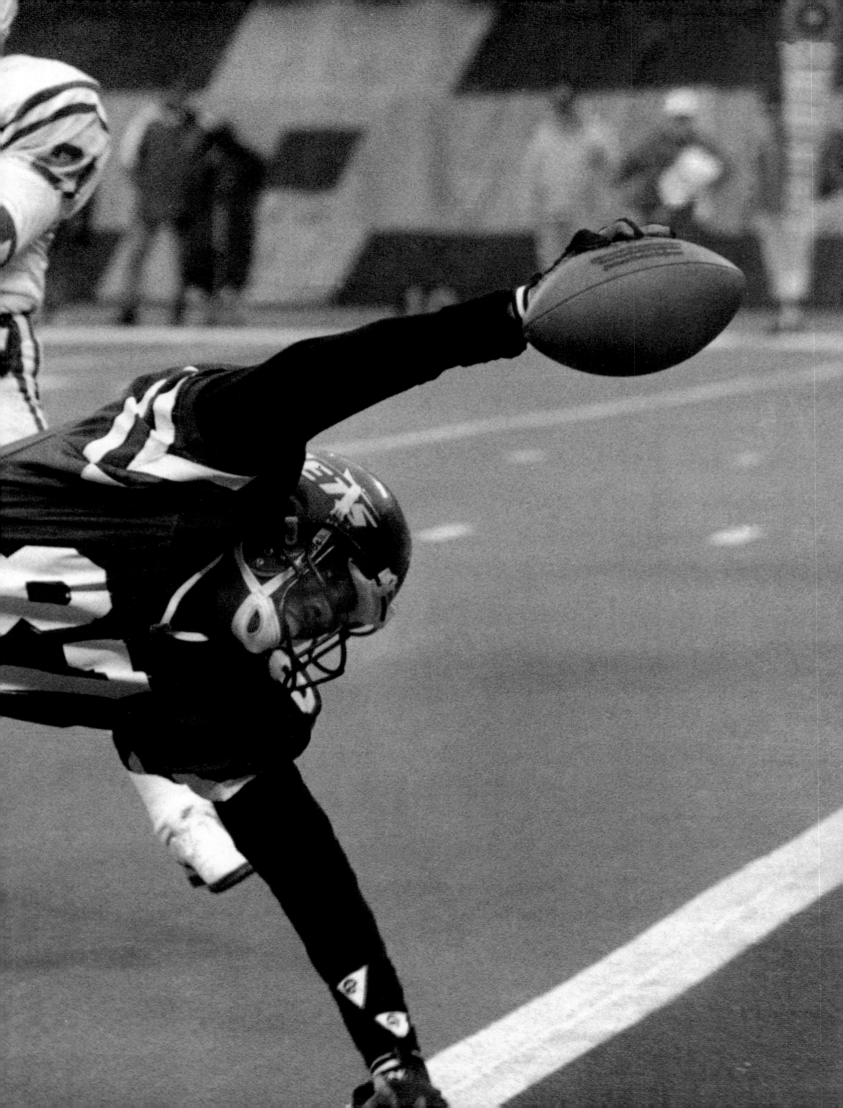

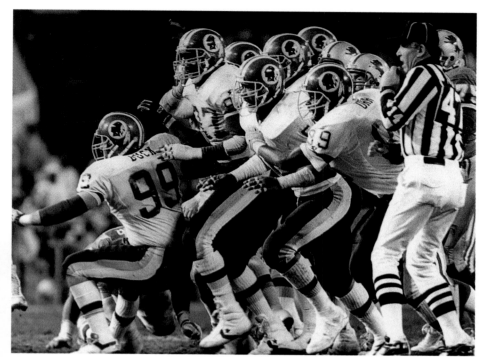

The special teams unit for the Washington Redskins gathers during Super Bowl XXVI against Buffalo in 1992.

Emmitt Smith of the Cowboys scoring a touchdown in Super Bowl XXX against the Pittsburgh Steelers in Phoenix.

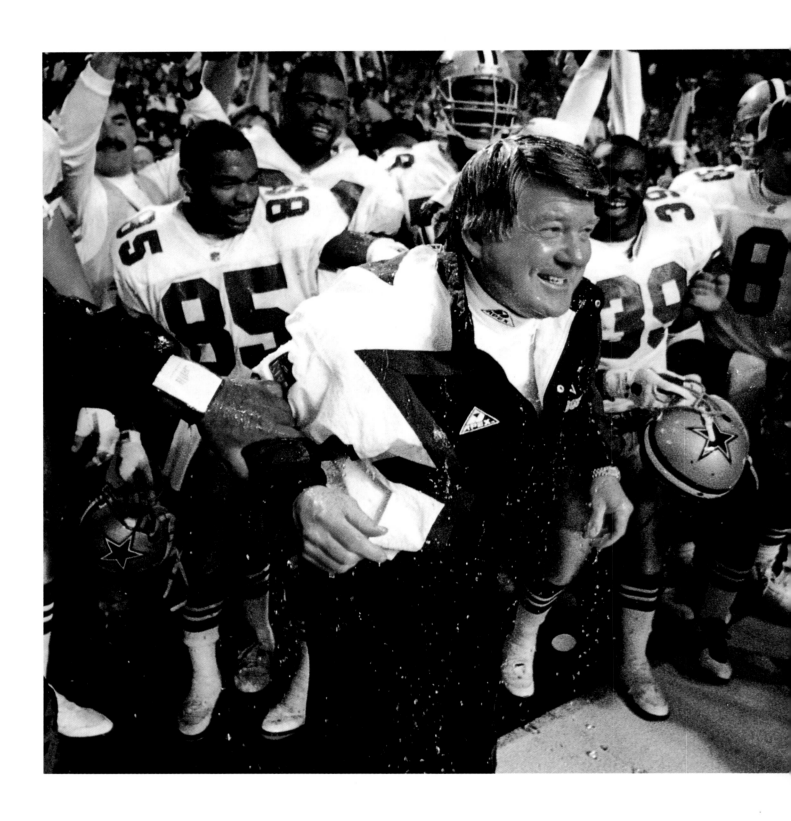

*Jimmy Johnson, the Dallas Cowboys' coach,
after winning his second Super Bowl in 1994.*

*Deion Sanders of Dallas holding the Super Bowl Trophy
after the Cowboys defeated the Steelers.*

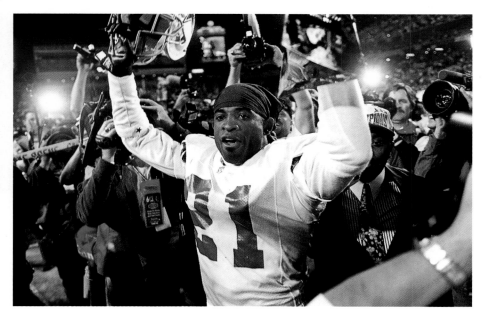

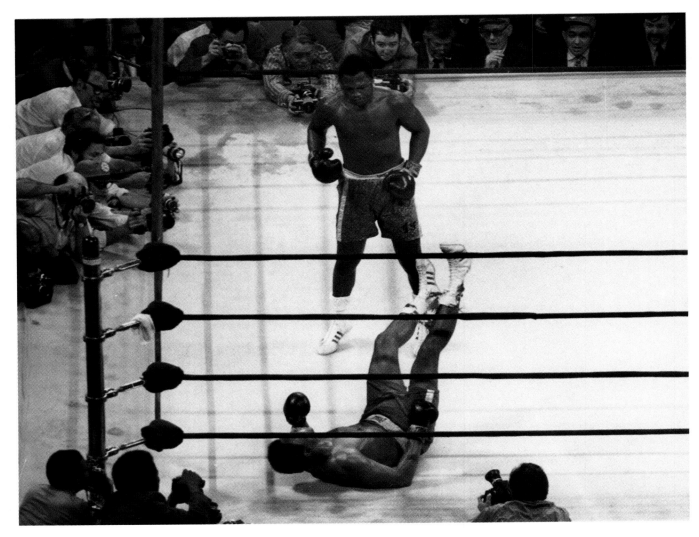

In one of the greatest fights ever, Muhammad Ali met Joe Frazier at Madison Square Garden on March 8, 1971. Both fighters were undefeated, and Ali was making a comeback from a forced retirement because he refused draft induction during the Vietnam War. In a close and brutal bout, Frazier clinched the decision after knocking down Ali in the fifteenth round with a devastating left hook.

Previous pages: Sugar Ray Leonard in 1976 during a training session at his hometown in Maryland.

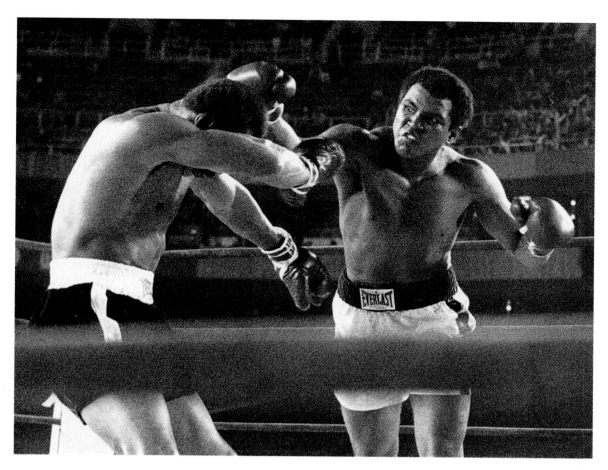

Ali battering Ken Norton with left-right combinations in a fight on September 28, 1976, at Yankee Stadium. Ali won the fight.

One of Ali's last fights came against Larry Holmes in Las Vegas on October 2, 1980. Ali failed to enter the ring for the eleventh round.

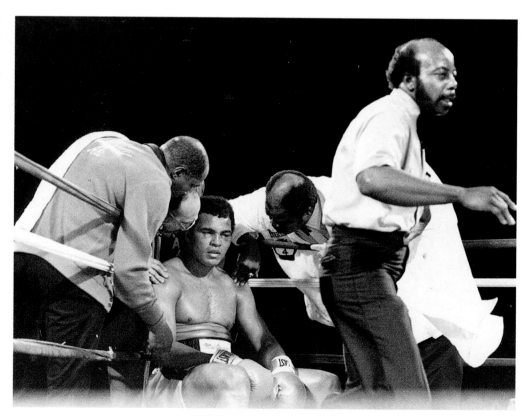

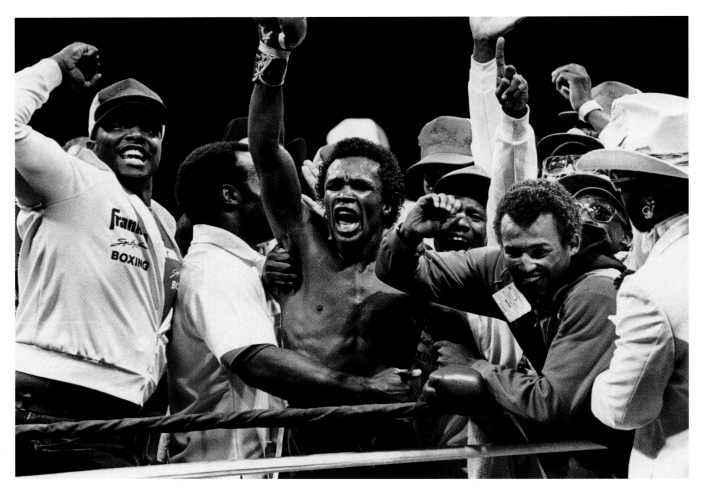

Sugar Ray Leonard after winning the famous "No Mas" rematch with Roberto Duran in 1980,
when Duran quit in the eighth round, saying "No mas, no mas."

Previous pages: Larry Holmes training early in the morning in the desert,
outside Las Vegas, for his fight with Muhammad Ali in October 1980.

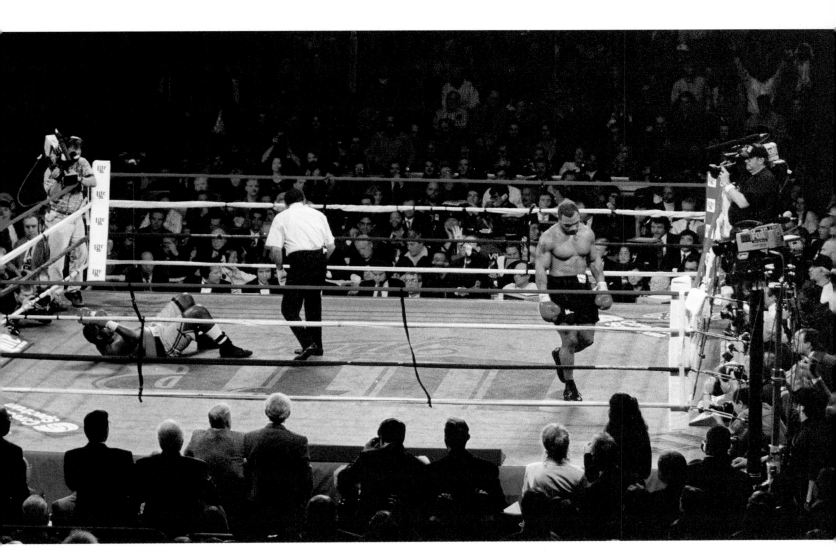

Mike Tyson walks back to his corner after knocking out Buster Mathis in the third round at the Spectrum in Philadelphia in December 1995.

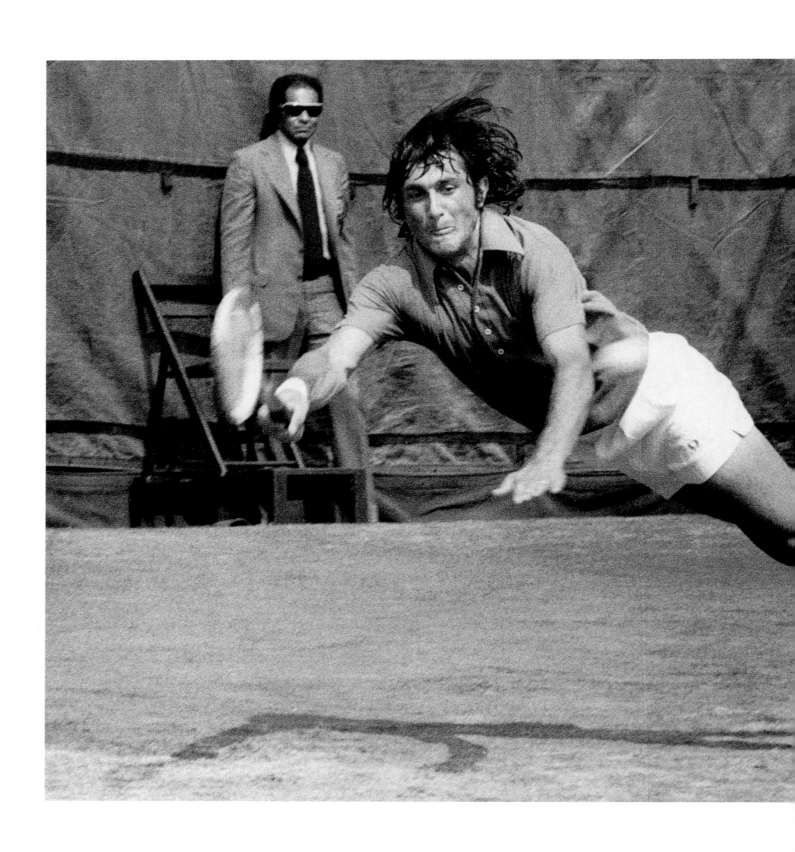

Previous pages: Pete Sampras in pursuit of the 1995 U.S. Open title, which would be his third.

Ilie Nastase at U.S. Open, Forest Hills, 1970s.

John McEnroe plays a balancing act at the net as the ball drops behind him during a Volvo Master match at the Garden.

Jimmy Connors, wildly popular with the New York crowd because of his competitive spirit, shown here in 1991.

Gabriela Sabatini making a return with a shot between her legs during a Virginia Slims match against Pam Shriver in 1988.

Boris Becker, U.S. Open, 1989.

Monica Seles, U.S. Open, 1989.

Martina Navratilova, U.S. Open, 1991.

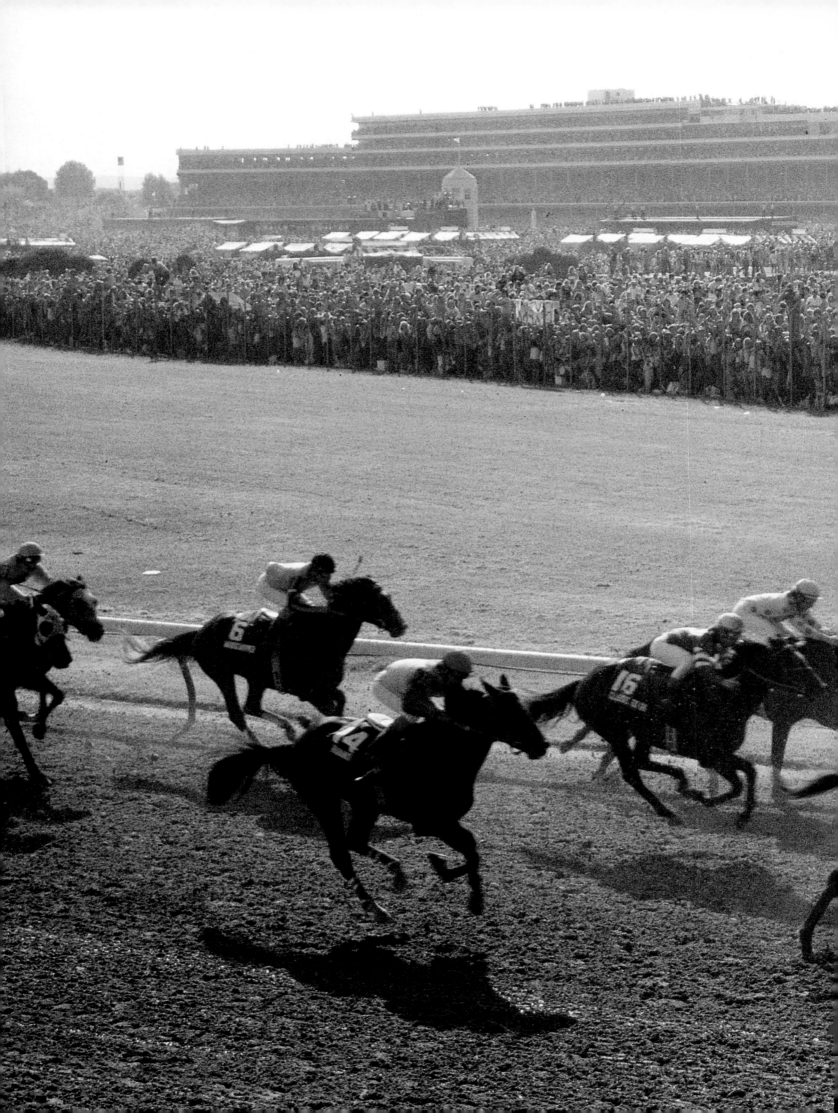

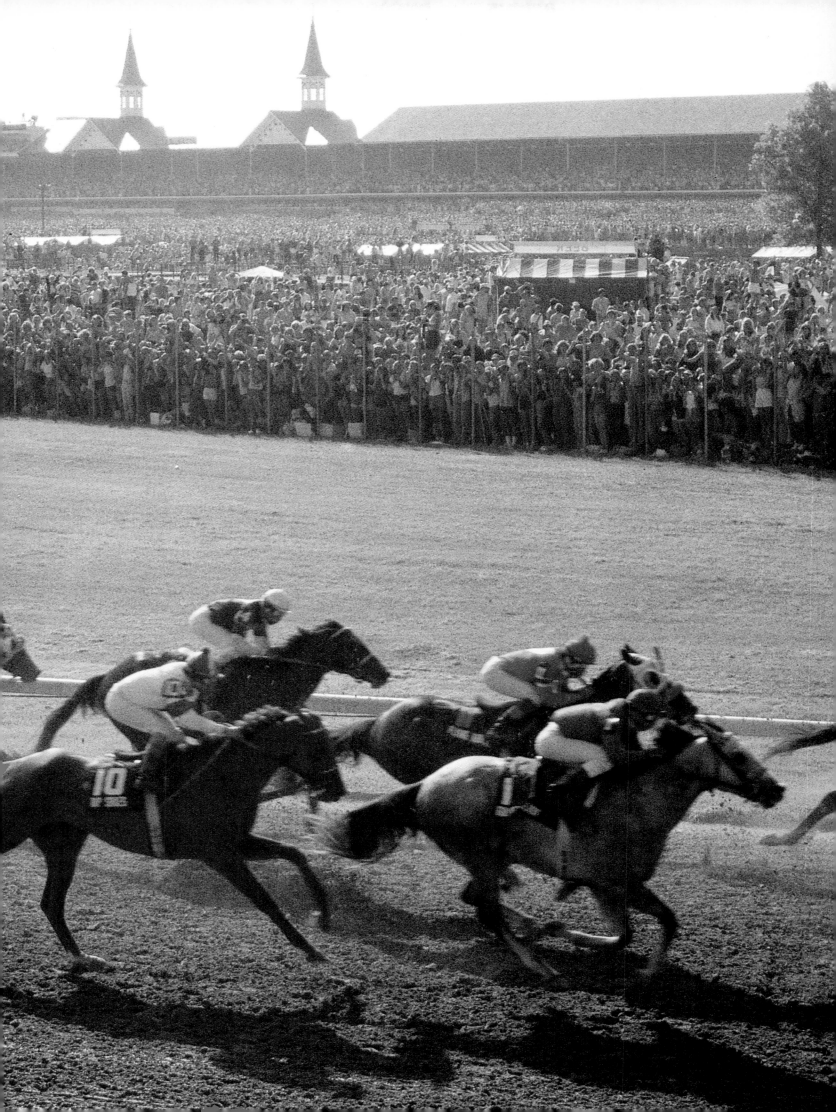

Previous pages: Horses jockeying for position as they line up in the backstretch during the 1982 Kentucky Derby.

Mike Kennedy and Dr. Jim Hill walk with Seattle Slew after a morning workout at Hialeah in 1977. Seattle Slew won the Flamingo that weekend and went on to win the Triple Crown.

Jockey Jean Cruguet guides Seattle Slew to victory in the 102nd Preakness at Pimlico Race Course in Baltimore. The race was the second leg of the Triple Crown. Slew, bought at a public auction for a mere $17,000, went on to win race after race and to become the only undefeated horse in history to win the Triple Crown.

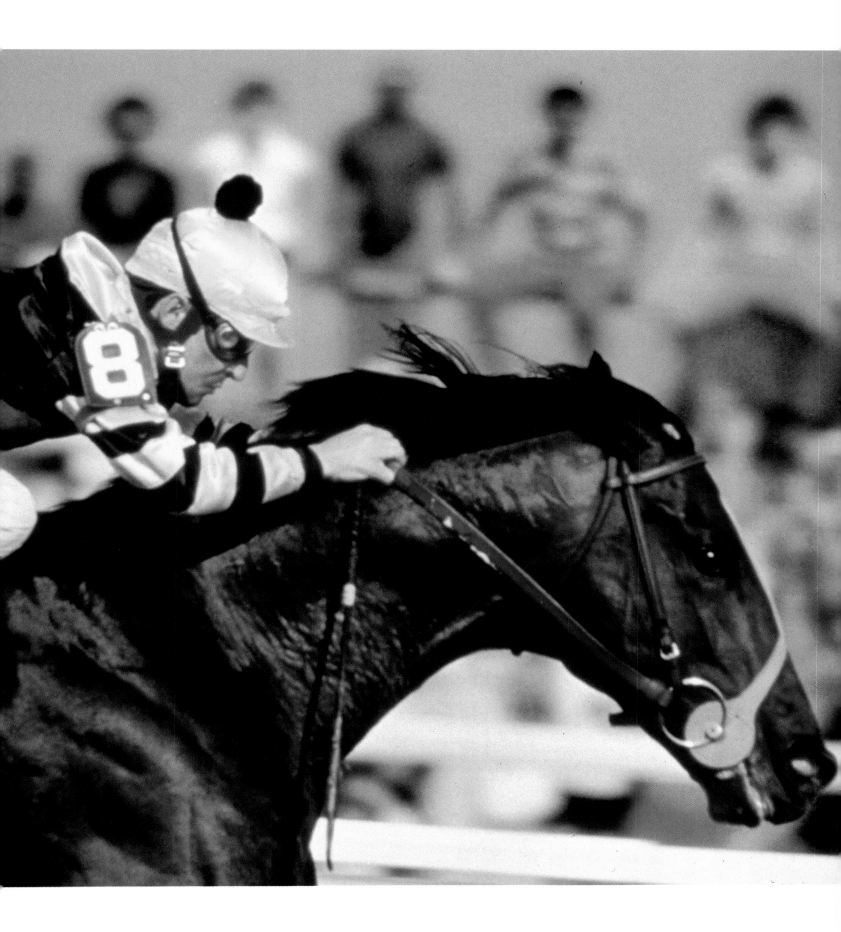

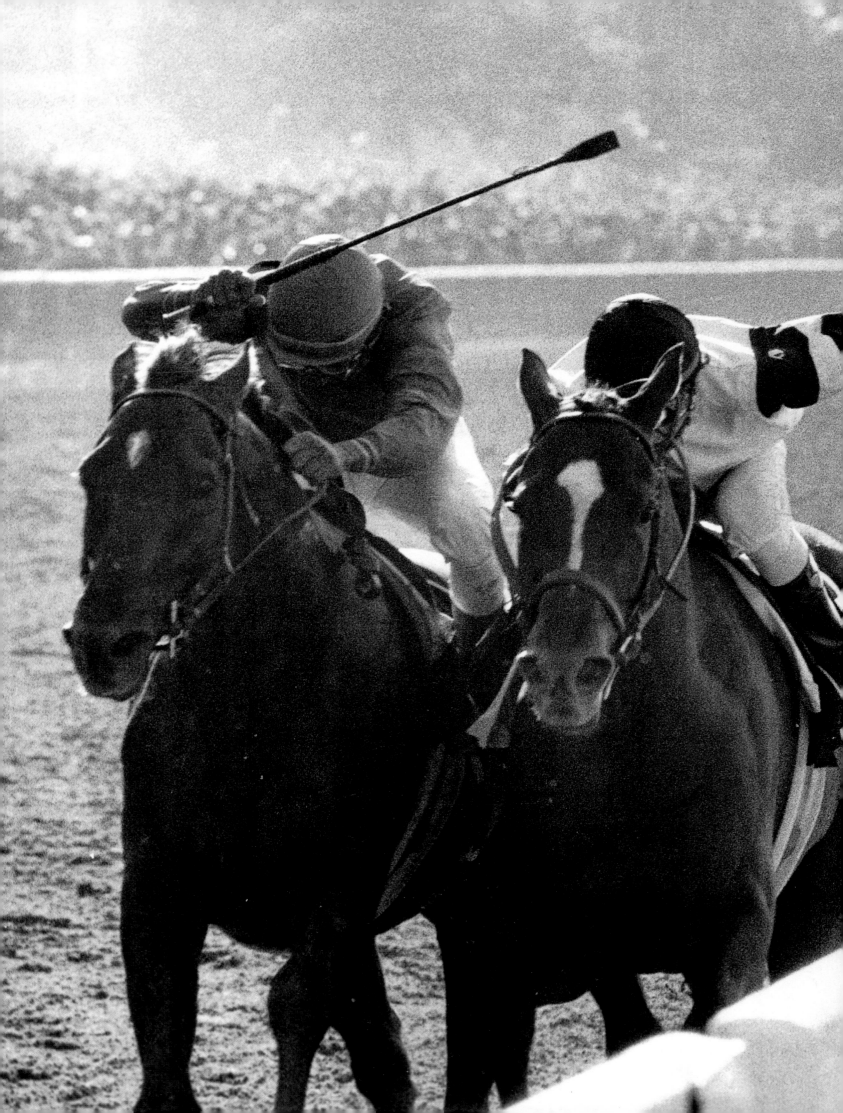

Steve Cauthen at Saratoga in the summer of 1978, the year he won the Triple Crown on Affirmed. He was the youngest jockey ever to win the Triple Crown.

Steve Cauthen whipping Affirmed as he outduels his rival Alydar to win the Belmont and capture the Triple Crown in 1978.

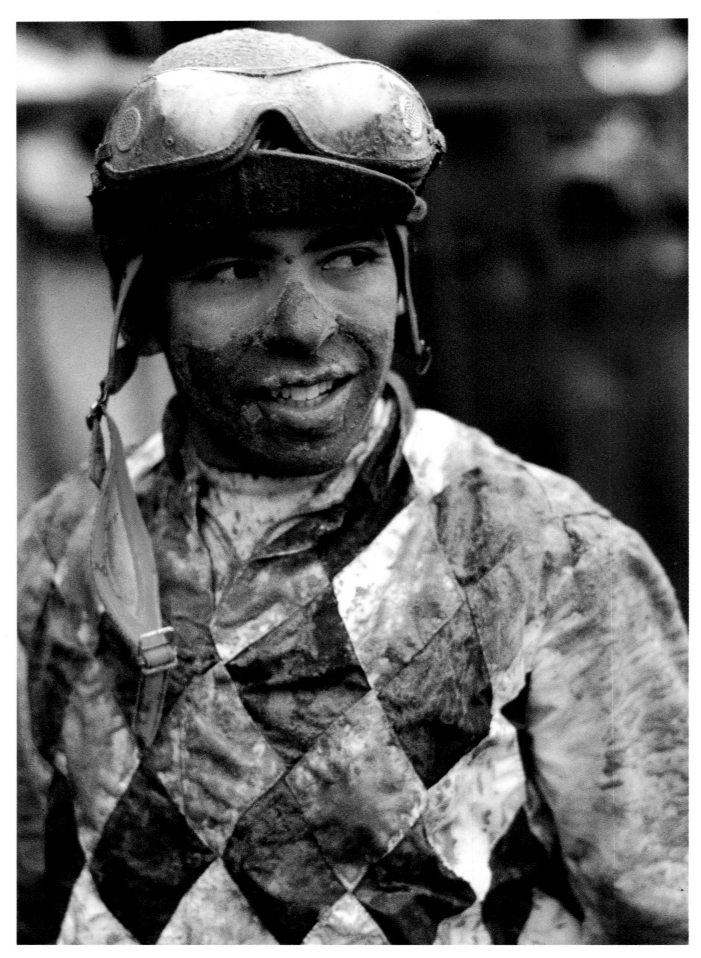

Angel Cordero, Jr., after a race in 1975.

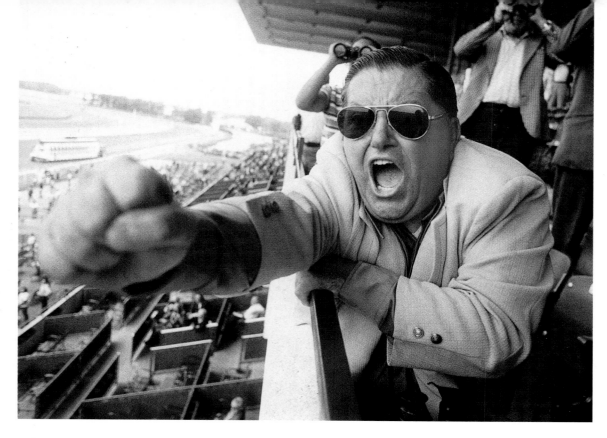

A fan cheers on his choice during a race at Belmont in 1977.

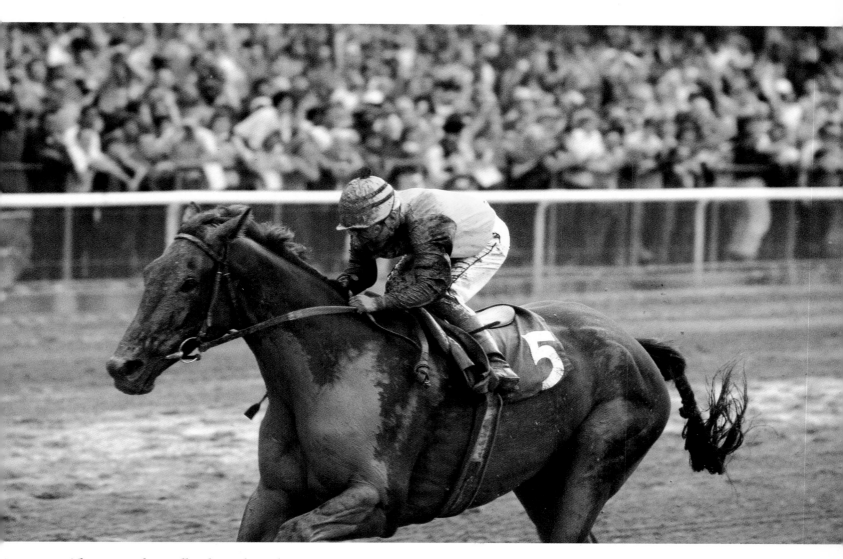

The great jockey Willie Shoemaker riding Forego in the mud during a fall race at Belmont.

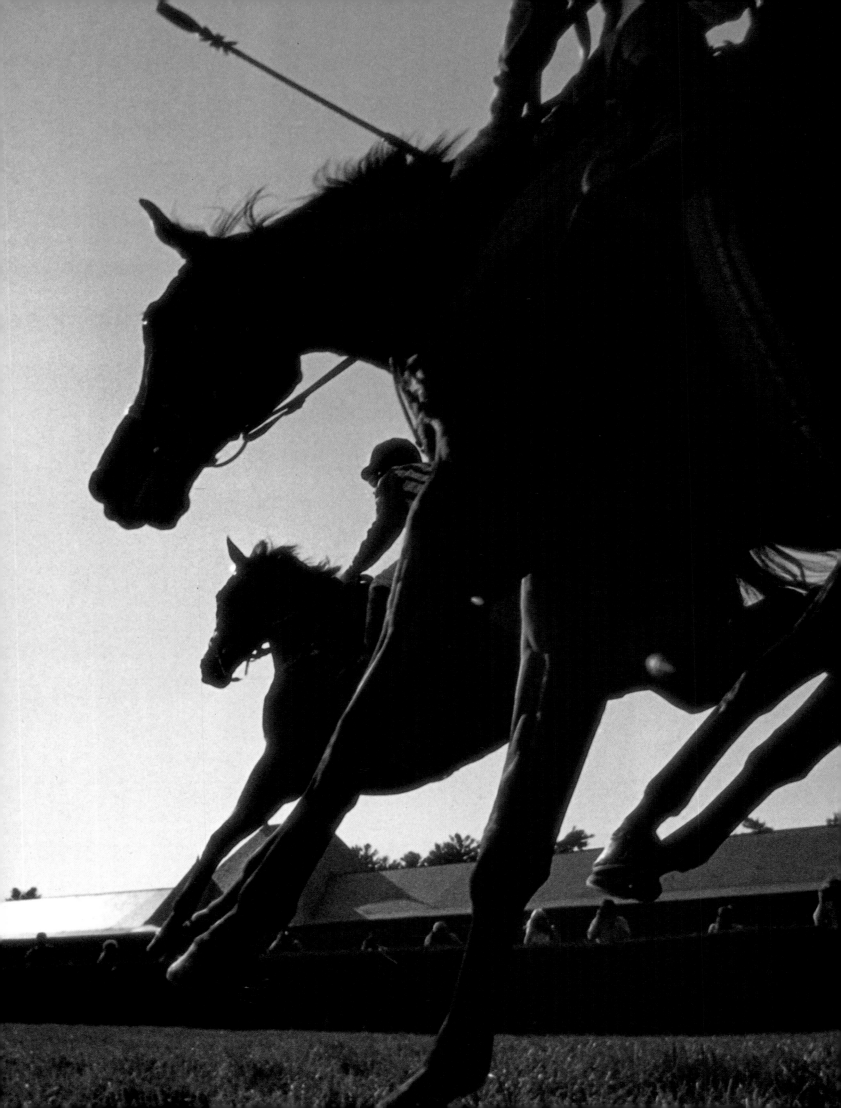

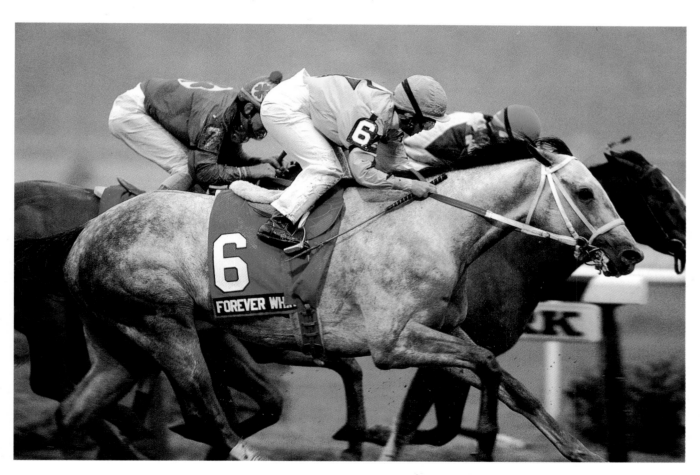

Julie Krone as she comes in second in a race at Belmont in 1993.

A steeplechase race silhouettes two horses against the sun-drenched sky at
Saratoga in 1995. Lonesome Glory is in the lead and won the race.

Krone with her first pony, Filly, at her neighbors' farm in New Jersey as she enjoys a quiet day off from racing. Krone became friendly with the neighbors' daughter, Stefanie Freundlich, and twenty years after giving Filly up, tracked down the pony at a 4-H farm in Canada, and presented it to Stefanie as a birthday present.

A portrait of Julie Krone during the spring meet at Belmont.

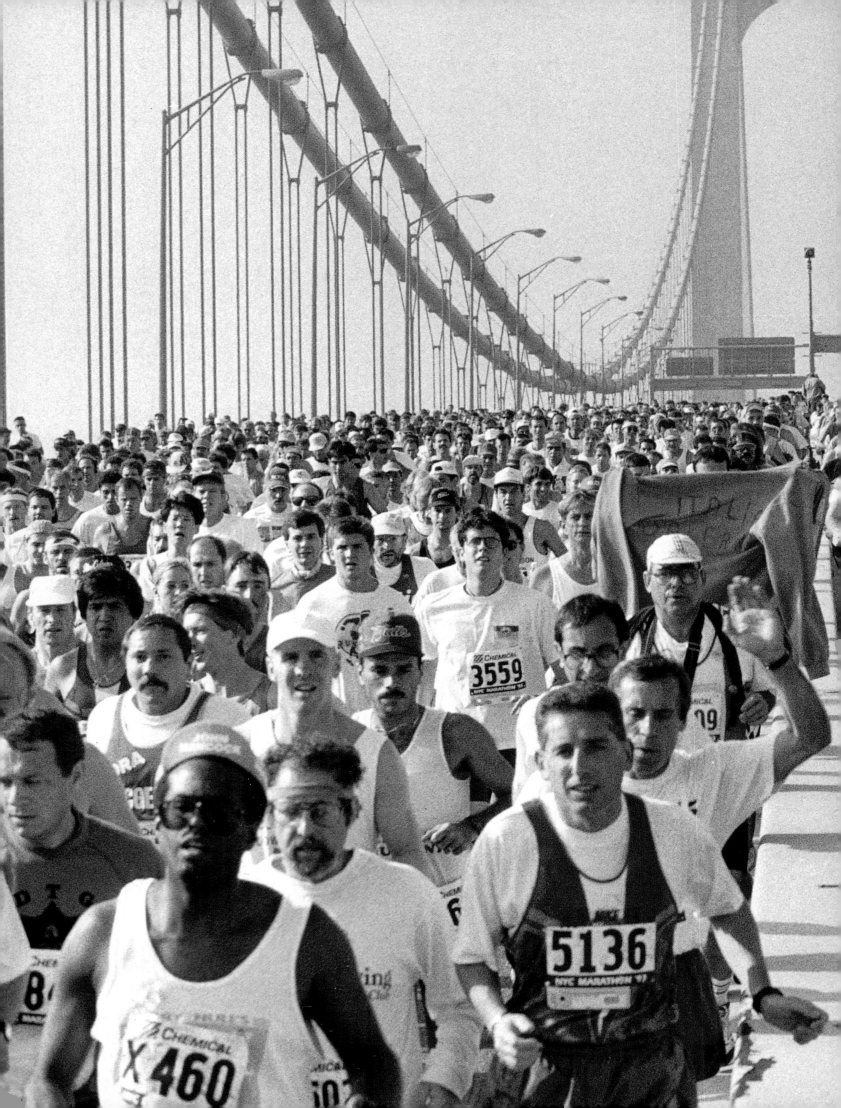

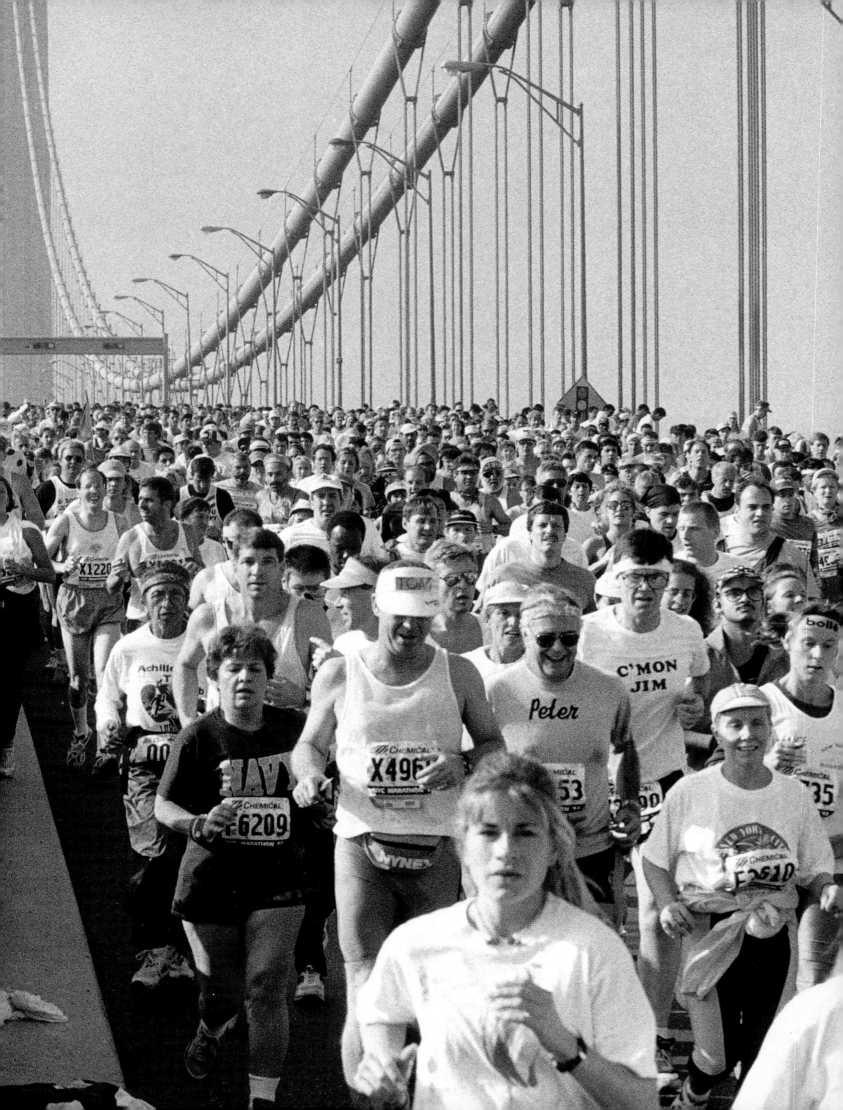

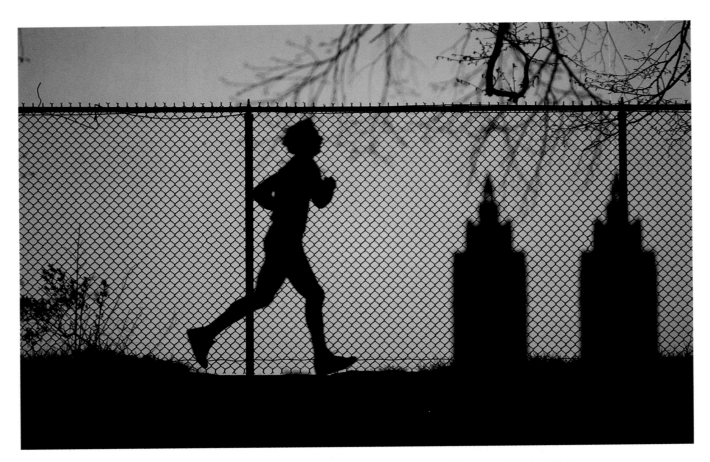

A jogger circles the reservoir in Central Park, New York, in the late afternoon of a spring day in 1984.

*The Fifty-ninth Street Bridge provides the passageway
into Manhattan during the 1978 Marathon.*

*Previous pages: Runners crossing the Verrazano Narrows
Bridge during the 1993 New York City Marathon.*

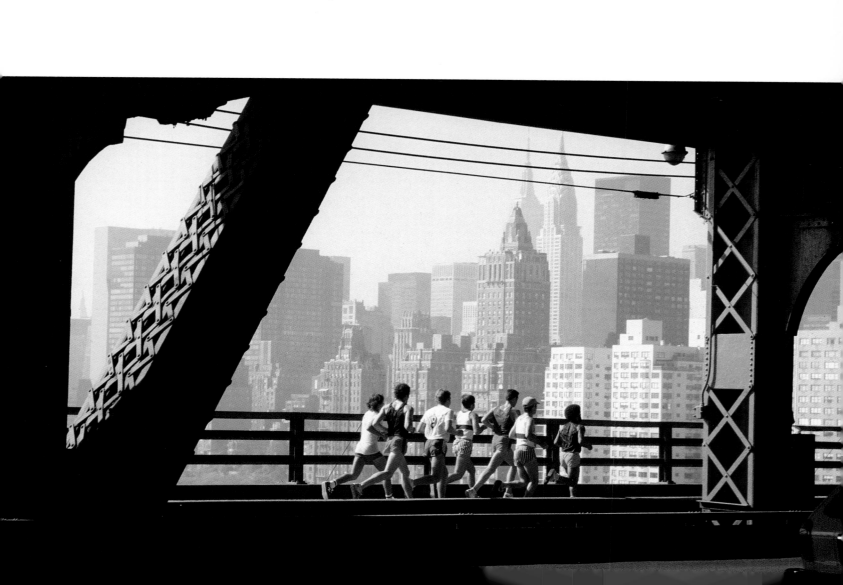

Few sights in sports have the majesty of those from above during the New York City Marathon. Here we see the trek down Fourth Avenue in Brooklyn, with the Manhattan skyline in the background. This picture, like many other marathon pictures over the years, was taken from a helicopter. This provides the most dramatic shots of marathons and allows you to cover the greatest distance in the shortest period of time. But it's not without risks. One year, watching our finances, we charted a low-budget helicopter driven by a pilot who had flown in Vietnam and knew no fear. Moreover, I had to sit in a jump seat that was actually outside the copter, with my feet hanging down, as he streaked boldly through the air. To top it off, there were 40-mile-an-hour gusts and rainy weather. I ended up doing my own version of the marathon that day, because after landing and sending in my film, I headed out to Giants Stadium to cover the football game. But at least my feet were planted firmly on the ground.

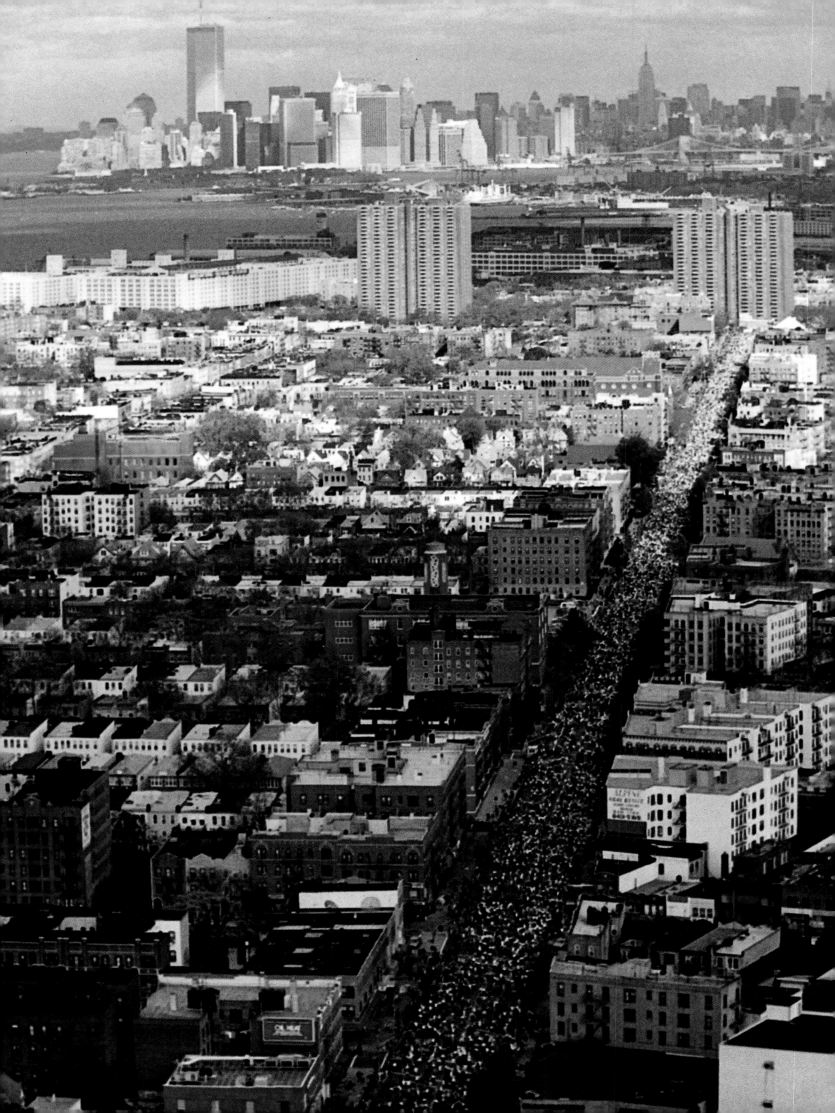

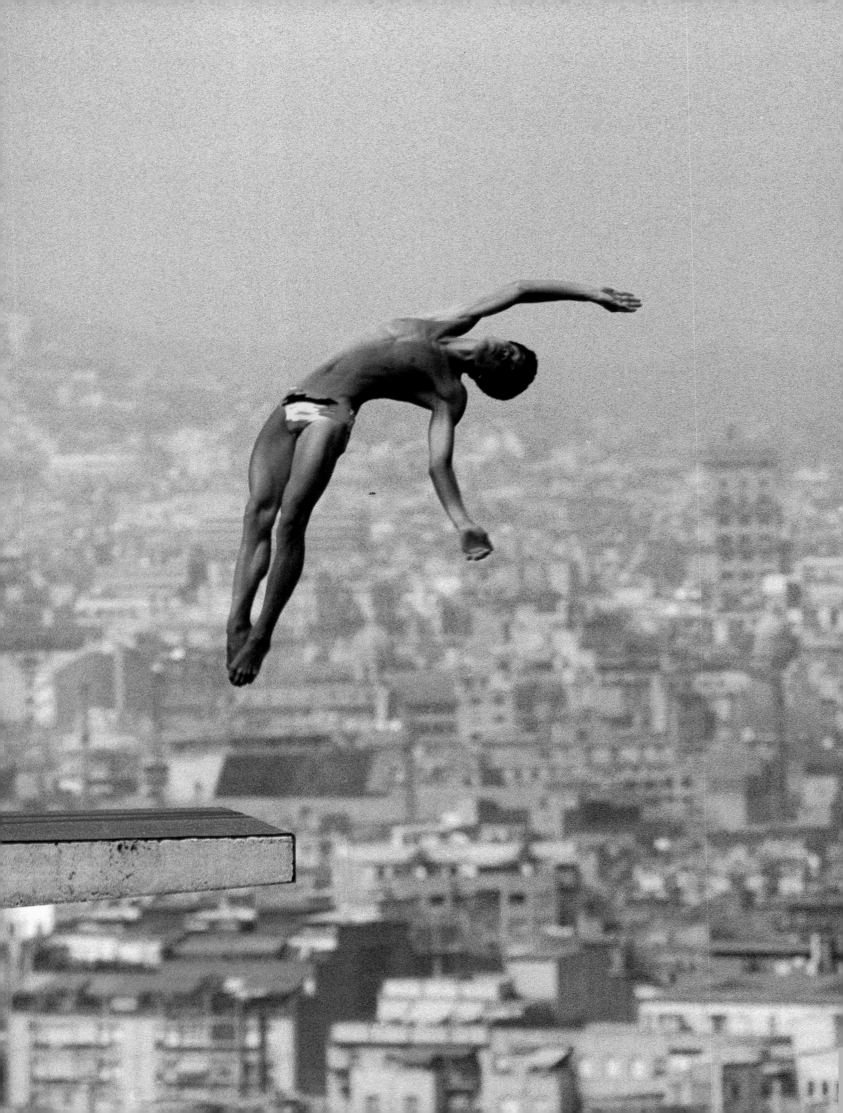

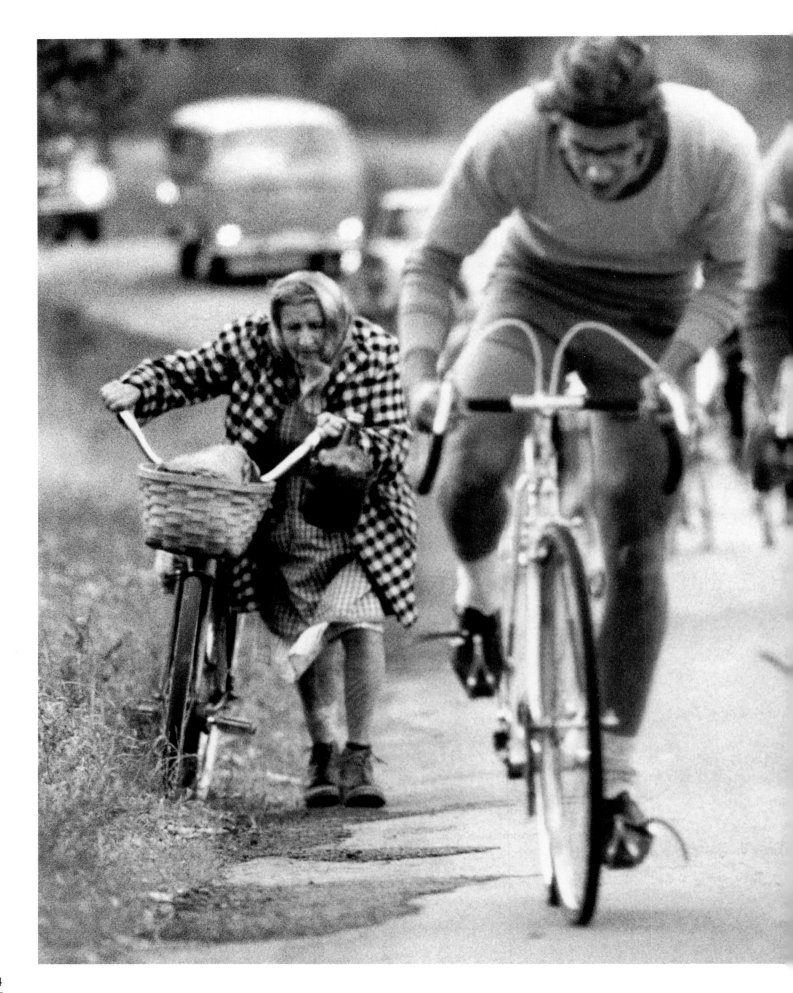

Riders in a bicycle race in the Catskills in 1975 have the upper hand on a woman who struggles up a hill behind them. My position was on a truck facing the riders, so I had no idea who or what was coming up the hill. I just snapped at the image, and it turned out to be this woman.

125

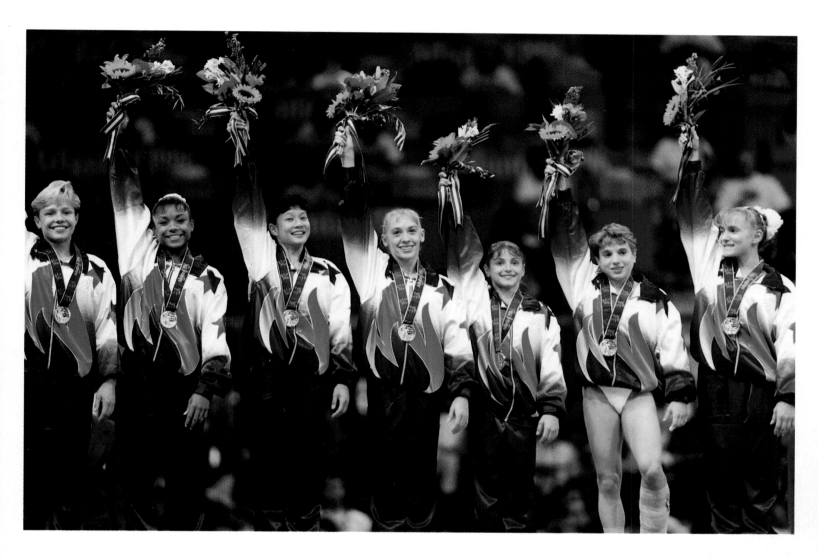

"The Magnificent Seven," the strongest team ever fielded by the United States in Olympic gymnastics competition, achieved dreams of gold at the Atlanta Games in 1996. Kerri Strug (above, second from right) assured the victory with her gutsy effort in the vault competition. Shannon Miller (right), the quiet leader of the team, performs on the balance beam.

Nadia Comaneci dazzled the world at the Montreal Olympics in 1976 with her perfect performances and perfect scores. Here she performs at an exhibition meet in Dallas in the 1980s.

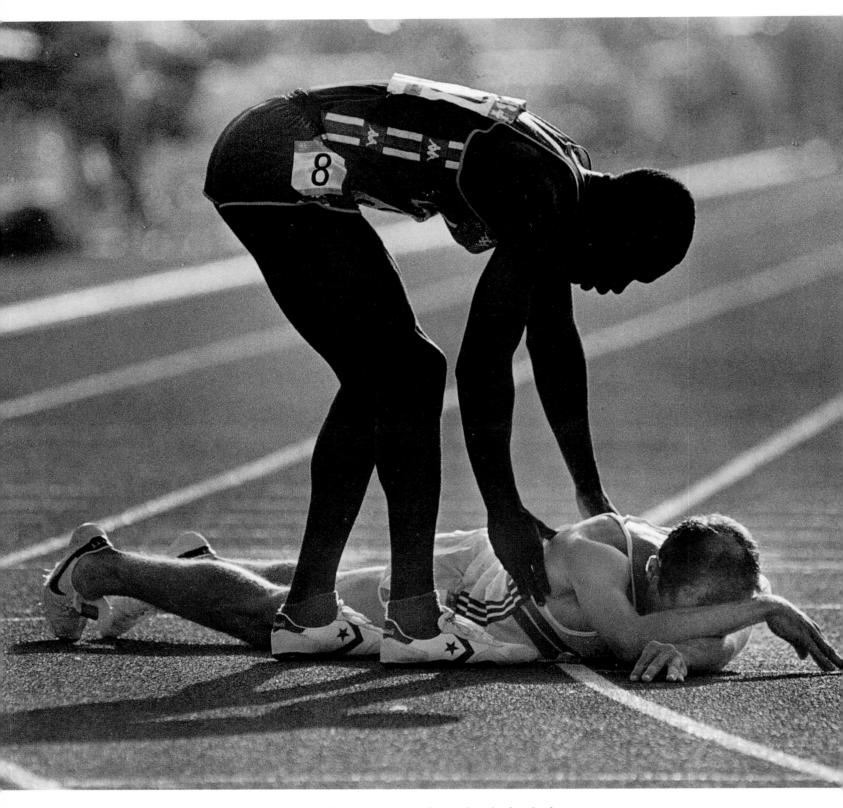

At the 1984 Summer Olympics in Los Angeles, two runners exhausted at the finish of a race.

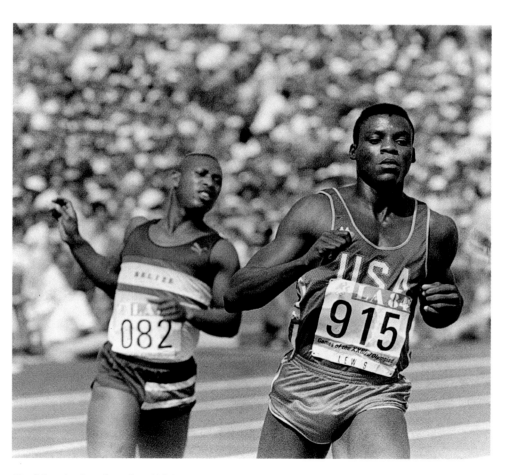

Carl Lewis, Los Angeles, 1984.

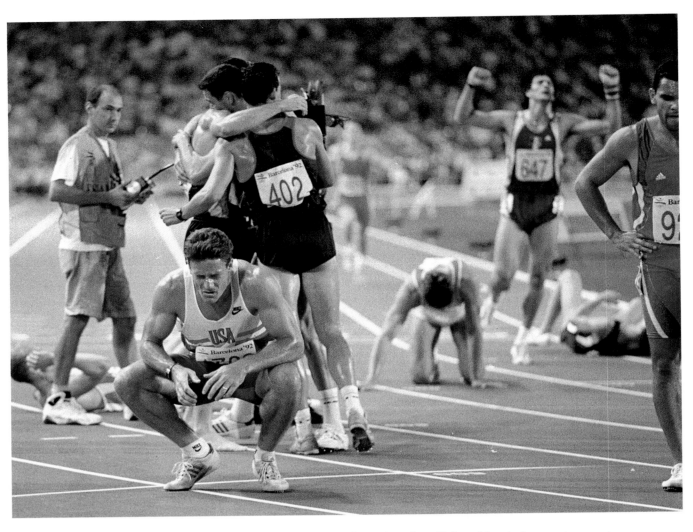

The finish of the 1,500-meter portion of the decathlon in Barcelona. American Robert Muzzio is at center, as he and other decathletes catch their breath after completing the race.

Jackie Joyner-Kersee getting set for the javelin part of the heptathlon at the Olympics Stadium in Barcelona.

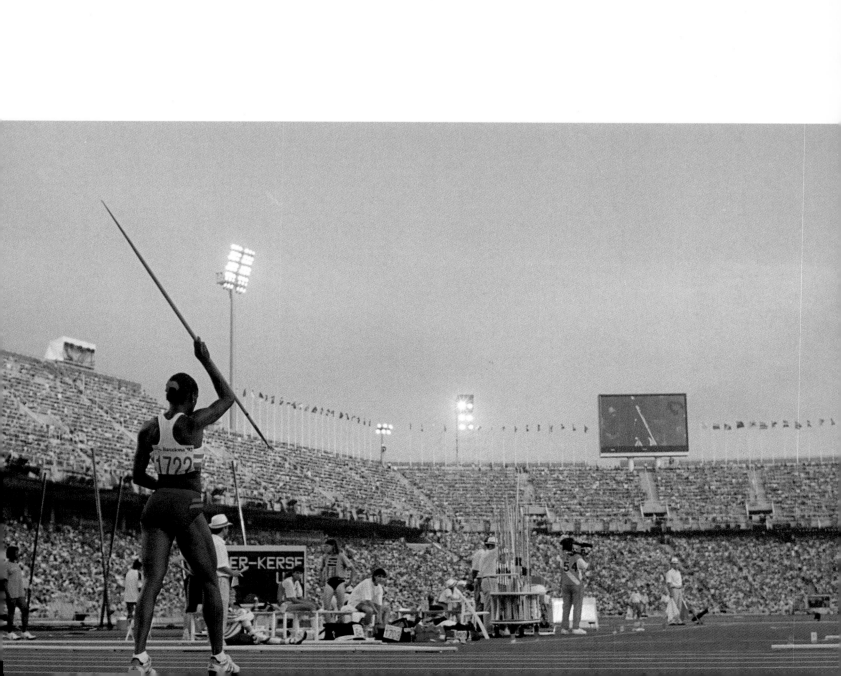

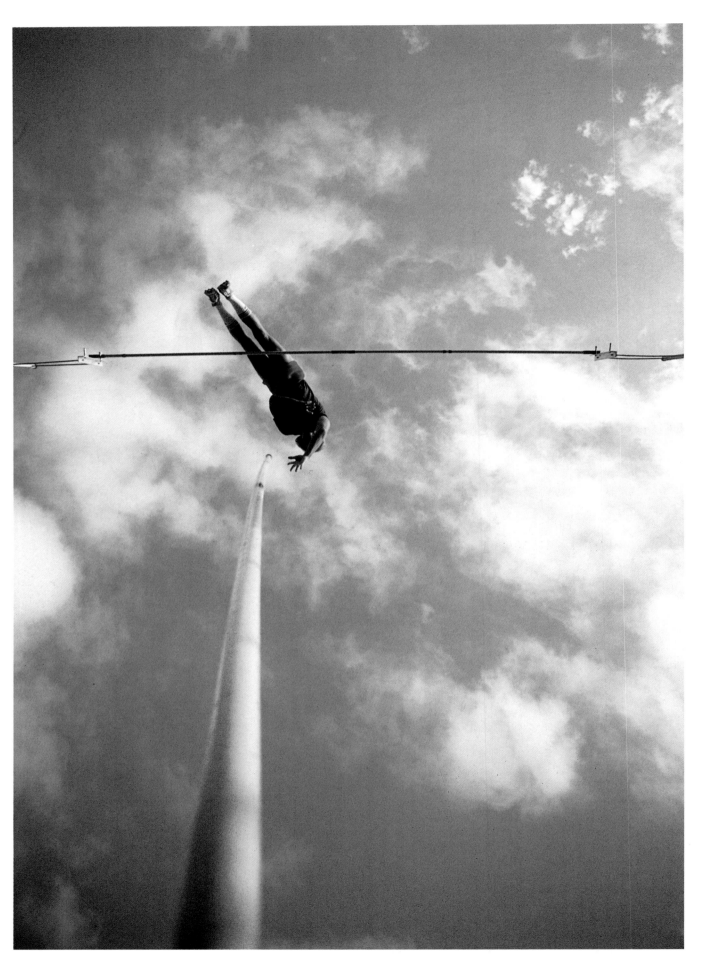

Billy Olson of the United States practices for the 1984 Olympics at Abilene Christian University. To make this shot, I mounted the camera on the ground near where he would plant his pole, then used a remote to snap the picture.

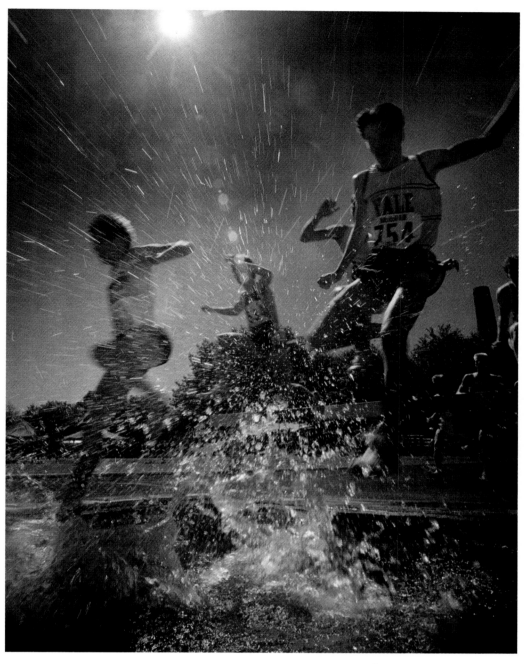

Steeplechase participants send water flying as they hurdle through it during a track meet at Randall's Island in New York in 1993.

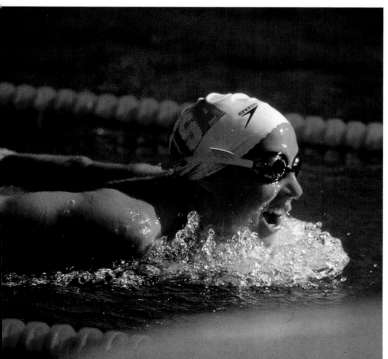

A United States swimmer competing in Los Angeles, 1984.

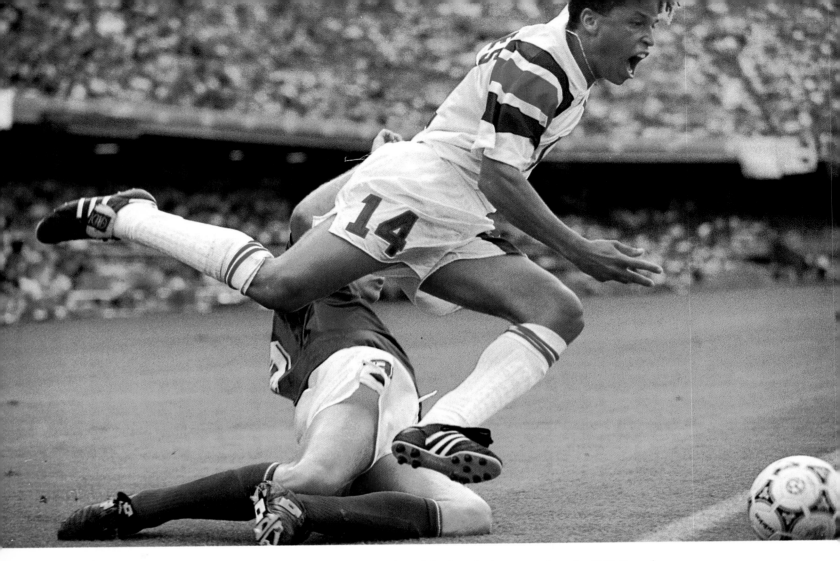

Cobi Jones of the United States kicking the ball past Italian defenders during a match at the 1992 Barcelona games.

Michael Jordan leaning in on Drazen Petrovic of Croatia
during the basketball competition, Barcelona, 1992.

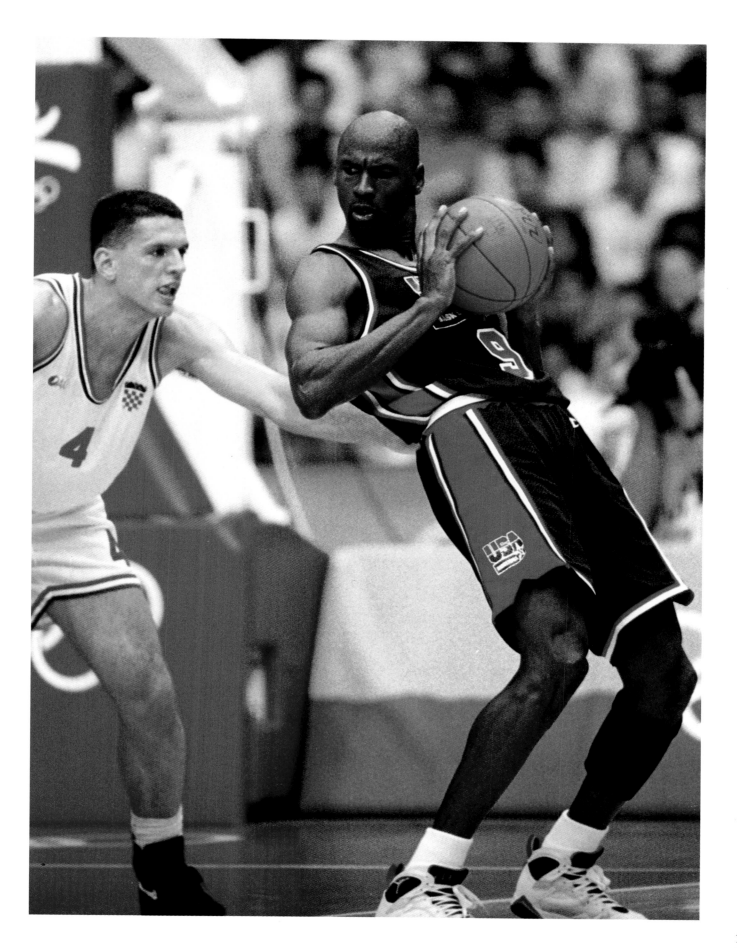

*Wilt Chamberlain of the
Philadelphia 76ers goes up for a
basket against the Knicks in 1967.*

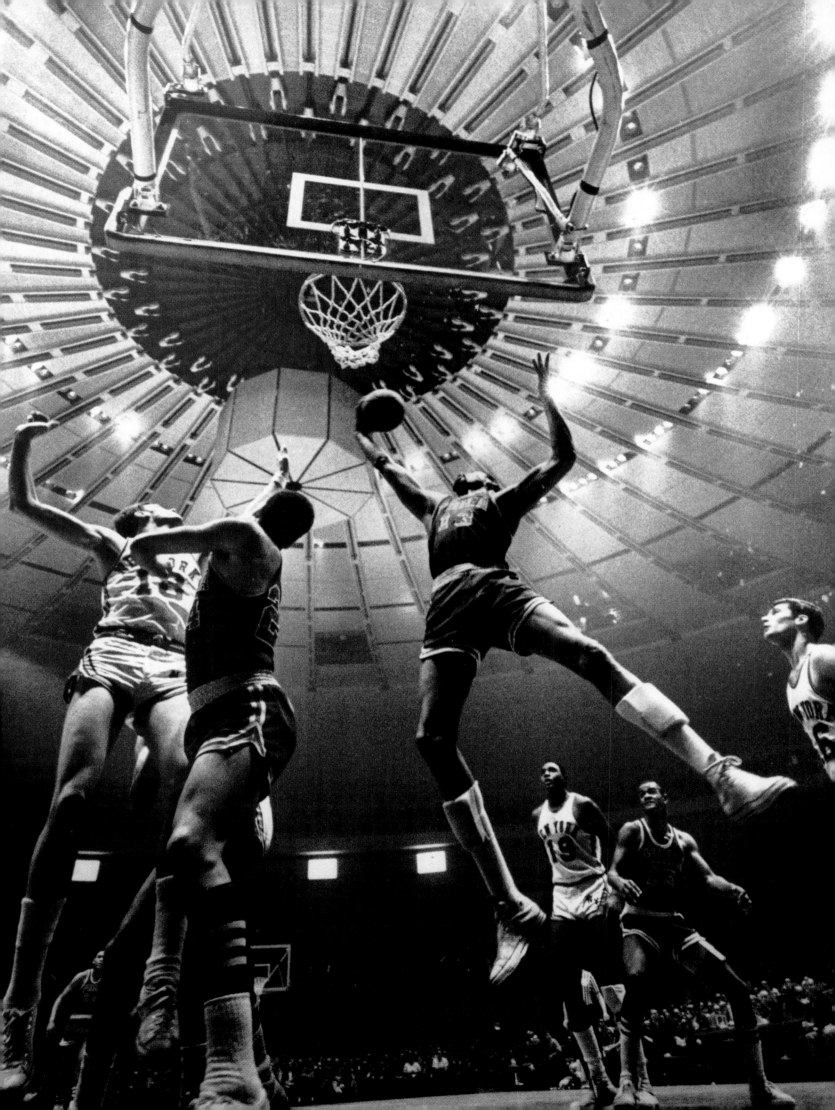

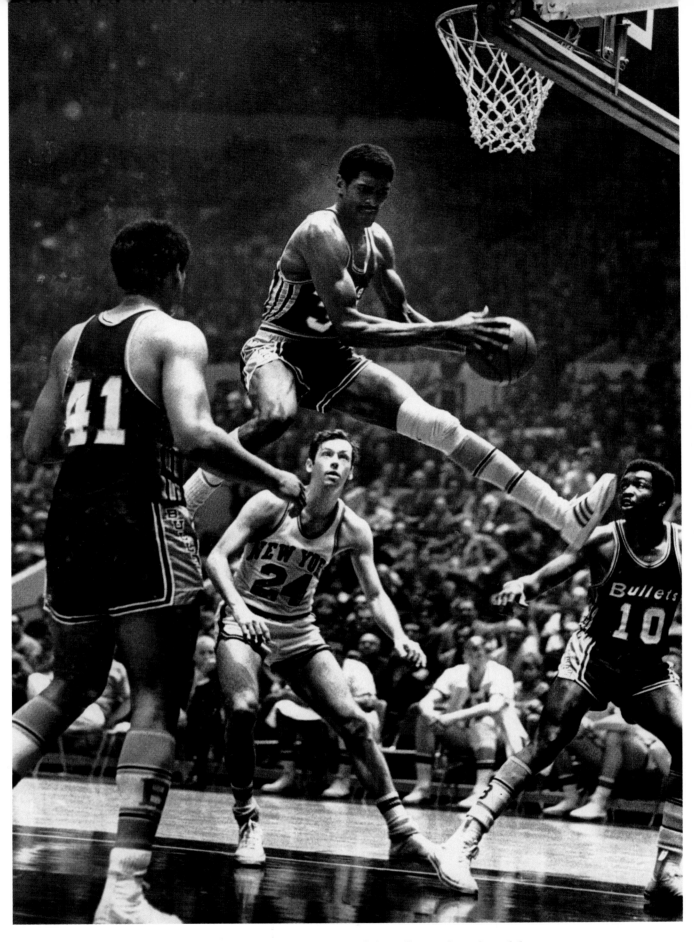

Bill Bradley of the New York Knicks (24) watches Ed Manning of the Bullets grab a rebound during a game in 1969. Earl Monroe (10) and Wes Unseld (41) of the Bullets look on.

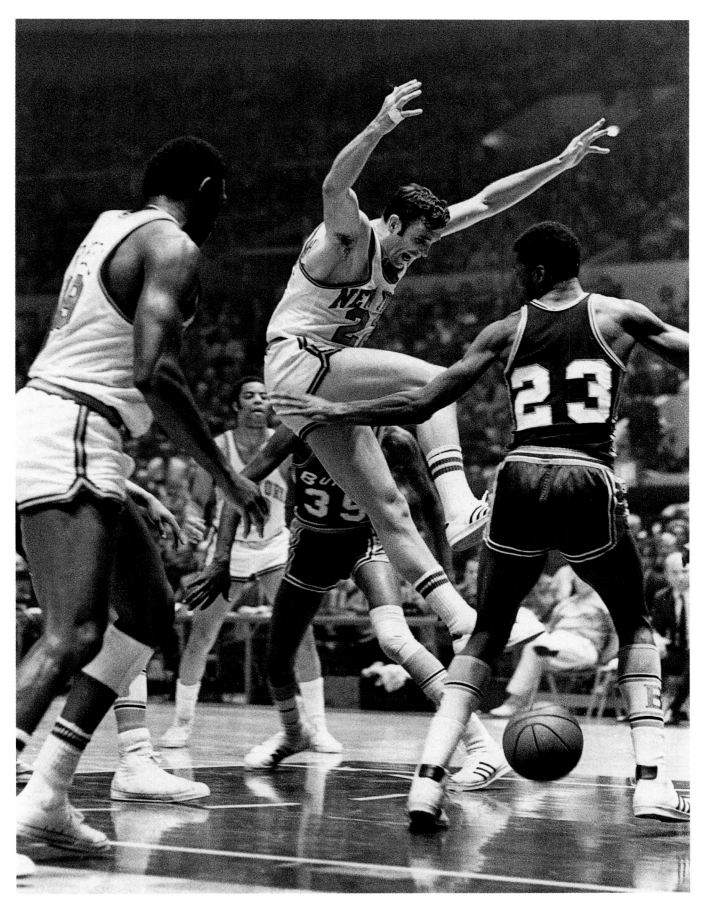

Dave DeBusschere of the Knicks goes airborne, but the ball remains below during a game with Baltimore at the Garden.

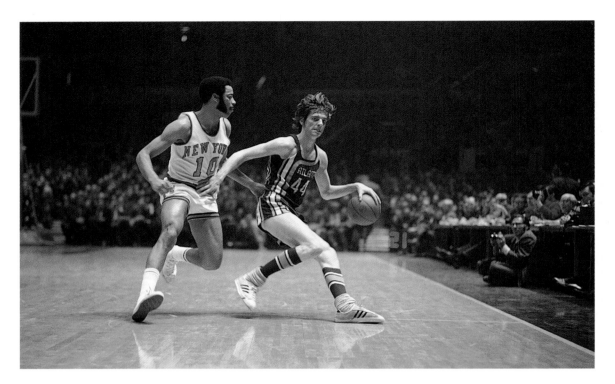

Pete Maravich (44) of the Atlanta Hawks dribbling past Walt Frazier (10) of the Knicks at the Garden in 1970.

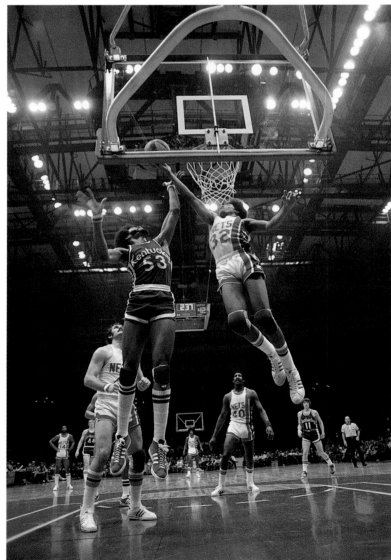

In a swooping move that exemplifies his soaring skills, Julius Erving of the Nets goes up for a dunk in a 1973 game with Kentucky.

Far right: Magic Johnson shooting during a practice session at Madison Square Garden in December 1991, five weeks after he announced his retirement because he had contracted the H.I.V. virus.

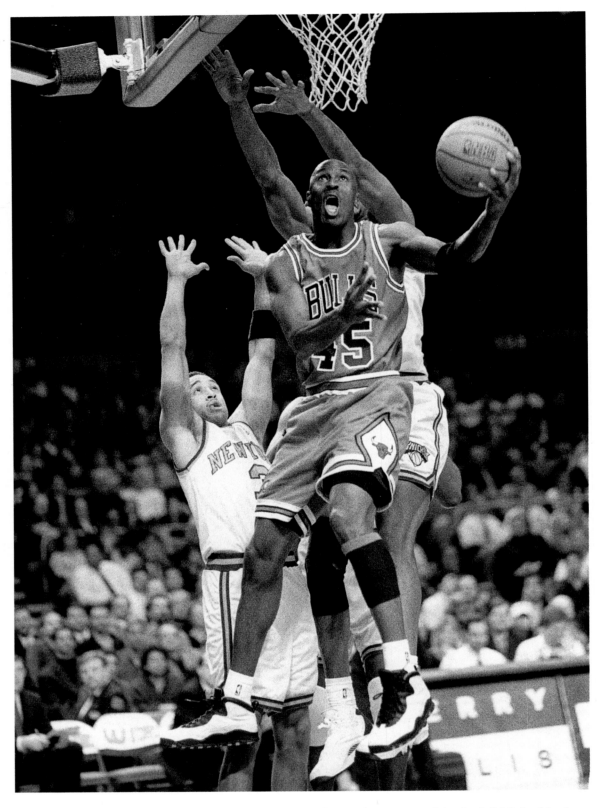

Michael Jordan playing against the Knicks in a game at the Garden in 1992. "I'm back," Michael Jordan shouted emphatically in March 1995, in his first game at Madison Square Garden after ending his basketball retirement. He scored an astonishing 55 points wearing his new number, 45, which replaced the 23 he had worn throughout his career (he later returned to number 23).

Michael Jordan scoring against the Philadelphia 76ers on the way to the Bulls' record-breaking seventy-two games won in the regular season, 1995-96.

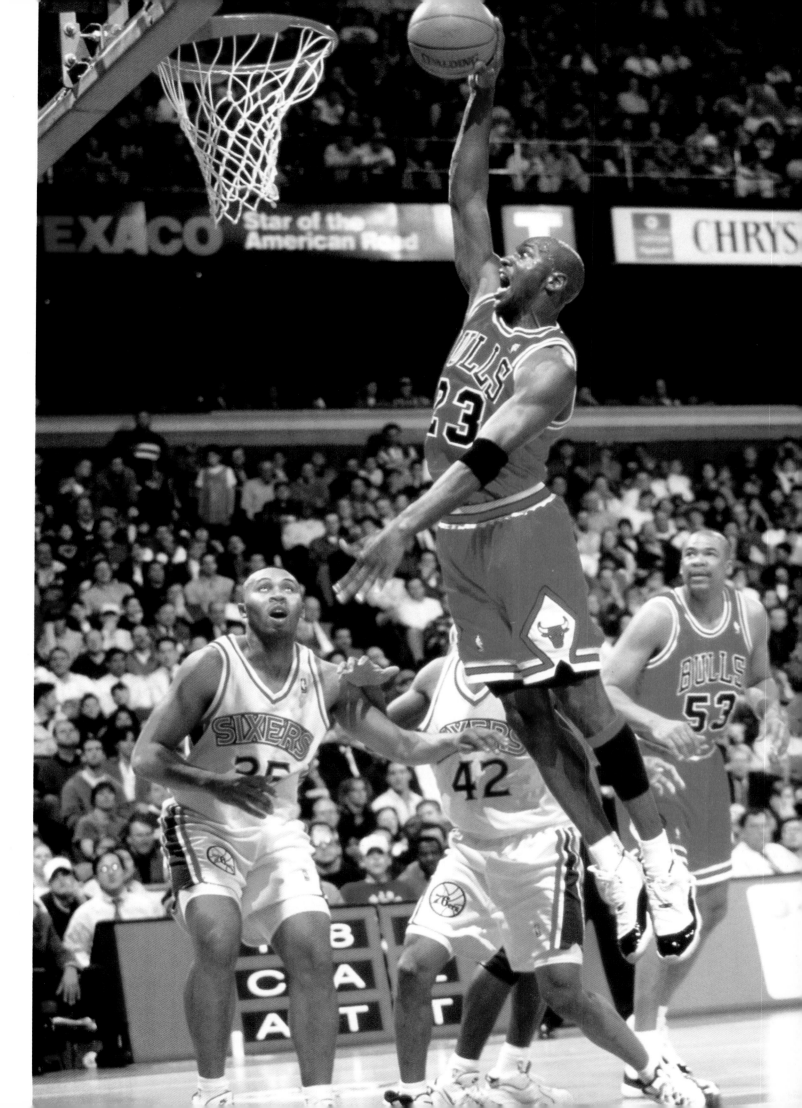

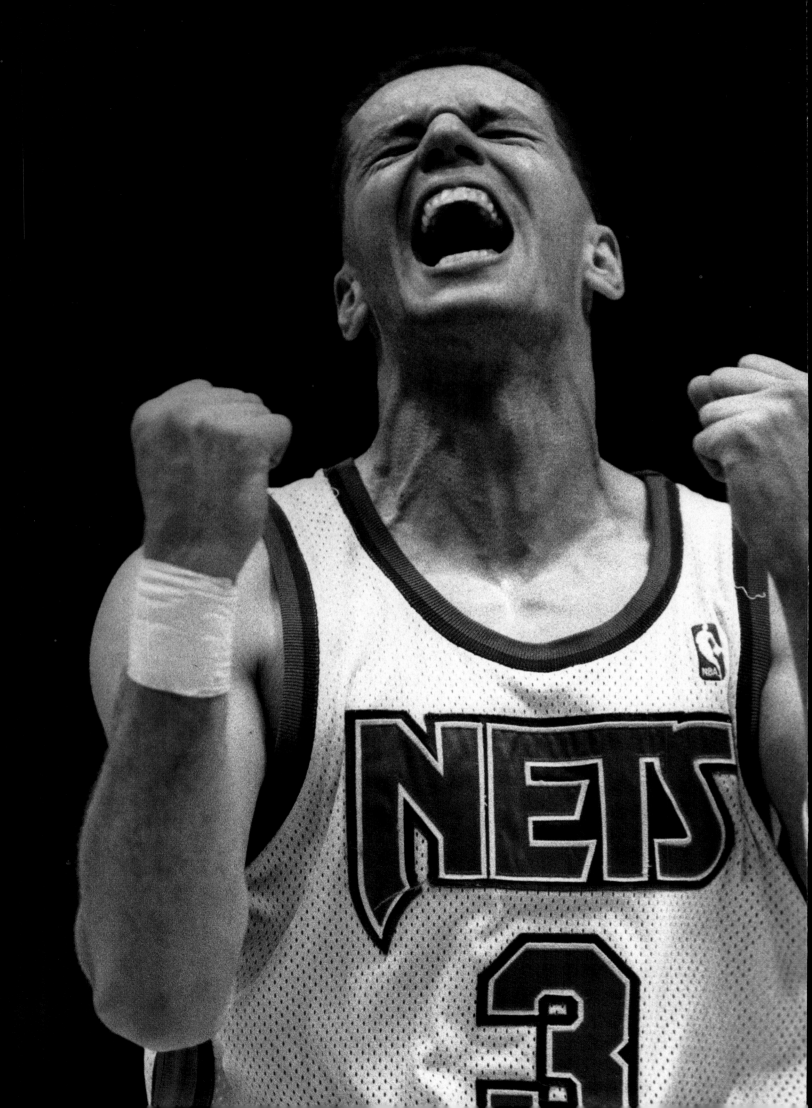

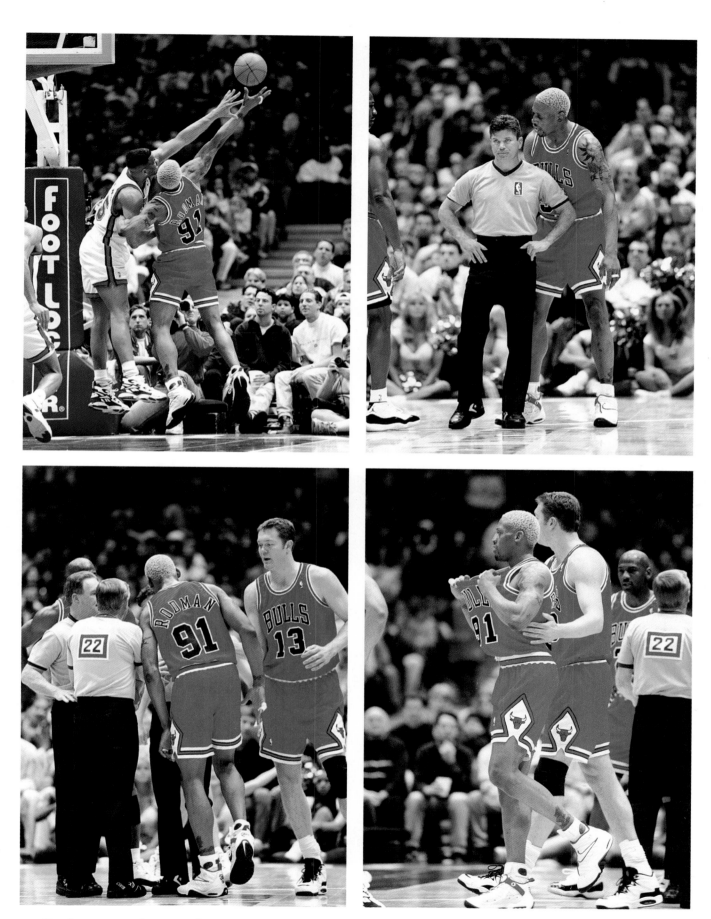

March 16, 1996, Chicago Bulls v. New Jersey Nets. Dennis Rodman fouls Jayson Williams as they reach for the rebound. Rodman's protest of his next foul escalated into the infamous head-butting incident with official Ted Burnhardt.

Drazen Petrovic of the New Jersey Nets reacting to a 3-point shot against the Cavaliers in April 1992 at the Meadowlands. Petrovic was killed in a car crash in Europe in June 1993.

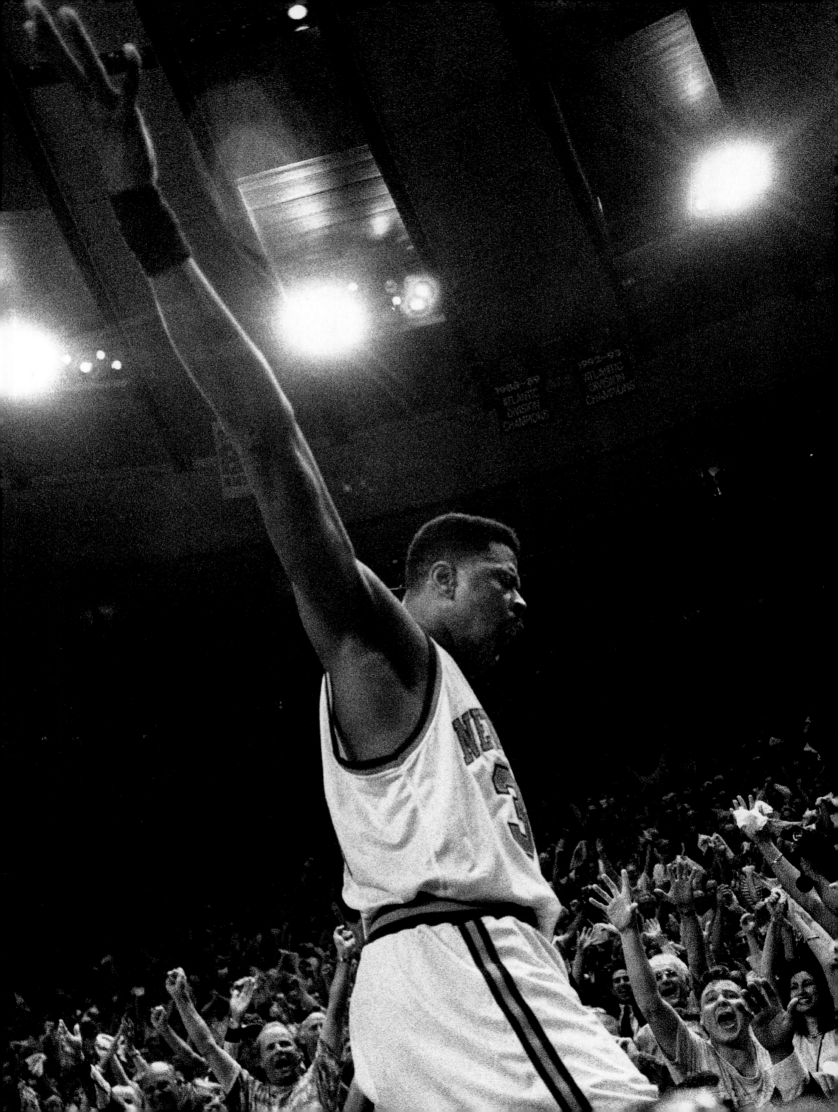

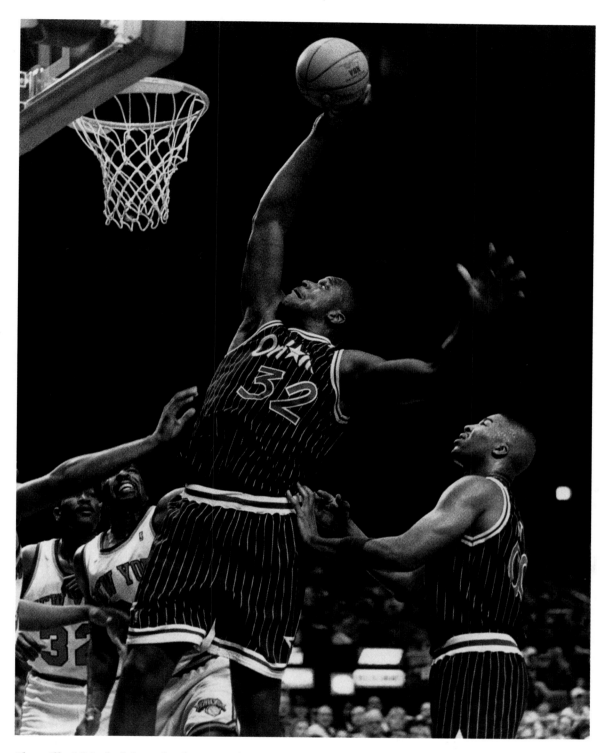

Shaquille O'Neal of the Orlando Magic shooting against the Knicks in a game at the Garden in the spring of 1995.

Patrick Ewing reacting to the crowd at the Garden after the Knicks defeated the Pacers in 1994 to advance to the finals.

John Starks of the Knicks making a shot during a 1993 game with the Nets.

It's all arms and legs as players for the Nets and the Phoenix Suns reach for a rebound during a game at the Meadowlands in April 1994.

Reggie Miller of the Pacers scoring against the Nets at the Meadowlands in 1996.

Hakeem Olajuwan of Houston shooting against the Knicks during the N.B.A. finals in 1994. The Rockets defeated the Knicks in seven games to win the championship.

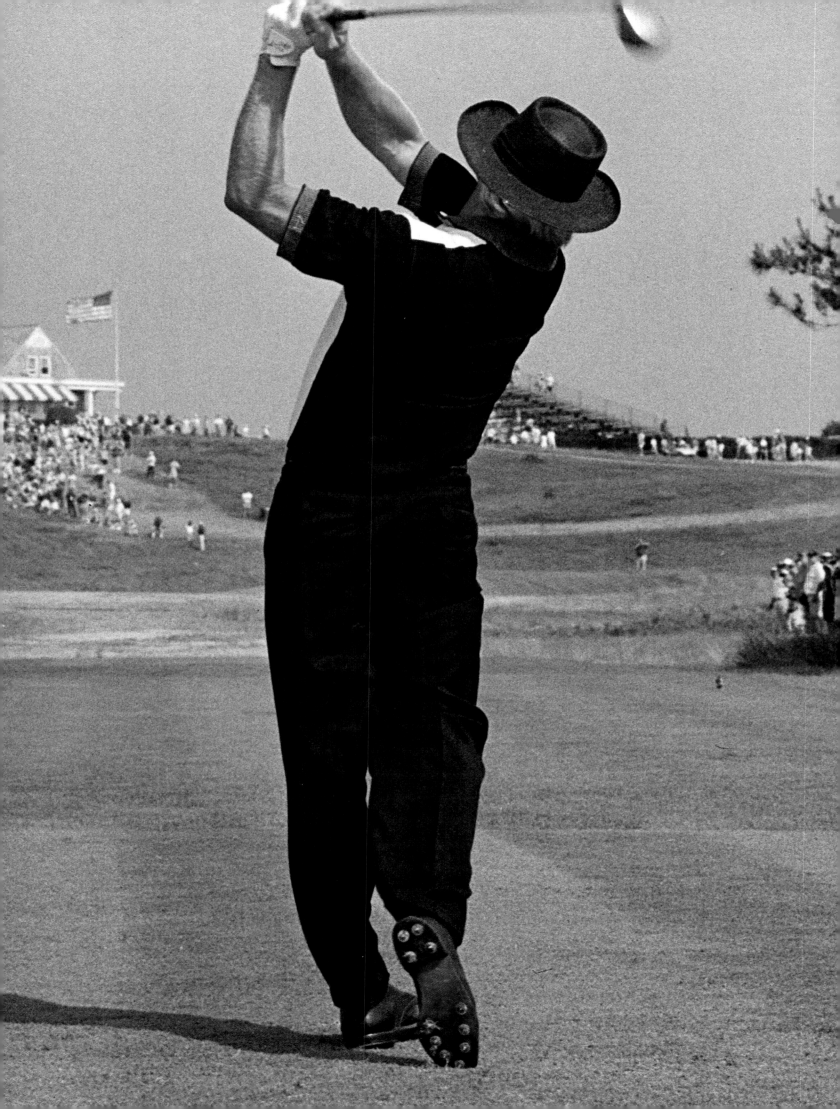

Jack Nicklaus hitting off the seventeenth tee during the second round of the 1995 Open. He missed the cut.

Previous pages: Greg Norman driving on the ninth hole of the 1995 Open at Shinnecock.
Norman remained in contention through the final round but fell back at the end.

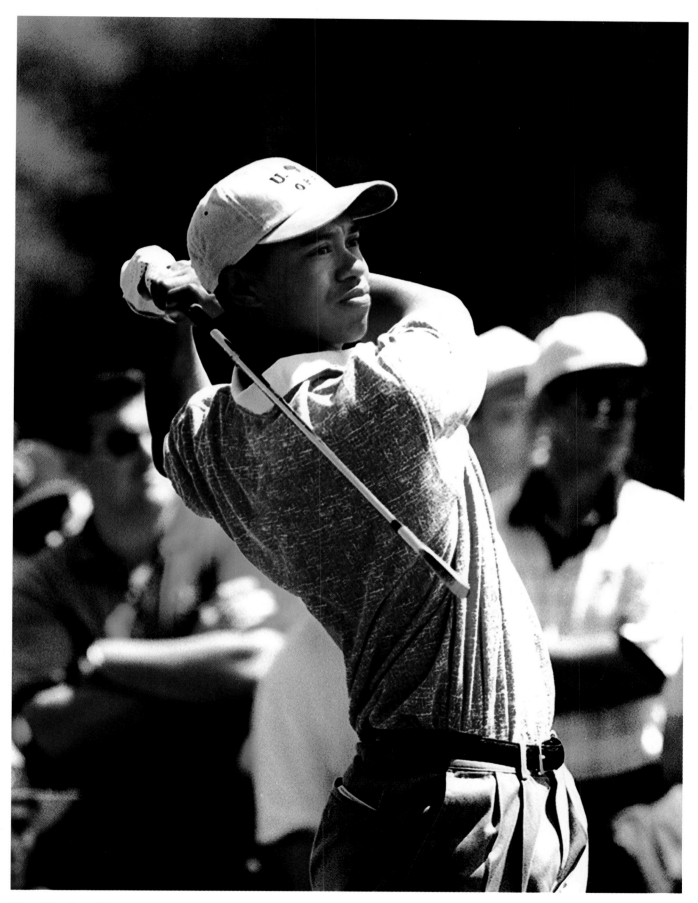

Tiger Woods, still just an amateur, was one of the longest hitters in the field of 156 golfers at the 1995 Open.

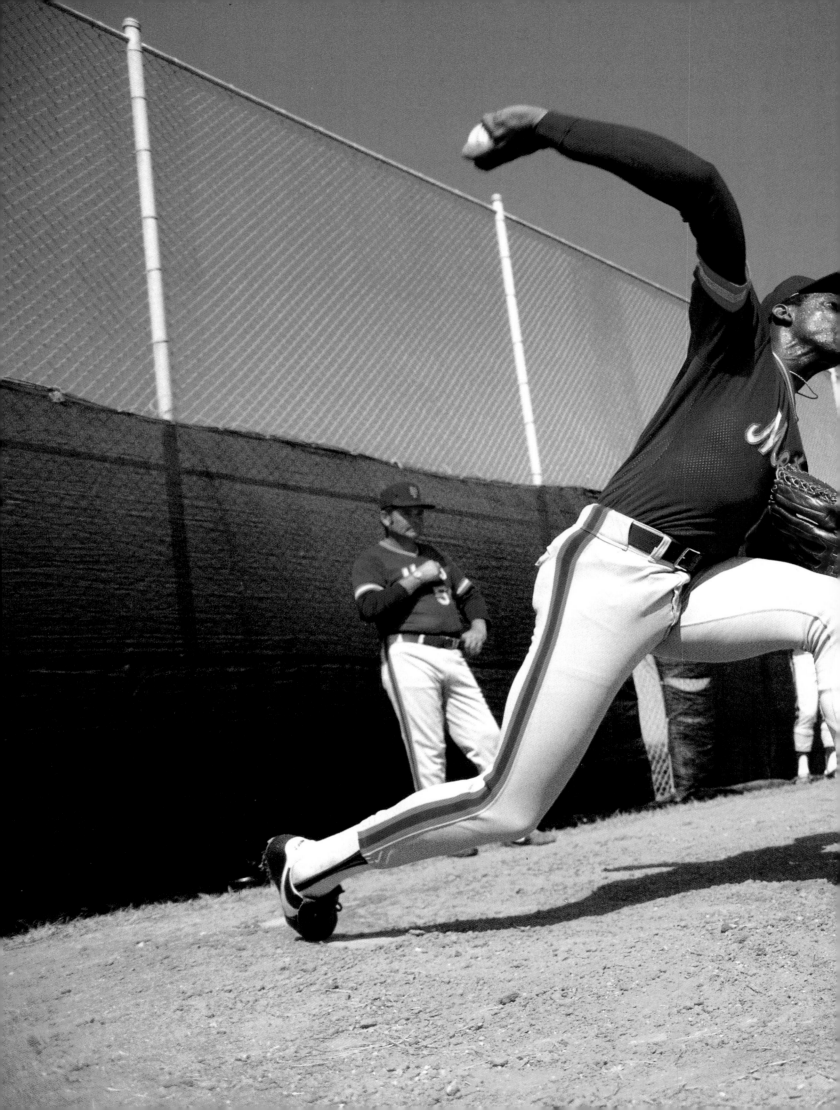

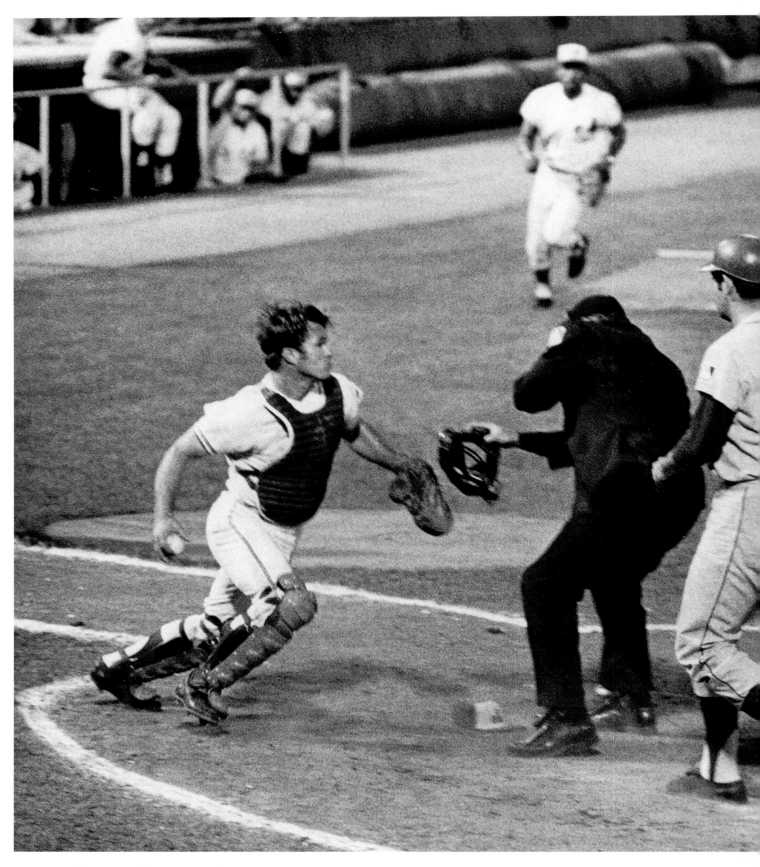

An incensed Expos catcher, Ron Brand, on July 17, 1969, heads out to take a swing at a Mets player during a game at Montreal.

Previous pages: Dwight Gooden pitching at the Mets' spring training camp in Florida. Gooden's career started sensationally.

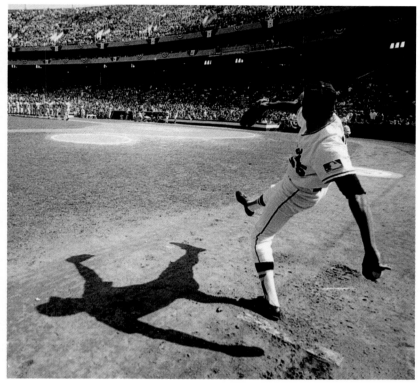

*Baltimore left-hander Mike Cuellar warms up before the first game of the
1969 World Series against the Mets in Baltimore.*

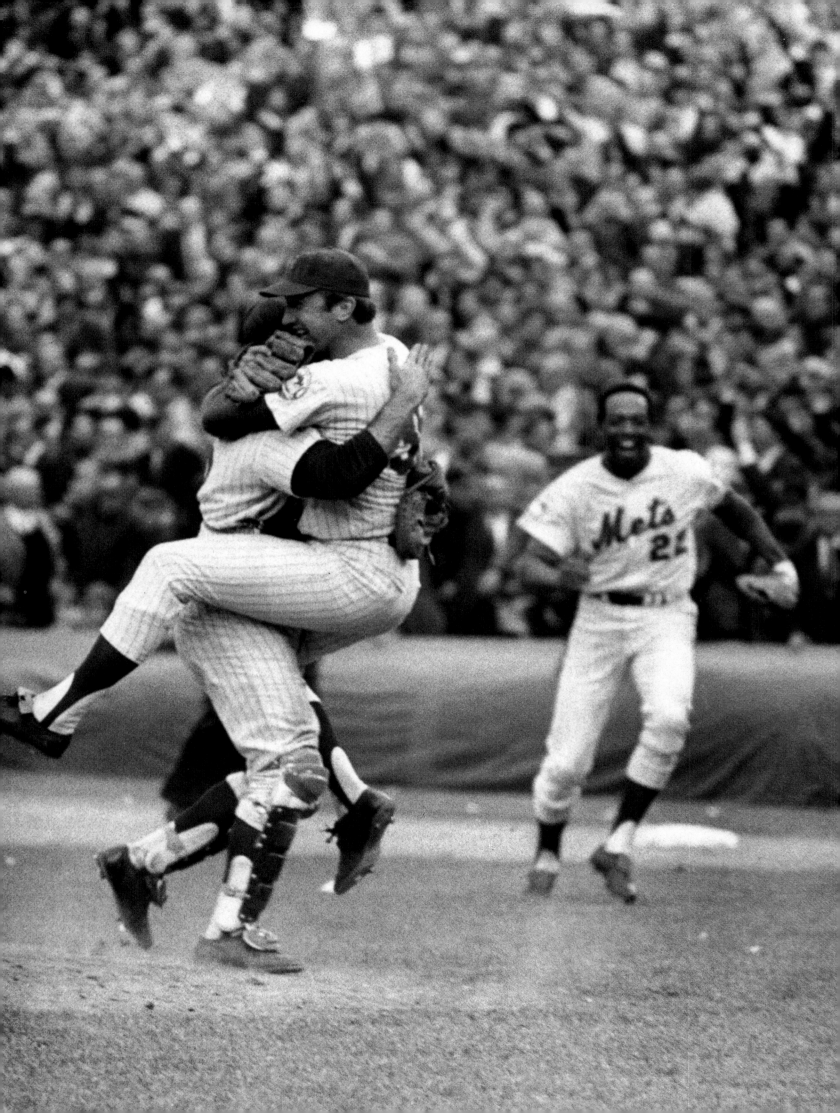

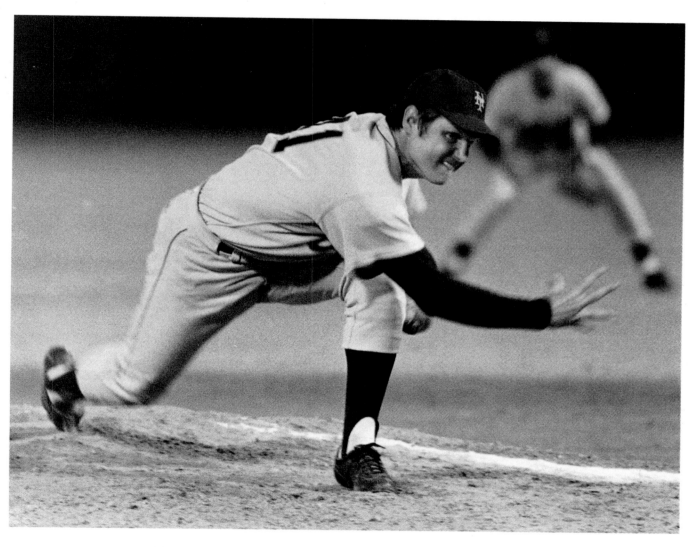

Tom Seaver's classic pitching form earned him 311 victories in the major leagues. Here he pitches during a spring training game in Saint Petersburg, Florida, in 1971.

Jerry Koosman of the Mets hugging catcher Jerry Grote after the Mets won Game 5 and clinched the 1969 World Series. Donn Clendenon (22) reacts in the background.

Kiko Garcia of Baltimore robs Omar Moreno of the Pirates of a base hit during the 1979 World Series.

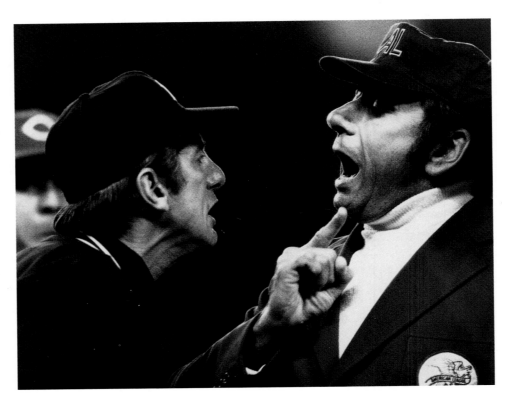

Billy Martin's best-known form was face-to-face with major-league umpires. The combative Yankee manager argues here with one of the umpires in the 1976 World Series.

Reggie Jackson salutes the crowd at Yankee Stadium minutes after hitting his third home run of the sixth and last game of the 1977 World Series, against the Los Angeles Dodgers.

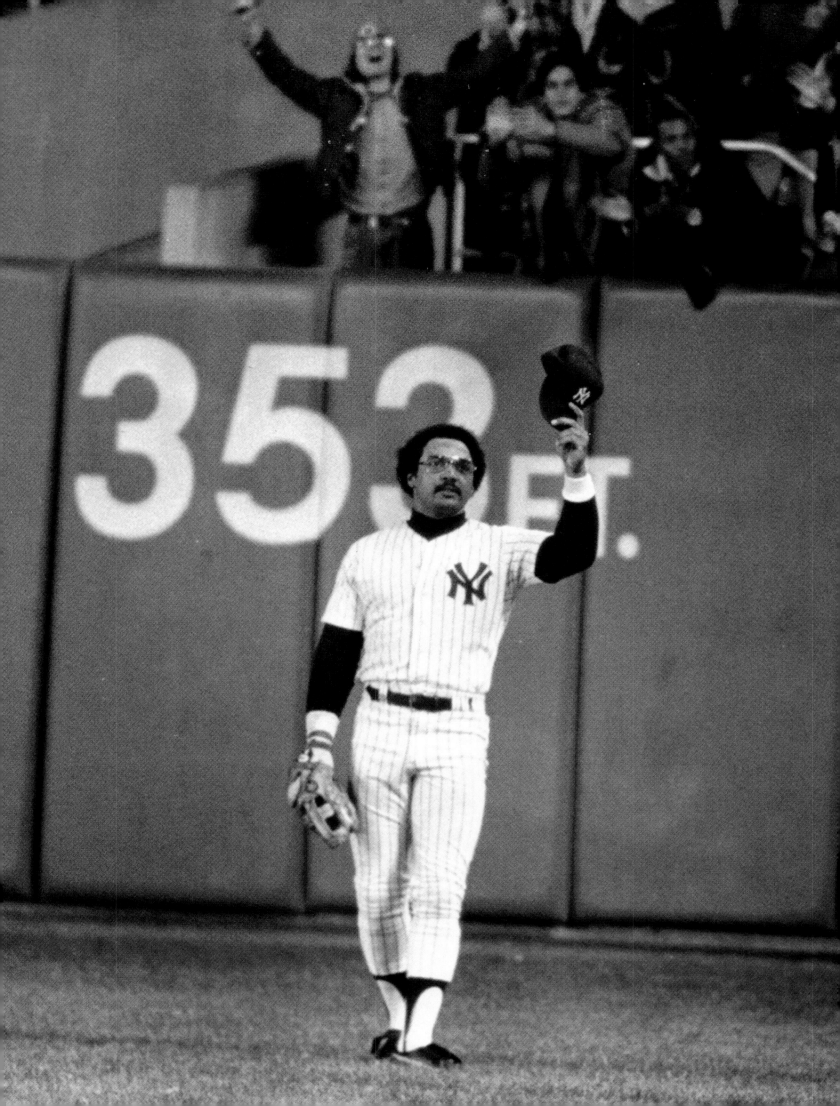

Craig Nettles of the Yankees making one of the leaping throws he became famous for while playing third base for the Yankees in the late 1970s.

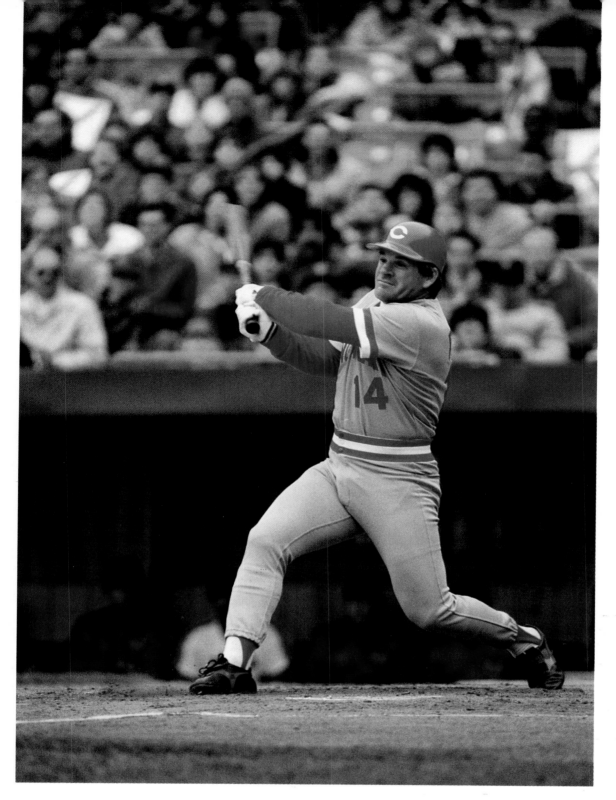

Pete Rose of the Cincinnati Reds during the 1980s, when he returned
to the team after stops in Philadelphia and Montreal.

Overleaf: Dave Winfield in the batting cage at the Yankees'
spring training complex in Fort Lauderdale, Florida,
after just having signed a lucrative contract.

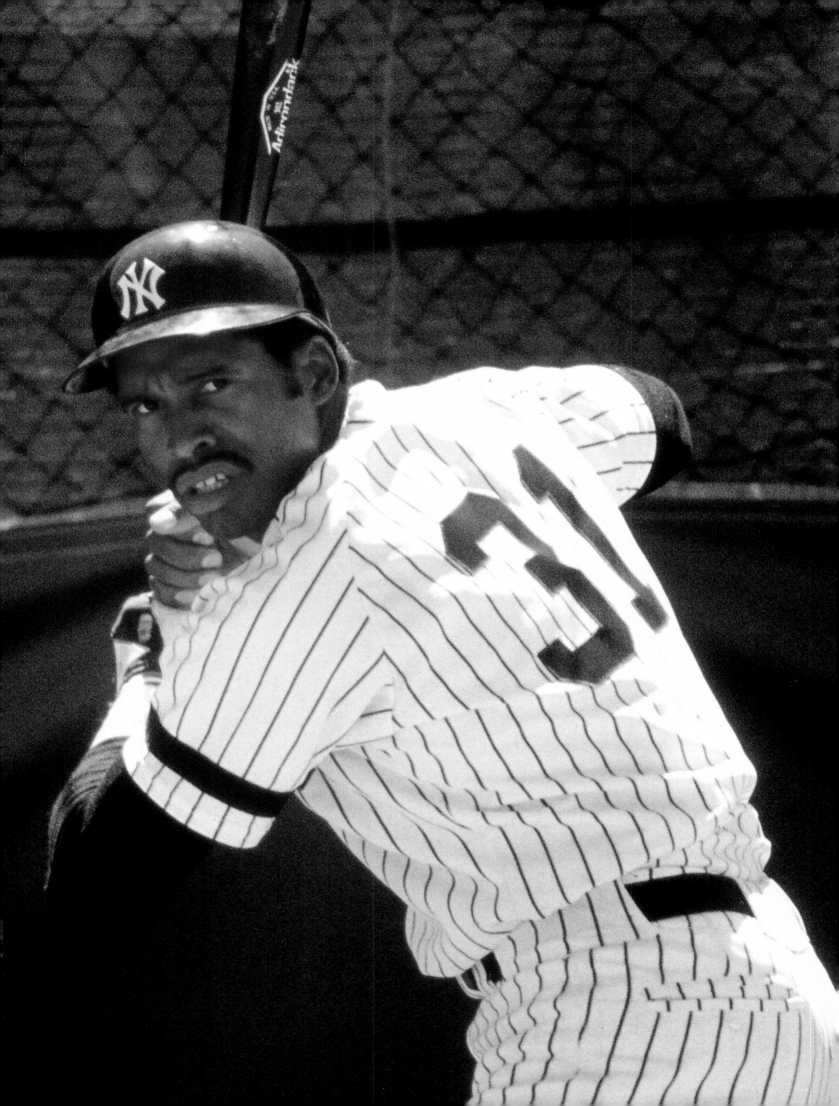

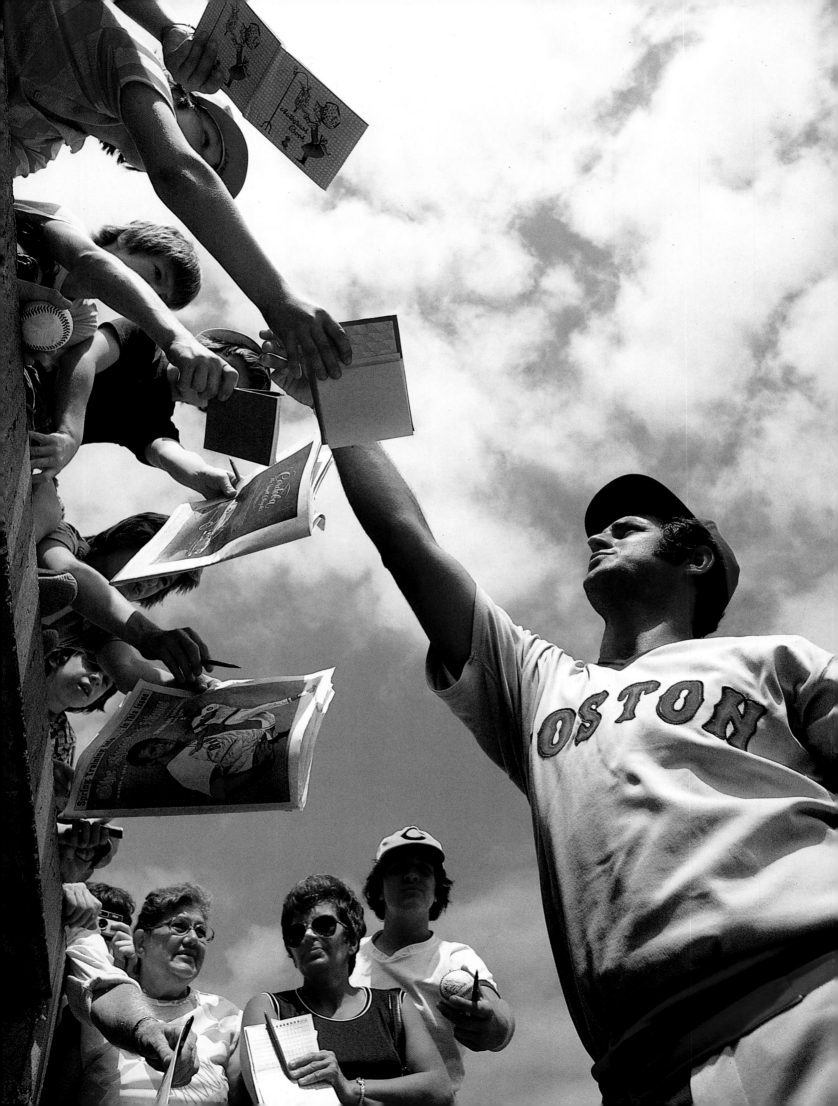

Tug McGraw celebrates after the Phillies won the 1980 World Series from Kansas City.

Boston pitcher Tom Burgmeier signing an autograph in 1982 at spring training.

Overleaf: Dave Righetti of the Yankees strikes out Boston's Wade Boggs to complete a Fourth of July no-hitter at Yankee Stadium in 1983. Whenever there's a no-hitter going in the late innings, photographers usually scramble to get positioned behind the plate in the latter part of the game. So some people went around the seventh inning, but the stadium people chased them. I made my move in the ninth inning, situated myself in the crowd behind home plate, and made this picture of Righetti with the scoreboard in the background.

George Foster of the New York Mets at spring training in Florida in the 1980s.

Tommy John watching batting practice at Anaheim Stadium in California.

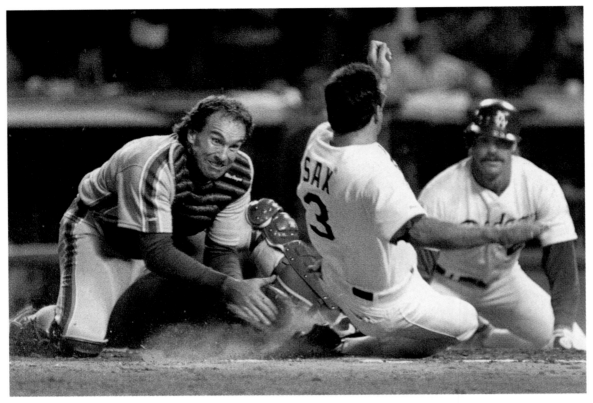

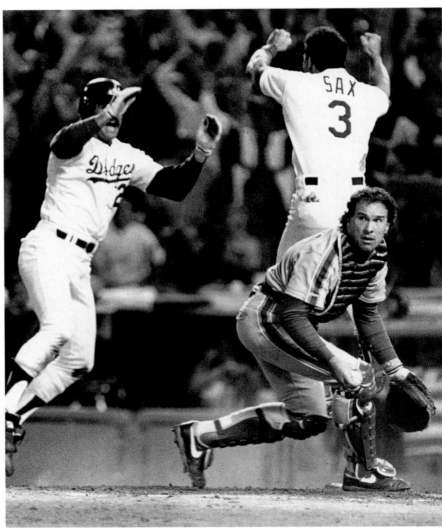

Gary Carter of the Mets trying to tag out Steve Sax of the Dodgers as Sax scores during a 1986 play-off game in Los Angeles.

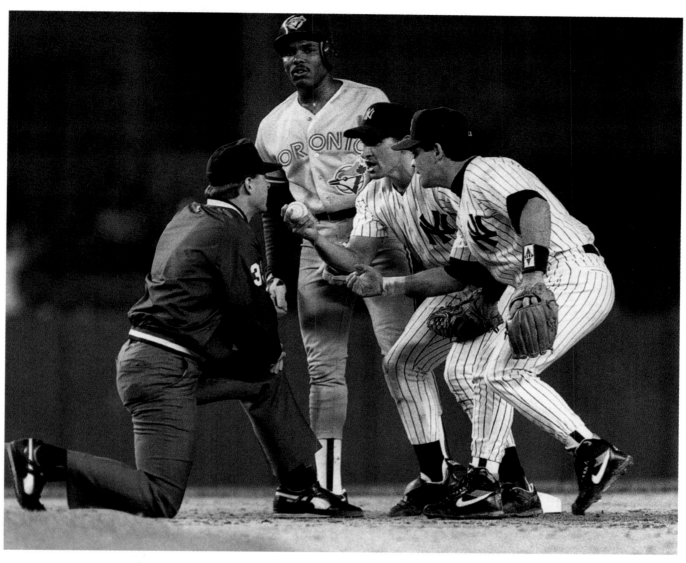

Steve Sax and Randy Velarde of the Yankees don't like the call and they're letting the umpire know it during a game against Toronto at Yankee Stadium in 1991.

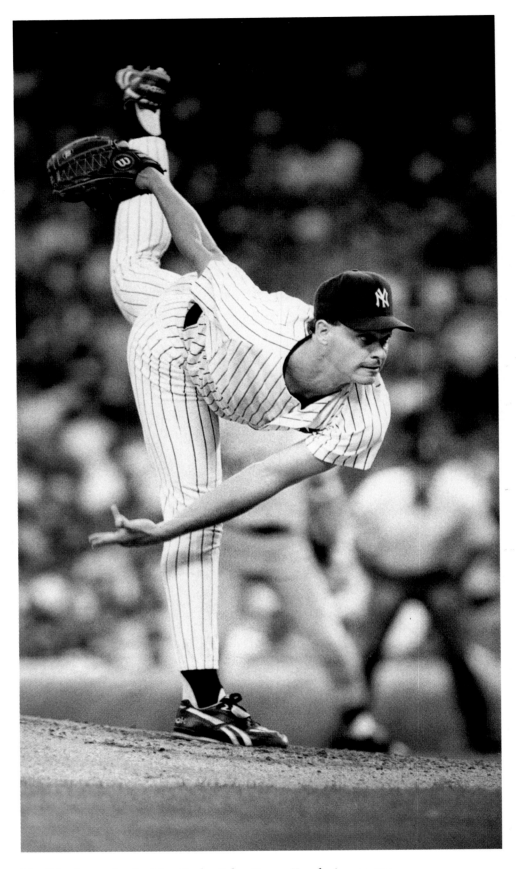

It's all in the motion for New York pitcher Jimmy Key during a game at Yankee Stadium in 1993.

Don Mattingly of the Yankees stroking one of his four hits during the last game of the 1984 season to win the league batting title with a .343 average.

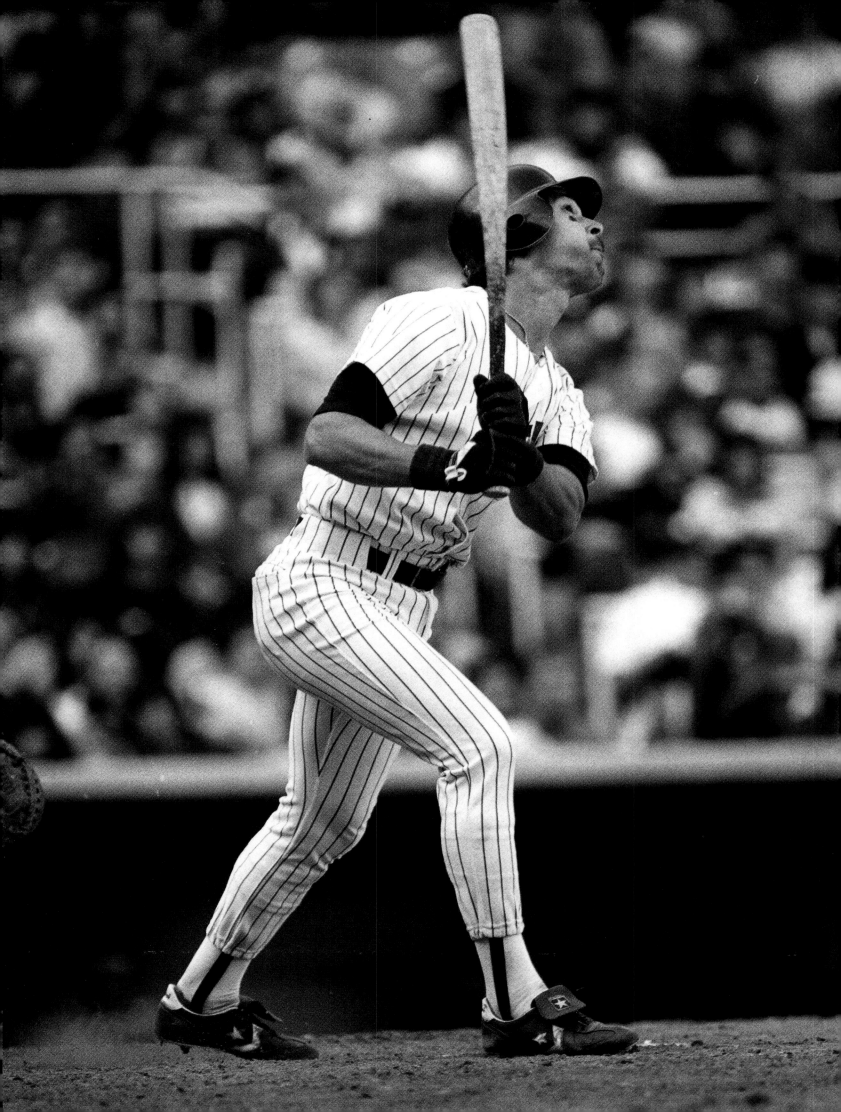

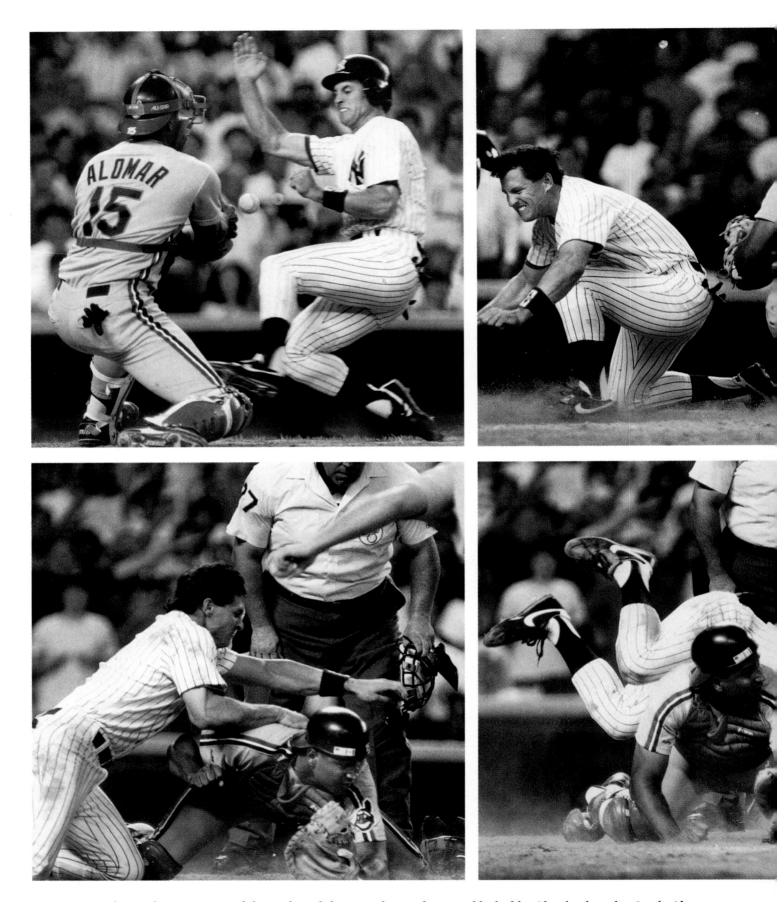

It's a territorial struggle as Steve Sax of the Yankees slides into a home-plate area blocked by Cleveland catcher Sandy Alomar. Sax misses the plate but Alomar misses the tag, and both try mightily to beat the other back to the plate as Sax tries to tag home and Alomar reaches to tag Sax. The umpire ruled him safe on the play.

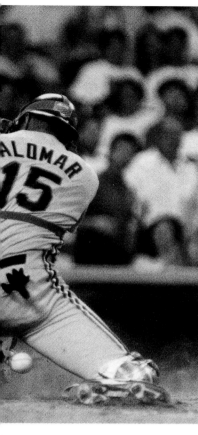
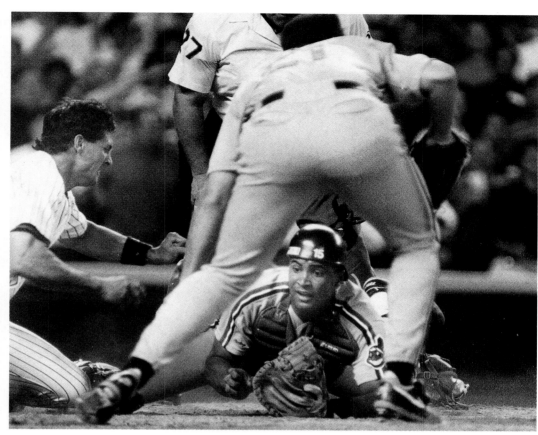

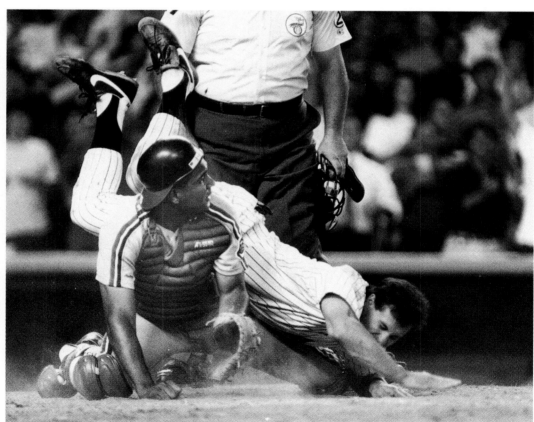

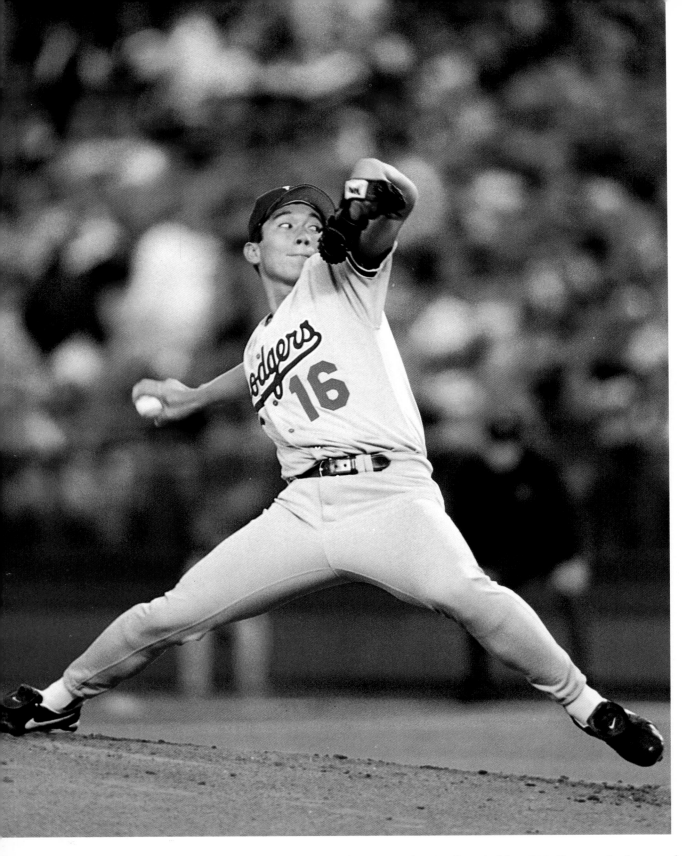

Hideo Nomo of the Dodgers pitching against the Mets at Shea Stadium in May 1995. Nomo, only the second Japanese-born player to play in the majors, went on to win the National League rookie of the year award.

Greg Maddux of the Atlanta Braves pitching during the 1995 World Series against the Indians. Maddux won a fourth consecutive Cy Young Award that season, with an e.r.a. of 1.63.

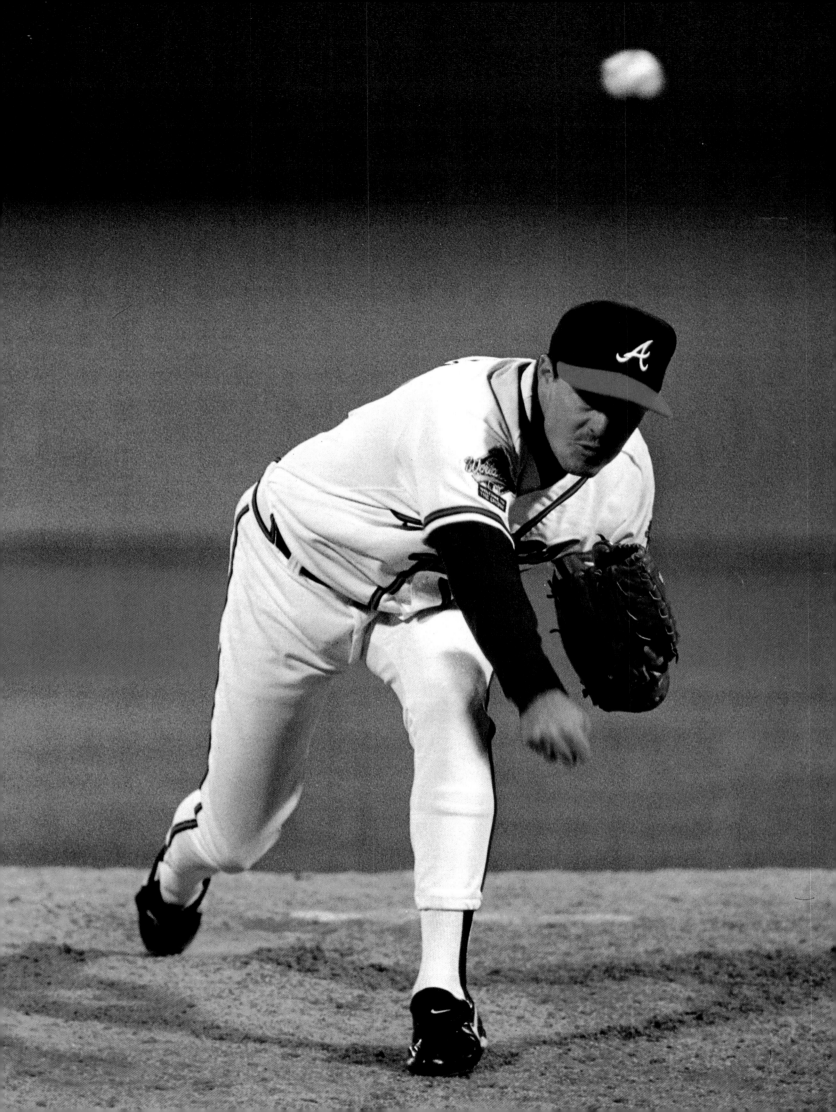

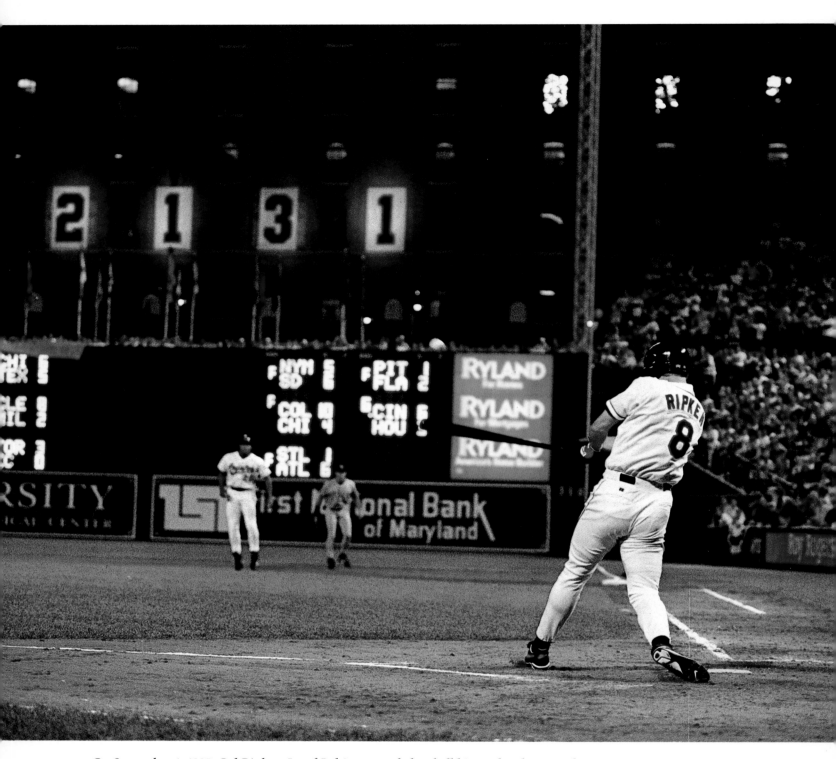

On September 6, 1995, Cal Ripken, Jr., of Baltimore made baseball history by playing in his 2,131st consecutive game, breaking the mark set by the legendary Lou Gehrig. Here, Ripken strokes a base hit in the eighth inning.

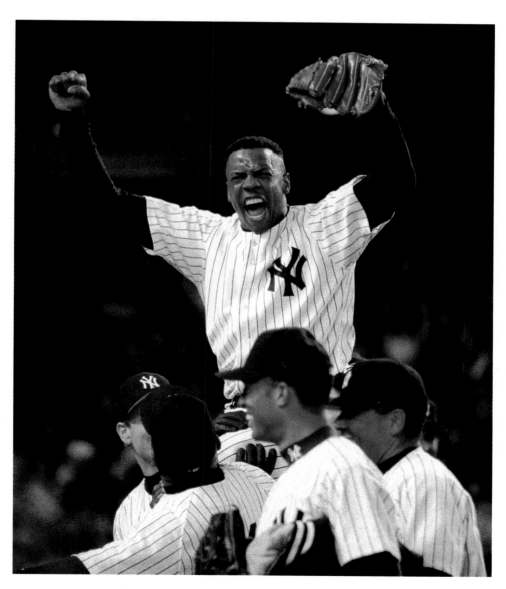

Dwight Gooden being carried off the field at Yankee Stadium after pitching his first no-hitter, May 14, 1996. Only two weeks prior, he had been on the verge of being cut from the team, and he had been suspended the entire 1995 season owing to substance abuse. He dedicated the game to his father.

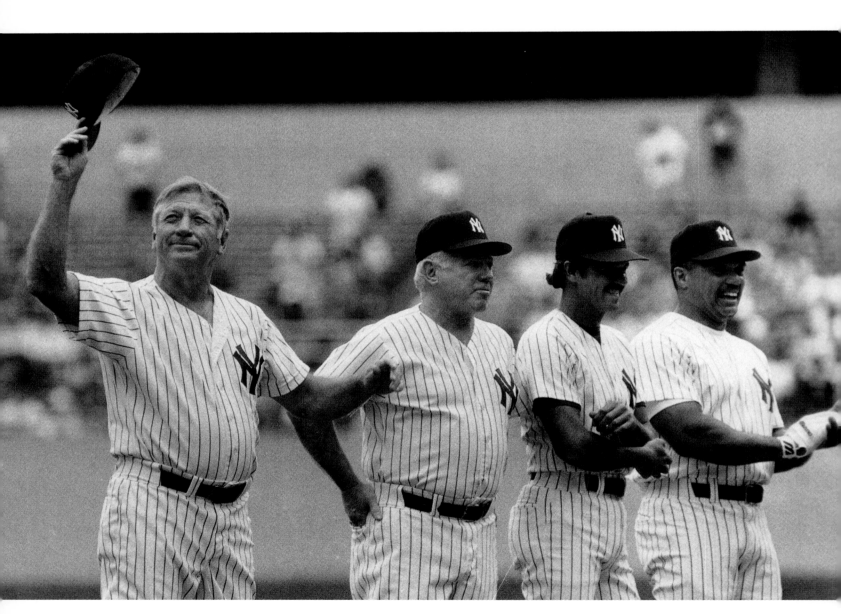

Old Timers Day at Yankee Stadium. From left to right: Mickey Mantle, Whitey Ford, Ron Guidry, and Reggie Jackson.

Afterword

Barton Silverman

Capturing the moment. That's what it's all about. The Knockout Punch. The Game-Winning Catch. That split second when athletes grab victory or see it slip through their fingers.

I've spent the last thirty years trying to capture the essence of those great moments as a sports photographer for *The New York Times.* Some folks joke that yesterday's newspaper is only good for wrapping fish, and they're probably ninety-nine percent right. But I think the best work is not forgotten. It lives on in people's minds.

Think baseball and you see Babe Ruth wearing number 3, leaning on his bat, and bowing farewell to a packed Yankee Stadium in 1948. Football? Joe Namath holding up his index finger after winning Super Bowl III. Basketball's Dream Team? Magic Johnson grinning as only Magic can, wrapped in the American flag. Every assignment, I have the same goal: To take the picture that will become people's memory of the event.

It doesn't always happen. Believe me, not every game has a great moment. And, I've been to a few great games where I just plain missed the shot. But when it all comes together, as in the photographs collected here, well, that's what keeps me going. Now that you've seen the pictures, let me tell you how I got them.

The man who said "position is all in life" must have been a photographer.

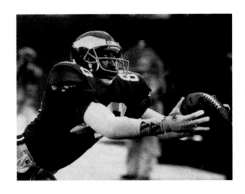

Cris Carter, of the Philadelphia Eagles, 1991.

No matter how great your camera eye, if you're in left field while the action's in right, you're out of the picture. Getting perfect position is a matter of anticipation, timing, reflexes, motivation, and, of course, a little luck. It was luck that seated me near the judges' box at the Lillehammer games when a tearful Tonya Harding held up her leg to show them her lace was broken.

But mostly, you make your own luck, applying your knowledge and feel for the game so the percentages will fall your way. The more percentages you have going for you, the luckier you'll be. I know it may sound strange, but the key is the ability to be completely in the moment and completely outside it at the same time.

It works like this. At an event, I'm immersed in the flow of the game, as focused on the moment-to-moment action as the players on the field. But part of me is thinking like a coach, standing back, analyzing and anticipating. I'm not just watching the action, I'm trying to figure out what's going to happen, so I can position myself to capture it.

At a football game, for instance, you get a feel: Is it going to be a running game or a passing game? Will they be throwing long or short? Who looks strong? Who doesn't? If it's a running game, I work parallel with the line of scrimmage to capture the back-breaking tackles. If it's an air show, I'll set up downfield so I can catch the ball just as it kisses the receiver's fingertips.

But you also have to know what you don't know, and find a way to overcome your limitations. Take as an example the picture of Sun Shuwei winning the gold medal in platform diving at the Barcelona games. I'm not a diving expert, so before the competition I went to a top official and asked him to handicap the event for me.

That's how I knew Shuwei was a favorite and that the swan dive, which is the most elegant to shoot, was his best. When he hit it, I hit it, snapping him in twisting flight with the cathedral of Barcelona as a backdrop.

Believe it or not, sports photography is a lot like playing chess—while you're making one move, you're planning the next six. Like the picture of Nicklaus on the seventeenth hole at Shinnecock. I had scouted out the course the day before and saw that the sun shone at just the right angle around 6:30 P.M. I

checked the pairings for the next day and saw that Jack was in an afternoon group, so he'd probably swing by the hole near twilight. When he teed up, I was ready, in the perfect spot, with the right lens to catch the light dancing off his face—the aging bear still fired with the hungry gleam of youth in his eye.

I am a sports photographer because I like the excitement, the pressure. I love being on the edge. I think of myself as a ballplayer in a tied game with a full count, two on, two out in the bottom of the ninth. Does he let that fourth ball go to get a walk and load the bases or does he reach for the pitch to get the game-winning hit? Me, I swing for the fences, going for the picture that people will remember. I never settle for the safe shot.

My Golden Rule is an old saying from the track: If you have a hunch you bet a bunch.

That's how I got the shot of Ali dazed in his corner during the Holmes fight. He had taken a beating that night and even though he had never before failed to answer the bell, I felt he wasn't coming out for the eleventh round. So I left my assigned seat in the top of the arena, got around some security guards, and asked a photographer friend at ringside if I could use his seat to shoot between rounds.

Of course, if Ali had come out, he probably would have been knocked out and I would have missed the shot while trudging back to my seat. But I bet he wouldn't. And he didn't. And I made the picture of a great athlete who had stayed around too long.

While you don't have to be Evel Knievel, sports photographers must be fearless. I've hung out of helicopters, dangled from bridges, and climbed the top mast of tall ships to get the job done. Like a war photographer who thinks the bombs will go off everywhere but around him, I think I'm indestructible.

The shot of Wilt Chamberlain pulling in a rebound is a good example. It was 1967, the first game played in the new Madison Square Garden. Its suspended roof was the talk of the town and I wanted to feature it. But to do that, I had to lie on my back right under the basket waiting for someone to leap into my viewfinder. I never stopped to think that Wilt and his seven feet could just as easily have stomped on my chest. If I'd worried about that, I couldn't have focused on getting my shot.

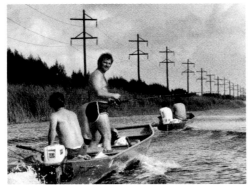

Yankees on a break from spring training, 1975. Thurman Munson standing.

If I had to name the most important trait you need to succeed in sports photography it would be this: You can never give up. At spring training in 1975 I was assigned to get shots of the Yankees enjoying their free time. So I arranged to go with Thurman Munson, Mel Stottlemyre, Craig Nettles, and a few other players on a fishing trip. Little did I know the guys saw this as a chance to play a practical joke on me. My job was to get the last laugh.

At 7:30 A.M. I was following Stottlemyre in my car to Saw Grass Park in the Everglades. He said he knew a shortcut so I didn't give it a second thought as we left the highway, entered the swamp, and started down not even a road but a mud embankment built for flood control. Suddenly, he sped off. I tried to keep up, but he lost me. Before long I found myself at a four-way fork in the road. Either I chose a fork or turned back. But there was no turning back; I had a job to do.

So I made my choice. It was the wrong one. An hour went by. I'd seen nothing but thick forests and hungry alligators. My heart was racing, my hands were sweating. Finally, I saw a highway in the distance. I raced toward it. But when I got as close as I could I saw the padlocked fence between me and safety. So I left my car and scaled the fence. I walked fifteen minutes to a gas station, where I called the park rangers. They unlocked the fence and told me how to get to Saw Grass Park. Once there, I hired a power boat to take me where the Yankees were fishing. When I saw them, we sped up and shot past them, creating a huge wake that rocked their tiny boats. The look of surprise and grudging respect on Munson's face when I roared past, clicking away on my camera, was worth the trouble they'd put me through.

You see, snapping the picture is the easy part. The hard part is getting in the right position to capture the moment. That's what my game is all about.

Acknowledgments

After working for more than three decades as a sports photographer for *The New York Times*, I have been asked many times when I was going to put out a book. I often considered it, but never did anything about it until a fan letter provided the motivation. I would like to acknowledge the writer of that letter, Robert A. Mitchell, my number one fan, a sincere friend, and the inspiration behind this book.

Bob introduced me to Christopher Sweet, Executive Editor at Penguin Studio, and Christopher provided tireless guidance and help along the way as I moved into the fast lane and tried to put thirty years of photojournalism together in a meaningful and exciting way.

This book would not have been possible without the cooperation and support of many people at *The New York Times*. I am deeply grateful to those who contributed their writing skills. Dave Anderson is a good friend and a long-time supporter of my work. Ira Berkow and Neil Amdur, Sports Editor, are as well, and Mark Bussell was a valuable supervisor of my work. All have written essays for this book. Bill Brink caught the essence of the photographs with his captions, and Peder Zane provided valuable help with my afterword.

Steve Fine and Kathleen Ryan spent many hours evaluating the pictures and helping to select them. Carolyn Lee, Assistant Managing Editor, Dennis Stern, Associate Managing Editor, and Nancy A. Lee, my Picture Editor, were supportive from the beginning. Others deserving of thanks include Virginia Avent, Steve Jesselli, Margarett Loke, Jim De Maria, Elliott Tricoche, Paula

Giannini, Tom Burke, Frank Molloy, Walter Kenzel, Ed Gross, Sarah Kass, Ray Corio, Vinney Mallozzi, Fern Turkowitz, David Santus, Neil Leifer, and Paul Bereswill, as well as Anthony Alexander, who made many of the prints.

This book has become a reality through the support of Viking Penguin. At Viking Penguin, I would like to thank Michael Fragnito, Cathy Hemming, Laurie Rippon, Roni Axelrod, Bitite Vinklers, and the designer Jaye Zimet.

My appreciation to all, and last and in many ways most important, I want to thank the athletes themselves who appear in the book and whose feats and accomplishments are the "moments" that I was fortunate enough to have captured. I'd particularly like to thank Dave Winfield, Joe Namath, and Mark Messier. I would also like to thank LeRoy Neiman and Robert Lipsyte.

I am grateful to the people who put me in the position to have my photographs published and who helped me in the early part of my career. James Roach and Jim Tuite, former Sports Editors, published my first photographs in *The New York Times,* Paul Durkin of Dell Publishing gave many young photographers an opportunity to get their sports photographs published. John Morris, former Picture Editor at *The New York Times*, inspired so many of us. Carmel and Steve Cady encouraged me to expand my creativity, and Joe Goldstein, John Halligan, Phil Burke, Frank Ramos, Bob Wolff, Bill Shannon, and Sam Kanchugar guided me in the right direction.

A special thanks to the management of *The New York Times* for directing my career toward photographing sports, including Joseph Lelyveld, Executive Editor, Max Frankel, former Executive Editor, and Eugene Roberts, Managing Editor. Thanks also go to David R. Jones, Warren Hoge, and Allan M. Siegal, Assistant Managing Editors, as well as former Picture Editors that I have not yet mentioned, John Radosta, Mort Stone, Dane Bath, and John Durniak, and also Joseph J. Vecchione, former Sports Editor.

A special note of thanks to all my friends and colleagues in the photographic community who helped and guided me during the early stages of my career. They are Ernie Sisto, Bob Walker, Jack Balletti, Danny Farrell, Vic DeLucia, and Eddie Hausner, who acted as my mentor, and Bob Glass, who was my photographic assistant on many assignments that are represented in this book.